FOUNDRIES
AND
ROLLING MILLS

FRED DIBNAH
& DAVID HALL

FOUNDRIES
AND
ROLLING MILLS

Memories of

INDUSTRIAL BRITAIN

BOOKS

This book is published to accompany the television series entitled
Fred Dibnah's Industrial Age, first broadcast in 1999. The series was produced by
BBC Factual Entertainment, in association with The View from the North Limited.

Executive Producer: Paddy McCreanor; Producer: David Hall

3 5 7 9 10 8 6 4 2

First published in 1999 as *Fred Dibnah's Industrial Age*

This edition published in 2015 by BBC Books, an imprint of Ebury Publishing.
A Random House Group Company

The Random House Group Limited Reg. No. 954009

Addresses for companies within the Random House Group can be found at:
www.randomhouse.co.uk

A CIP catalogue record for this book is available from the British Library.

ISBN 9781849909723

Penguin Random House is committed to a sustainable future
for our business, our readers and our planet. This book is
made from Forest Stewardship Council® certified paper.

Front Images: Fred Dibnah portrait by Stuart Wood,
© BBC Worldwide. Saltaire Mill © Photolibrary.
Back Images: Top left – The Scottish Mining Museum © David Hall.
Top right – Pretoria Pit and postcard © Museum of Science and Industry,
Manchester. Bottom right – Workers at Astley Green Pit © Lancashire Mining Museum.
Bottom left – Foundry at Garrett and Sons © Trustees of the Long Shop Museum.
Spine – Puffing Billy Engine © Mary Evans Picture Library.

Design: O'Leary & Cooper
Maps: All Terrain Mapping

Printed and bound in Great Britain by Clays Ltd, St Ives PLC

To buy books by your favourite authors and register for offers, visit:
www.randomhouse.co.uk

CONTENTS

INTRODUCTION

Britain was the birthplace of the Industrial Revolution. Throughout the eighteenth and nineteenth centuries we led the world in harnessing the power of coal, water and steam to drive the heavy machinery that made mass production possible. Perhaps the most significant breakthrough was the one that took place in 1709 at Coalbrookdale in Shropshire when Abraham Darby patented his coke-smelting process for making iron. Soon his coke-fired iron-works were producing more iron than anywhere else in the world, and the iron made there was cheaper and better than any seen previously.

At about the same time, Newcomen's steam engine, developed for draining mines, allowed miners to dig deeper than had ever been possible before and to reach richer seams of coal and iron ore, the raw materials of the Industrial Revolution. As the eighteenth century progressed, one invention followed another: James Watt's rotary steam engine, which improved on Newcomen's design and adapted it to other uses, Hargreaves's spinning jenny and Arkwright's water-powered spinning frame were just some of the inventions that enabled British manufacturers to increase their output while cutting their costs, making Britain prosperous on a scale that no other country in the world could match.

By the nineteenth century steam power was being adapted to provide revolutionary new means of transport and, through the work of the great railway pioneers, such as Stephenson, Hedley and Hackworth, Britain saw the development of the first steam locomotives and the world's first railways. Portable steam engines were developed to provide the power to increase agricultural production, and Brunel built the world's first steam-powered iron ship.

It is only within our own lifetime in the second half of the twentieth century that the great industries of iron and steel, coal-mining, textile-manufacturing, and ship and railway engine-building, on which our industrial supremacy was built, have disappeared. In the 1960s the skylines of the Lancashire mill towns bristled with the chimneys of huge cotton-spinning mills. In the 1970s crossing Sheffield's Tinsley Viaduct on the M1 motorway at night gave a view of something like Dante's Inferno, with the fiery glow of the furnaces lighting the sky and glimpses of rivers of glowing, white-hot, molten steel flowing through the smoke. And the miners' strike and pit closures of the Thatcher years are still very recent history.

But as the mines, the mills, the factories, the steel-works and the engineering works closed, the demolition men moved in, and the machinery that had made Britain the workshop of the world came under the wrecker's hammer. The scrap merchants became wealthy as they stripped the brass and anything else that was worth having from the engines.

Then dedicated bands of enthusiasts began to appear – people who were aware that, if action were not taken quickly, nothing would be left to show for one of the most important parts of our history. Steam railway preservation societies sprang up; individuals started to rescue traction engines from breakers' yards, and groups such as the Greasy Gang, who restored the magnificent beam engine at the Levant tin-mine in Cornwall, began to appear.

When the Northern Mill Engine Society first started its collection of mill engines in the 1960s, its members were looked upon as being slightly unbalanced. Who in their right mind would want to spend all their time restoring old engines? But the society made a stand and rescued all it could from the scrap men, realizing that these engines would be lost for ever if it didn't. Fortunately, there were like-minded individuals and groups all around the country – preserving pumping stations, restoring old mills and rebuilding coal-mining engines. Thanks largely to the dedication of these people, a small part of our great industrial heritage has been preserved for future generations.

INTRODUCTION

This book tells the story of our industrial past and provides a comprehensive guide to sites throughout Britain where this industrial heritage has been preserved and brought to life again. It's as important a part of our history as our great houses, abbeys and castles, and in many cases these sites provide opportunities for real hands-on involvement in history. Restoration and preservation work is an ongoing process, so with few funds available, volunteer help is often welcome at many of the sites listed in the Gazetteer. (Sites in bold in the main text appear in the Gazetteer.)

I've always been interested in our industrial past and over the years I've built up my own collection of steam engines and steam-driven machinery, so I think it's vitally important work. But that's not the only thing. It's fun as well. And if you get even half the enjoyment and satisfaction out of it as I've had, you're in for a good time.

THE POWER TO DRIVE MACHINES
Wind, Water and Steam

My father had a bicycle, and when I was big enough and capable of riding with two wheels he used to take me along the Bridgewater Canal and show me what he called one of the seven wonders of the world – Barton Bridge. It's where the Bridgewater Canal passes over the Manchester Ship Canal in a big iron tank, and was one of the sights of my early youth that has always stayed with me. The canals are part of a whole network around Manchester and Bolton that had been built in the eighteenth and nineteenth centuries to transport coal and cotton. Some places were completely waterbound and you couldn't get to them by road. Along the banks of the Bolton-Bury-Manchester Canal, where we went on another of our bike rides, there were wonderful examples of Victorian mining engineering, all made of wood, with inclined railways down the side of the banking, pit winding headgear, a huge boilerhouse at the bottom of a great big chimney and, near the access to the pithead, a little basin for the canal boats. Even the old pit winding engine was still *in situ* with gas lamps all around it. It was like going into a time warp.

I was fascinated by this industrial landscape, and I have been ever since. I wanted to know more about the people who built it and about those who worked there. But more than anything I was fascinated by the machines and the engines that drove them, and I wanted to know how they worked. Ever since then I've been finding out.

Those first bike rides along the canal with my dad were what got me started, but things were changing even then. It was sad, really – I saw these pitheads, winding gear and machinery only about three times, and every time I got there the feeling of anticipation was magic. Each time I went I was full of excitement at the prospect of seeing these strange things and at the thought of being able to stand at the top of the mineshaft and see the cage hanging on the rope and hear all this water swishing about with strange noises coming up from the bottom. Then, after about three visits, we turned up one day and were bitterly disappointed to find the wires had gone, the wheels had gone, the chimney had been felled at the bottom of the hill and all the railway lines had been taken up. The railway wagons were all in the lagoon at the bottom of the hill, and you can see them under water even to this day. Soon after this, they pulled down the last aqueduct and, of course, dammed up the canal when they were doing it.

But I started to go round looking for more of these sorts of places because they were like magic lands to me. I remember one day as a kid when I really thought I'd found something. I climbed over a fence made from railway sleepers and found an old water wheel. It was about 25 feet (7.6 m) in diameter and 5 feet (1.5 m) wide with a tree growing through the spokes and coming out the other side. I don't know how old it was, but you could still see the millrace where it went under what was left of the mill and the yard. This was a great discovery for me – seeing how water had been used to power the mills and factories round where I lived. In fact, I realized that some of them were still being driven by water power. Marsden's bleach-works, where my mum worked, must have been powered by some sort of water turbine because you could see clearly where the water was taken in from a stone weir round the back of the works. But all the mills and factories used steam as well. That's the way a number of them operated, with water and steam power running side by side. I know that when I was little, there were two Lancashire boilers at my mum's works just like the one in my back garden that drives all the machinery I've got there.

The boiler I have in the garden makes steam for turning a steam engine round, and that engine powers no fewer than fifteen machines. The boiler comes in handy for lots of occasions, and particularly for repairs to the traction engine. I've been repairing the engine now for fourteen years and it's almost a kit of parts that's ready for assembly – just a little bit more finance and time and I could complete the work.

It will be an unbelievable sense of achievement when I get the engine finished because by then I would have built the whole thing myself from scratch with a complete new boiler and all the parts hand-made. I've made new piston rods myself and new covers and valve rods for the valve chest covers and taken off all the corroded parts to get them looking like new – even better than new, some of them.

The vertical boiler I've got out in the back is very primitive. It's the simplest form of boiler next to a kettle. Basically, it's just a cylinder full of water with a very shallow firebox at the bottom and a tube straight up through it for the gas and the smoke to escape and to create a bit more heat. The crudest boilers like this have just two tubes going from one side of the firebox to the other; all the water is in those two tubes and the flames have to circumnavigate them. When they were being used commercially coal was cheap, you know, and these vertical boilers would burn any old rubbish – wet coal dust, they would fire them on, stuff they would normally throw away. It's amazing how late they survived on British Rail. All the breakdown trains were steam-driven and all had vertical cross-tubed boilers.

Another boiler I have, the horizontal one, is quite modern, and the design is good because the circulation of the water in it is very good, and that's the most important thing with a steam boiler.

People say I'm eccentric, running all this old machinery in my back garden, but it's more efficient than some of the modern things I've come across that people have working for them in their gardens. I know one man in Shropshire who's built a windmill in

his – that's really going back to an old-fashioned way of generating power. The wind was one of the very earliest forms of power used to drive machinery, and there are basically two different types of windmill. There is the post mill, which pivots on a vertical shaft so that the whole mill can be turned automatically to face the sails square into the eye of the wind. Then there's the conventional windmill, which is called a tower mill. In this the whole top is on a bit of a railway track to allow the top to turn automatically so that it faces into the wind. As you can imagine, there's not a lot of room, so it was quite a precarious occupation being a miller; you could end up mangled in your own machinery.

If you want to see a good example of a post mill, Suffolk is the place to go. East Suffolk post mills were reputed to be the finest of their type in the world, and **Saxtead Green** near Framlingham has one of the best. There has been a mill there since 1287, but from the records we know that the present mill dates from at least the end of the eighteenth century. A close look at it reveals quite a sophisticated level of technology. All the vanes in the sails could be opened or shut simultaneously, an action that's a bit like opening and shutting an umbrella. This made it possible to 'put the power off' with all the vanes open or 'put the power on' with all the vanes closed, without stopping the mill. The speed of the mill could also be regulated. A mass of weights was hung on a separate chain within the mill, which would open the vanes to decrease their speed should the wind rise sharply. This was known as 'spilling the wind'.

The milling process is divided into three stages on three floors. The top one is called the bin floor and the most prominent features of this are the heavy wooden windshaft that carries the sails and the grain bins. The second floor is called the stone floor. Here, two pairs of millstones are located on either side of the upright, wallower shaft in the front or breast of the mill. The wallower shaft is vertically positioned and holds the wallower, which is an iron gear wheel that's turned by the sails. Above the stone cases, which house the millstones, are wooden stools supporting the hoppers, which hold the grain and feed it to the millstones.

The two sets of stones are typical of most mills. The right-hand pair are made of Derbyshire millstone grit and are usually referred to as Peak stones. These are used for grist work – that is, relatively coarse meal used for feeding livestock. The left-hand stones are those used mainly for milling wheat for flour and are constructed from a very hard stone quarried from freshwater quartz from the Paris (Seine) Basin. Its common name is 'French Burr', owing to the nature of the stone, which looks a bit like Gruyère cheese. It cannot be quarried in large pieces, so each millstone has to be built up from a number of smaller sections. This stone was so valuable that even at the height of the Napoleonic War dealers, with government permission, paid handsome prices to the enemy for it. The lower stone or bed stone of each pair of millstones is stationary; only the upper stone, called the runner stone, revolves and so grinds the corn.

The meal floor lies at the base of the windmill on the ground floor, and it's here that you can see the actual drive to the millstones. The iron great spur wheel is mounted on the lower end of the wallower shaft. Its wooden cogs drive two iron stone nuts that, each in their turn, drive a runner stone on the floor above.

The grain was ground between the two sets of runner stones and bed stones. These are fed from above by grain hoppers leading from the bins on the bin floor. Grain trickles into the 'eye' in the centre of the millstones and slowly passes out towards the edge of the stones. All the time the grain is being crushed and ground into finer and finer particles.

A centrifugal governor controls the gap between the millstones which determines the fineness of the flour that is produced. The governors regulate the gap automatically according to the speed of the sails. So if the wind is light, the stones are kept further apart and grinding is slow; if the wind increases in force and the sails begin to revolve faster, the action of the governors is to lower the runner stone and create more friction. This prevents the sails from 'running away', while at the same time maintaining the fineness of the flour that is being ground.

Windmills are usually associated with corn milling, but not all mills were built for the grinding and processing of corn. The Norfolk and Suffolk marshes at one time depended entirely on wind power to keep them drained. With seven floors, the **Berney Arms Windmill** is by far the tallest marsh mill in the Broadland area. For the latter part of its life it has been used solely for draining the marshes, but at one time it ground cement clinker and was probably built for that purpose. The cement was made on the site from the chalky mud drained from the river. The mill is just near Great Yarmouth, and it's worth going to see because it's as good an example of a working tower mill as you'll find.

Tower mills were usually built of stone or brick – unlike post mills, which were usually constructed of wood. At the top of the tower's brickwork is a trough-shaped iron track or 'curb'. In this track runs an independent ring of rollers. A similar track is attached to the bottom of the cap, which sits on top of the ring of rollers. The whole arrangement forms a roller bearing, and it's on this that the cap turns.

The problem with any type of windmill is the unpredictability of the weather, so water has been used to power machines for more than 2000 years. It was the Greeks who were first credited with using it for milling cereals in the first century BC. The Romans also used grain watermills and introduced them to Britain. But it was from the twelfth century onwards that the number of watermills in Britain increased significantly. Most of them belonged to either the local manor or to a monastery.

The dissolution of the monasteries, an increasing population and the development of better transportation all contributed to the establishment in the eighteenth century of the independent miller, who milled for a living. It's with the appearance of the independent miller that we reach the heyday of water-driven stone mills. This lasted for more than 100 years from the mid-eighteenth century to the end of the nineteenth.

The basic principles of grinding corn are common to both windmills and watermills but, unlike wind, water can be harnessed far more easily and much more dependably. When a water wheel

is in operation, water passes through the mill 'leat' and falls into 'buckets' that are attached to the wheel. The weight of the water in the buckets causes the wheel to turn. As the wheel turns, it operates a gearing system that eventually causes the millstones to rotate. The flow of water on to the wheel from the leat is regulated by a penstock, a sluicegate that is operated from inside the mill.

Before starting the mill, the miller would open the penstock to start the water wheel. He began the milling process by lowering the runner stone that would have been resting just clear of the bed stone. As in windmills, the stones were usually Peak stones and French Burrs. The speed of the runner stone, the amount of grain fed into the eye and the adjustment of the gap between the stones all combined to determine the quality and quantity of the meal.

There are plenty of working water wheels to see all over the country. **Otterton Mill** is in South Devon and can be traced back to 1785. The sluicegates divert water from the River Otter into the mill's own millstream, or leat; from this the water wheel harnesses the water's energy to drive the mill. The process is cyclical – when the water leaves the mill it flows for about a quarter of a mile (0.4 km) and then rejoins the river again.

Tide mills are a variation of watermills and use trapped tidal water to turn the machinery. When the tide comes in, it flows into a millpond through a one-way gate. When the tide goes out again, the water is released to flow under the water wheel and turn the machinery. In practice, this gives about four or five hours' work twice a day. Tide mills were usually located along shallow creeks some miles away from the open sea; a large pond would be dug out to hold the water from the incoming tide. The pressure of the incoming tide opened sluicegates in the bank and filled the pond. As the tide fell, the first out-flowing water closed the gates, which were held firmly in that position by the pressure of the trapped water. When the tide had fallen sufficiently, the miller opened the sluicegates and the escaping water rushed out and turned the wheel. **Woodbridge Tide Mill** is a rare example of this type of watermill. Situated on the Suffolk coast not far from Ipswich, it was built in the eighteenth century.

Water power has been used for a wide variety of industrial purposes. **Gunton Park Sawmill** near Cromer in Norfolk was constructed in the 1820s and is probably the oldest surviving mechanical saw in Britain. It uses two iron water wheels to harness the water power – the right wheel drives the circular saw bench, while the left wheel drives the frame saw. The wheels themselves turn an intricate system of pulleys and belts, which in turn provide the motion for the mechanical saws.

Muncaster Watermill in Cumbria is next to the **Ravenglass & Eskdale Railway**, which I've visited many times. It is a working corn mill and is very old and quite interesting. It's one of two water wheels that you'll see if you take a trip along this line. The other is **Eskdale Mill** at Boot, which is at the top end of the line right up in the high Lakeland fells near Scafell Pike. There was quite a lot of mining activity here in olden days, which was what the Ravenglass & Eskdale Railway was built for. I've been to this mill on my travels, or at least I bobbed in to have a look at the water wheels for the sake of interest when I was there to see the railway. It's amazing how some of these places have survived, hidden away as they are up little valleys like this one. Thinking about it, though, I suppose they've got more chance of surviving in these places than they would in somewhere like Bolton. But when you compare them with the sort of big industrial water wheels that you used to get around Bolton they are quite small things of small power.

Before the development of the steam engine, water power was used for just about everything – forging, spinning, weaving, nearly everything that requires machinery that will turn round. A number of rural areas had water wheels for making things like scythes and ploughshares and lots of other agricultural tools and implements; anywhere, in fact, that needed a bit of something that took the pain out of doing the work by hand. Round Bolton I think more than half of the bleaching industry and the spinning industry used water power. On nearly every river, if you follow its course coming into Bolton, you'll find five or six bleach-works that all used water wheels initially. And

you can see in the buildings, if you look carefully, when steam replaced water, because the architecture of the engine houses is more modern than the original set-up of the place.

You can't see any of Bolton's wheels now, which is a pity because some of them were huge and must have been quite a sight. There was one at a bleach-works just down the road from where I live at Edgerton that was 16 feet (4.8 m) wide and a massive 64 feet (19.5 m) in diameter. That's a big wheel! It was made by William Fairburn in Manchester. Fairburn was the pioneering water wheel construction company in Lancashire – well, in the whole of England, really. The biggest water wheels that were ever made were at a place in Glasgow, and they were something like 80 feet (24 m) in diameter, an unbelievable size, and they were reputed to be Fairburn's.

In the industrial development of Britain water continued to serve man, but it also frustrated him. At the start of the Industrial Revolution in the eighteenth century, it was water that was used to power all the early mills and factories. So a number of those first factories were built in the countryside in scenic areas. Places such as Richard Arkwright's **Cromford Mill** at Matlock in Derbyshire and Robert Owen's **New Lanark Mill** were built in rural settings by the side of fast-flowing rivers that provided the power required to keep the millwheels turning. As with wind power, though, water power wasn't the most reliable source of energy. Something was needed that would be certain to keep the machines running day and night. Relying on water meant that a drought would bring a factory to its knees as everything would have to stop.

The water that provided the power for hundreds of mills threatened to destroy the very basis of prosperity for another growing industry. Until 1712 the 'engines' available for pumping water from flooded mines were quite inadequate to deal with the problems that faced the owners of coal-mines and of the Cornish tin-mines. The problems of pumping water and drainage had been met with varying degrees of success throughout history since the early empires of Babylon and Egypt. The 'chain of pots' system of drainage used then hadn't changed much by the

eighteenth century. Power to drive this sort of bucket elevator system could be provided by man, beast, wind or water, each of which was either inefficient or unreliable.

Certainly, this method couldn't cope with the pressing drainage problems that faced the Cornish tin-mine owners at the start of the eighteenth century. The search for a more efficient and reliable source of power for draining mines was the most pressing technological problem of the time. And so the steam engine was born.

Basically, it started life as a rather crude creation for pumping water out of deep mines. By the middle of the seventeenth century, the quest for mineral wealth had driven miners deep enough to encounter flood water, their most impenetrable barrier. English miners were beginning to find the greatest difficulty in clearing their shafts of the vast quantities of water they were meeting at the great depths they were getting down to. Many mines had been drowned out and abandoned; existing pumps simply could not cope with the water.

By the eighteenth century every element of the modern type of steam engine had been separately invented and practically applied. Ideas about atmospheric pressure and the pressure of gases had become understood. The nature of a vacuum was known, and the method of obtaining it by the displacement of air by steam and by the condensation of the vapour was also understood. The importance of utilizing the power of steam was not only recognized but had been attempted successfully by pioneers such as Denis Papin and Thomas Savery.

It was Thomas Newcomen, however, who, between 1710 and 1712, invented the atmospheric engine, so named because its power was derived from the weight of the atmosphere pushing down the piston in an open-topped cylinder containing a partial vacuum. With its invention, the original template for the beam engine, which was to last 220 years, was created and, once created, it spread very quickly.

Newcomen has his predecessors to thank for his invention. It was their pioneering work that made it possible. Denis Papin, a

French doctor, can be credited as the first to develop the idea of using steam, while Thomas Savery actually patented an engine that had been used to drain water from mines. This was used in the Cornish mines with some success. Indeed, Newcomen may well have even been employed by Savery. What is certain is that Savery's water-draining engine was known to Newcomen.

Savery recognized the engineering difficulties involved in keeping the deep pits of Cornwall free from water. But it was Newcomen who had the foresight to combine the ideas of both Papin and Savery in developing his atmospheric engine to achieve this task. In principle, the Newcomen engine is simply a combination of earlier ideas. All he did was to take the piston and cylinder concept that had been developed by Papin and combine it with Savery's principle of boiling and condensing steam. The resulting engine was so similar to Savery's patented engine that Savery was prevented from taking legal action against Newcomen only by being taken into partnership with him. The first successful model was completed in 1705, and the first engine was then set up at Dudley Castle in Tipton, Wolverhampton, in 1712.

Within a few years of its invention, Newcomen's engine had been introduced into nearly all the large mines in Great Britain. Many new mines, which could not have been worked at all previously, were opened when it was found that the new machine could be relied on to raise the large quantities of water to be handled. Newcomen's engine now meant that mines could be sunk to more than twice the depth of what had until then been possible.

Old as they are, it is still possible to see a working Newcomen engine today. When the Newcomen Society for the Study of the History of Engineering and Technology decided to create a suitable memorial to Thomas Newcomen on the occasion of the tercentenary of his birth, the British Transport Commission donated to the society a small engine very similar to the 1712 Dudley Castle one. It had stood idle for around fifty years, but was dismantled, removed and re-erected at Dartmouth in Devon, where what is now the **Newcomen Memorial Engine** is on show

in a newly constructed engine house. Dating from 1725, it is a direct descendant of Newcomen's first machine, displaying many features of the earlier engine.

A similar engine can be seen at **Elsecar**, near Barnsley in South Yorkshire. Believed to date from 1795, the Newcomen-type pumping engine there is claimed to be one of Britain's finest surviving legacies of the Industrial Revolution. The engine operated continuously as an efficient system of mines drainage until 1923. Ironically, it was briefly brought out of retirement in 1928 when the electrically operated pumps that were introduced to replace it were put out of action by flood water! Although damaged in 1953 and no longer having a source of steam, it is still technically workable and now deservedly holds pride of place at Elsecar.

As recently as 1947 a Newcomen atmospheric pumping engine was still working on a colliery between Oldham and Ashton-under-Lyne. Henry Ford, in England on a fact-finding mission, found it, bought it lock, stock and barrel, and re-erected it in America. On the same visit he was in the middle of Manchester when he saw a steam wagon coming along the street. He flagged the driver down, enquired who his boss was, bought the wagon from him and took that back to America with him as well, where it was displayed for many years, along with the pumping engine, in the Henry Ford Motor Museum. Recently, though, a collector in the south of England heard that the museum was selling the wagon and he has now brought it back to this country.

But these engines of Newcomen's were only the beginning, and all these early developments paved the way for the man who is regarded as the father of steam. James Watt came from a humble background. He was born in Greenock, Scotland, in 1736. As a child he was sickly; his health was delicate and he was unable to attend school regularly or to apply himself to study. Yet he was a man born before his time, and is worthy of the credit he is given as the inventor of the modern steam engine. Watt himself had no money to spend on experiments, and he didn't have the capital to start manufacturing steam engines if his experiments proved to be successful. This meant he had to look elsewhere for his capital, and

the two men who provided it, and made possible the successful development of his steam engine were, first of all, John Roebuck and then Matthew Boulton.

John Roebuck was born in Sheffield in 1718 and had become a wealthy man before deciding to establish a large-scale iron manufacturing business in Scotland. The site he chose was on the banks of the River Carron, in Stirlingshire, where there was plenty of water power, ready transport by sea, and good supplies of iron ore, limestone and coal. The first furnace was blown at Carron in 1760, and the first steam engine applied to working the blowing machinery of a blast furnace was erected at the Carron Iron Works in 1765.

The pits that Roebuck owned to provide the fuel for his iron-making were at Kinneil, near Falkirk, and he soon discovered to his cost that he had to ensure they were kept clear of water. In order to achieve this, he needed powerful pumping engines. In 1769 James Watt was engaged by Roebuck to construct a new engine for him from designs that he had already started to work on. Roebuck took on a £1000 debt that Watt had built up while developing his engine and put in further capital and funding in return for two-thirds of Watt's patent. Watt's engine, however, was not available for pumping the colliery, and Roebuck began to find himself in financial difficulties. It was in this year that he entered into an agreement with Matthew Boulton, in which Boulton would take a share of the business in return for paying half the expenses. But by 1773 Roebuck's affairs were showing no signs of improvement, so Boulton acquired two-thirds of the engine patent in exchange for the remission of a debt of £630 and a further payment of £1000. Ironically, Roebuck's financial difficulties were then further compounded by the fact that none of his creditors 'valued the engine at a farthing'!

With Roebuck off the scene, Boulton soon acquired the full patent on Watt's steam engine, and so the partnership of Boulton & Watt was born. Watt left Scotland for England, and the engine, which he designed for the Kinneil coal-mines, was erected at Boulton's Soho works in Handsworth, Birmingham,

in a factory that produced buttons, buckles, clocks, vases and silverware. It was used to pump the water that provided the power for the works. In the early days of steam this was to become a very common arrangement, with steam and water used together to run mills, factories and engineering works.

Matthew Boulton was the son of a Birmingham silver stamper and piercer. He succeeded to his father's business and built up a great and very profitable establishment. He wasn't just a businessman, though; he was also a learned scholar and won the praise of Watt as a man of great ingenuity and foresight. When he acquired the patent on Watt's steam engine from Roebuck, he went on to forge a partnership with Watt that was to be one of the most important enterprises of the century: a pioneer engineering firm that for twenty-five years was the sole producer of steam engines in Great Britain. The partnership was in fact the union of one of the most inventive brains of the age with one of the first great commercial intelligences, for the purpose of selling one of the most valuable things in existence – power.

Boulton, like Roebuck before him, was also to face a financial crisis. Although the engine business was doing well, Boulton had speculated in other interests indirectly linked with engines. Overproduction at a time of depression in 1787 resulted in the insolvency of several firms. Boulton badly needed an extension of credit. He appealed to Watt, but Watt, with characteristic caution, had already safely invested his money, so the appeal was made in vain. When it is remembered that Boulton had, throughout the hard years of struggle, taken all the financial risks and worries on his own shoulders, that he had paid Watt a regular salary when the company was not making any money, and that he had, out of pure generosity, allowed Watt half the profits, instead of the agreed one-third, when profits did begin to come in, Watt's action at this crisis appears mean and ungrateful. And while Boulton weathered the storm and never again had his prosperity jeopardized, it appears that Watt's struggles with money, or rather lack of it, when setting out with his engine design had made him very miserly.

Although Watt is rightly regarded as the inventor of the steam engine, others helped to perfect it. Richard Trevithick was born in 1771 and was reported by his schoolmaster as being a 'disobedient, slow, obstinate, spoilt boy, frequently absent from school and very inattentive'. However, he was to bring about enormous improvements on the Watt engines through his principle of high-pressure steam, which he labelled 'strong steam'. Following his visits in the 1790s to the Darby Ironworks in **Coalbrookdale**, Shropshire, the cradle of the Industrial Revolution, he constructed his first high-pressure engine for winding ore in 1798. Trevithick is perhaps best known for his contribution to railway locomotives, but so successful was his boiler development for the Cornish beam engine that the annual output of tin mined in the county rose from 2500 tonnes in 1750 to 14,000 in the heyday of the industry around 1860. The period 1800 to 1870 was a time of unparalleled prosperity and change for Cornwall. Trevithick himself, however, died a pauper after going to South America to mine for silver and tin.

Today Cornwall means holiday beaches, picturesque fishing villages and clotted cream, but in the eighteenth and nineteenth centuries the county was a key industrial area due to the massive deposits of tin and copper ore. From mining followed a number of other industrial activities, at first associated with mining and the machinery required for deep, hard-rock mining. Important iron foundries were established to build steam engines for pumping mines, and this expertise led to the 'Cornish engine' being adapted for all manner of purposes, including pumping London's sewage and de-watering Holland's polders. The success of the Cornish engine meant that it was quickly put into use all over the world.

The steam engine became an integral part of Cornish mining for two and a half centuries. The first Cornish miners concentrated on washing tin ore out of deposits near the surface. But the coming of the steam engine enabled the miners to pump water from these increasingly deep mines, to raise the ore to the surface and then crush it. At the height of the mining industry in the 1860s there were over 650 beam engines working in Cornwall.

The **Levant Mine** is probably one of the best known of the Cornish mines. This great mine, on the cliffs near Land's End, was sunk in 1820 and at its peak extended for a mile (1.6 km) under the Atlantic. It was one of the most successful in the county, extracting both tin and copper ores. In 1919, though, there was a disaster. The man who was driving the winding engine said, 'There's something wrong: the engine keeps creaking, groaning and making funny noises'. But no one took any notice. He was so concerned about it that he handed in his notice and moved on to another mine. Three weeks later the beam broke on the engine and about thirty miners fell down the shaft with the wooden platforms that carried them. It must have been awful being speared with 4-foot (1.2-m) pieces of timber in your belly as you went hurtling down the shaft.

Mining at Levant stopped in 1930 and everything on the site was intended for scrap. But efforts were made to save the Levant engine as a memorial to a period when Cornish engineers were in the forefront of engine design. In 1985 a team of volunteers from the Trevithick Society – nicknamed the Greasy Gang – began to refurbish the historic engine, while the National Trust restored the building itself. Today you can see the engine working in its clifftop engine house. The only trouble is that, although an appeal was launched to help put it back in steam, it was powered by a concealed modern plant fired by oil.

Just half a mile (0.8 km) along the clifftop from the Levant engine site is the **Geevor Tin Mine**. There have been underground workings in this area since the seventeenth century, with many ruins of old mine buildings still seen along the cliffs. The Geevor Mine, although not active, is open to visitors, so if you want to go down a mine and see how tin was once mined, you can take an underground tour. A museum at the site covers the history of some of the famous old mines in the St Just district.

Beam engines were not only used for pumping water out of mines. **The Crofton Pumping Station** is on the Kennet and Avon Canal near Marlborough in Wiltshire. The canal, which links London with Bristol, reaches its highest point here, and as its

summit level is higher than any natural source of water supply, it has to have water pumped up to it to fill the locks at the top every time a boat crosses the summit. The beam engines at Crofton were installed to ensure that there was always a supply of water to fill the locks. The two locks on the summit are 14 feet (4.2 m) wide and over 75 feet (23 m) long and require 70,000 gallons (318,215 litres) to fill them!

Today, Crofton is a wonderful working monument to the age of steam power. Its appeal lies in the fact that, when steaming, the engines perform the task for which they were originally installed – raising water vertically over 40 feet (12 m). The pumping house has the oldest working beam engine in the world still in its original building and still doing its original job. The Boulton & Watt engine dates from 1812 and its companion, a Harvey's of Hayle, dates from 1845. Both are steam-driven from a coal-fired boiler.

The building that houses the engines is on three floors. At the top is the beam gallery, where you can see the engines themselves. They are supported on the beam wall, which carries all the working loads of the engines into the foundations of the building. The engine beams are connected at one end to the pump rods and at the other to the piston rods; both connections use Watt's famous parallel motion linkage of which Watt has been quoted as saying: 'I am more proud of the parallel motion than any other mechanical invention I have ever made.' The device was necessary because a piston can operate only on a vertical axis, while the motion of the beam runs along a curve. Watt's invention was for a parallelogram of jointed rods fixed on the underside of the beam, with one angle fastened to the head of the piston rod. The whole contraption is carried through the curve described by the end of the beam, while allowing the piston rod, which is driving the beam, to stay on its vertical axis.

On the middle floor you really get an idea of the immense power generated by the engines as the piston rod is driven downwards on the power stroke, pulling the beam with it. On the ground floor you can see the condensers where the exhaust steam is condensed to produce the vacuum under the piston

that drives the engine. You can also see the cylinder room down here; it is from here that the engine is actually driven and the steam level is monitored and regulated. Also at ground level is the boiler room, where the water is boiled to produce the steam. If you want to see the power of steam at close quarters, this is as good a place as you'll find anywhere.

As the Industrial Revolution developed, new challenges came up. A rapidly growing population in the nineteenth century, together with the development of new industries and the expansion of older ones, produced a rapidly increasing demand for water for domestic and industrial requirements. This increased demand for water, combined with an awareness that a plentiful supply of pure water was essential to the people's health, led to parliamentary legislation for the supply of water. Because it provided such an efficient method of pumping water, the beam engine became the basic working machine of the water industry, and it was with the building of pumping stations in the nineteenth century that beam-engine technology reached its peak. So efficient were the engines that many of them continued to provide the main source of power until well into the 1960s.

So it was that at 3 p.m. on 1 July 1967, a century of pumping water by beam engines came to an end at **Ryhope Pumping Station** just outside Sunderland – the last steam pumping station to be used by the Sunderland and South Shields Water Company. Fortunately, soon after the end of its working life a group of enthusiasts got together to preserve the station in working order for the benefit of anybody who wants to experience the sight, the sound and the smell of a huge beam engine in motion. The high standard of the original design and manufacture and the subsequent maintenance over the 100-year working life of the two engines have left them in perfect condition, and they are now among the finest beam engines to be seen anywhere in Britain.

London also has its own magnificent beam engines at **Kew Bridge Steam Museum**. The people to thank for restoring the engines here are the same enthusiasts who had worked on the restoration of the Crofton beam engines. As they were finishing

their work at Crofton Pumping Station, they began looking at various premises where they could continue their work of restoring static steam engines. The Metropolitan Water Board had kept the steam engines on the site after they had been shut down, so the Crofton group approached the board to lease the Kew Bridge site. The board agreed, so the Kew Bridge Engines Trust was formed and work began on restoring the engines. That was in 1973. Today the Kew Bridge Steam Museum boasts the largest collection of static steam engines in the world. It is housed in a series of Grade I and Grade II listed buildings that include the original engine rooms and boiler rooms. Many of the engines are in steam every weekend. Among them are the Grand Junction 90 inch (the 90 inches refers to the diameter of the cylinder), the massive Cornish beam engine that pumped water to west London for over a century. It is claimed to be the largest working beam engine in the world. There is also a museum on the site, telling the history of water supply and usage in London from Roman times, and the waterworks' own working steam railway.

These engines remind me of the first glimpses that I got of the big, powerful steam engines when I was a little lad. There was one works near where I lived in Bolton that ran on steam. It was called T.T. Crook Stanley Ironworks, and basically it was a row of houses that no doubt Grandfather Crook had bought. The building is still there to this day, but when I was a lad it had a most unbelievable chimney stack. It was about 3 feet (0.9 m) square and about 60 feet (18 m) high and it had a lovely bend on it. They just used to burn coal dust there on a Cornish boiler which was in the back yard of the row of houses. When you looked in you could see two brick walls and in between them was the front plate of an old boiler with a water gauge and a pressure gauge on it. Crossing over the front of this was a wooden staircase going up to a hen cabin on the top of these two walls. And when you went up the wooden staircase and through the door, there were four big iron girders which went from one end of the room to the other. The girders had a steam engine on top of them with a 7- or 8-foot (2 to 2.4-m) flywheel, a single

cylinder and an exhaust pipe through the roof to the sky, so I could always tell when it was working. From this engine room a series of belts went all over the place – some spread out on this first-floor level and some went downstairs into the ground floor – a bit like my garden now, really. As a small boy I never went any further than gently creeping up the stairs and looking inside through the door and through the window. The guy who fired the boiler and looked after the engine was as black as the miners were when they came up from the pit at the end of their shift. Directly facing the premises was a pub, and the engine man was always standing on the pub doorstep. You never saw him near the boiler; he spent all day in the pub.

I never forgot that place. Then one day, years later, when I'd started steeplejacking, I met a decorator who knew Mr Crook – the man who owned the place. I was stuck for some iron bolts for this chimney I was working on, and the decorator said: 'Go and see Charlie Crook and tell him I sent you. He'll give you some nuts and bolts.'

While I was there I remember saying to him, 'Can I have a look at your steam engine?' and he said, 'What do you want to look at that for?' I told him I thought it was unique in this modern day and age, and I wanted to see it because it was the last place in Bolton to be driven by a steam engine. Anyway, I remember climbing up the stairs and there was a new engineer by this time; he had a black face and a big beer belly. I went up the wooden stairs at the back and entered the engine house and you couldn't see a thing in there because of all the steam that was blowing out all over the place. Through the steam I could see that the flywheel was bent and the bearing caps and pins and connecting rods were all loose. Every thrust of the engine was lifting it up off the girders it was standing on, and bolts were coming loose from the actual bed of the engine. I just looked at it and thought, God, it's going to come apart and wreck the place. It was doing fair revs, and in the precarious position it was in, on those four iron girders that crossed the two walls, it was asking a lot if anything did go wrong. I ran down the steps and went in to old Mr Crook

and said, 'Your bearings are coming unscrewed on your engine.' He just looked round and said, 'Oh, bloody hell. George, go and tighten it up, mate,' in a right nonchalant manner. I was amazed because I thought the engine was going to wreck the place. But this guy just went upstairs, got a big spanner out and screwed them back in while I followed at a safe distance expecting some terrible disaster. Anyhow, the place continued operating right up to the miners' strike. Then the old guy died and his son, who was quite old then himself, decided to pack up being an engineer and started to rent the place out for storage. The engine stayed in there for quite a long time afterwards, then somebody down south bought it and took it away. That was the last place to be driven by steam in Bolton – the end of steam as an actual working source of power in a real business.

Today the only steam engines you can see working are the ones that have been preserved to let a new generation see these great machines that provided the power that drove our great industries. There's a good business now in looking after these engines. The first one that I renovated myself for money was in Wales, and it is a very interesting story how it happened – all really through the power of the BBC. It's people seeing me on the television I've got to thank for this. The phone rang one day and a guy said, 'It's Caernarvon Council here. We've got a chimney that needs looking at.'

And I said, 'It's a long way from Bolton to Caernarvon Castle. How big is it?'

'Oh, it's about 75 feet (23 m) high,' he replied.

'Oh, it's not even a big 'un,' I said. 'I can't get much revenue out of that lot.'

And he said, 'You haven't seen it yet. And we've got a steam engine here as well.'

Well, that did it. When I heard that, I started to get a bit more interested in the job, so I changed my tune a bit. 'Oh, yes, I'm interested in that,' I said. 'I'll come and have a look at it.'

So – there were two of us, me and Ned, who used to work for me then – and we set off for Caernarvon. The place we

had to go to was called Glen Cleevan. It was a big estate like Chatsworth with a great house that was about five storeys high, and they had a workshop that maintained the whole premises. When we arrived the chimney stack was like one you'd get on a typical Cornish pumping engine house. It had ivy round it from the roof right up to the top so you could hardly see any of it; you could just about see a bit of nice stone capping on the top. I couldn't really tell how much it would cost to renovate that chimney because it was covered in all this ivy. You could hardly see the brickwork, and there might have been all sorts of cracks and holes behind the ivy.

The man from the council said, 'It's only a feasibility study that we're doing. Just give us a price for coming over and taking the ivy off, and then you can report on its condition and give us a price for doing it up.' So we said okay to that.

It was the first time that we had ever left home for a job, and we'd never camped out or been in lodgings before. So we went and stayed in the local pub down the road, just like travelling salesmen. The next morning we put the ladders up, got all the ivy hacked off and found that the walls did need pointing right from the top of the chimney down to the roof. There was no lightning conductor on the stack either, and it wanted a couple of iron bands round the top as well. In the engine room there was a beautiful single-cylinder 1854-vintage stationary steam engine with about a 10-foot (3-m) flywheel that had driven a big frame saw. Unfortunately, there wasn't very much left of the saw. The engine itself was in a very, very sad state because it had been robbed of all its brass. Immediately above it the skylight was broken and the rain had fallen on to it for donkey's years.

Anyway, we gave them a price for doing up the chimney and for making the engine run again, but we got the job only for doing the chimney – pointing it from top to bottom and putting a new lightning conductor and two iron bands on. The weather was nice, and we got on with the job quite well. But one day it rained and we couldn't work, so I said to the gentlemen who were assisting me at the time, 'Go and get the key and we'll have

a look at this steam engine.' When we got the key we found that, apart from the brass not being on it, the engine wasn't in bad condition. The only trouble was that it was half-buried under timber and wood posts. The plaster had all fallen off the ceiling on to the engine, and there were spanners all over the floor in among the plaster. When I saw the engine, though, I really wanted to have a go at fixing it.

Some time later, when the chimney had been done and finished, I got an after-dinner talking job in Deganwy, which is only a few miles down the coast, and half of the Caernarvon Architectural Department were there. So I said to one of the men there, whom I recognized, 'What about that steam engine? Have you done owt about it yet?'

'Oh, we'll send you a tender form,' he said.

Anyway, we put a tender in and we got the job and went over to Caernarvon, where we pulled the engine to bits. We brought all the brasses and everything and all the nuts and the other bits and pieces back, and I spent six months with it all going round in a steam-driven lathe, shining it all up. Then I took everything back to Caernarvon, where we stayed in the same pub. In the end we hired a big compressor with a great wagon engine in it, and we got it going on compressed air because, of course, I'd only fixed the engine: it still didn't have a boiler to give it any power. Part of the contract, though, was to jack up the boiler and get a boiler inspector to have a look at it. But it didn't need any boiler inspector to look at it: it was in such bad shape you could have put your boot through it. So what do you do? It looked as though the only thing we could do would be a cosmetic job – paint it matt black, put all the brasses back and the pressure gauge and paint 'Thomas and de Winton, 1854' in cast-iron lettering over the fire-hole door. And that's what we planned to do.

But every Wednesday, in the pub, the local coastguards met, and one of them in particular was talking and asking about what we were doing and how sad it was that we would have to be going and leaving this beautiful engine, which would run now and was as good as new. With its new piston rods and new piston rings

it would have run perfectly if it had a boiler. So he said, 'I know where there's a boiler. Mr Thomas, the pork pie manufacturer down the road, has just done away with his boiler. It's a good 'un, and it's just lying on its side in his yard.' So one evening, when we'd finished work on the steam engine, we decided to go down and have a look at it. When we saw it, it had twelve cross-tubes, which meant it was a very good steamer. But it was small – only about 3 feet (0.9 m) in diameter and about 7 feet (2 m) high, which was very small to provide power for the size of engine we were working on. Anyway, the man I was working with at the time was a clever man who knew all about steam boilers, and he said the boiler would drive the engine. But I'm thinking, Well, we're going to look bloody fools if we install the boiler and charge the council and it falls short of delivering the goods. We were going to look a bit stupid, weren't we? So I said, 'If we do get this boiler from Mr Thomas, I think what we should do is stick it in the middle of the yard and do not waste money on lagging or fire bars, just in case it doesn't work. We'll build inside with breeze blocks, put some iron bars on for fire bars, any old rubbish will do, light it with rubbishy wood, put a steam pipe from the stop valve and through the window of the engine house to the stop valve of the engine, light the fire, get the steam up, and we've got the pressure gauge, so we can see what it will do with a 100 PSI in it.'

So we lit the fire and the steam engine went round no trouble. We got another £7000 for installing the boiler. We lagged it with mahogany and put brass bands round it, and I must say it was one of the nicest things I'd ever done. It was beautiful when we'd finished it – looked like something out of Jules Verne's *20,000 Leagues Under the Sea,* with all the brass glistening on it. It was such a good job that I won a £500 prize for it. There was one award for the best steamship restoration, one for the best railway preservation effort, one for the best road vehicle, and I won the award for the best stationary engine.

That's how I got started restoring steam engines. But 200 years ago the steam age itself was only just getting started. By the year 1800 the steam engine had not made such a transformation

in industry as is often imagined. Water power was still very much in evidence, but the new industries – cotton manufacture, iron, engineering and mining – were gradually changing over to the new source of power. All the new firms were free to select their own sites, and the places they went to with their new factories were the parts of the country where fuel for their steam engines was readily available – the coalfields. One of the most important contributing factors to the development of steam and the Industrial Revolution was the presence in England of large coal deposits. The unlocking of British coal seams turned Britain into a great manufacturing state. The steam engine provided the power to drain the coal-mines, which supplied the fuel that was needed for newly developed methods of smelting iron – which then, in turn, provided the metal used in the construction of engines and machines.

But it wasn't just the big factory owners who were turning to steam. If you go to visit **Denver Windmill**, near Downham Market in Norfolk, you can see how a forward-thinking miller found a way of keeping to the old methods while getting the best of the new. The Denver miller decided that he wasn't going to let himself get caught out when the wind dropped – not when there were these new steam engines around. So he installed a steam engine and steam mill machines next to his windmill to back up the sails and the traditional milling machinery. If he had this new means of power at his disposal, the miller wouldn't have to rely on the wind to power his mill and would be able to continue grinding even when the wind was not blowing. All the steam mill machines can still be seen in the windmill alongside the old milling machinery.

But while this clever miller got the best of both worlds, so too did lots of the factory owners and mine owners who had invested in steam engines. Water power, in particular, was never completely replaced by steam. Water was a lot cheaper for one thing and, where it was readily available, the water wheel continued to be used alongside the steam engine to provide the power to drive machines.

MILLS AND FACTORIES

One of the very first sights that I remember was the factory chimneys that surrounded Bolton, especially all those near the old football ground at Burnden Park. When the sun was setting in the west, I used to look at them silhouetted against the evening sky above the area that I played in as a kid. Then, at night, when you looked in the dark at this great big five-storey spinning mill when the night shift was on, it was an unbelievable sight. All the lights would be on, and when you looked through the window you could see literally hundreds of yards of 2-inch (5-cm) shafting with the chromium plate all shining in the dark. I don't think I'd ever have liked to work in a spinning mill myself. It was all a bit too humdrum for me, but, as with my interest in coal-mining, the interest I had in the mills was in the mechanical side of things – how they got the power to drive all the machines they had in them.

The other thing I remember was the mills' lodges. That's a Lancashire word for millponds. Some of them were as clear as drinking water with fish in them; others tended to get silted up with lots of flora and fauna growing in them. Me and my mate were very experimental as kids. We made diving suits out of crisp tins and things like that so we could go diving in the lodges. We went to try them out at the local swimming-baths, but they wouldn't let us go in the pool with them – said we'd contaminate the water sort of thing. It didn't matter because they didn't work anyway; they held that much air in them that your head wouldn't go down under the water.

Anyway, these lodges were often the only water supply for the boilers and condensing plant in the mill. You know, you never see a mill engine going 'Woof, woof' into the sky; it's always silent as it goes round because the steam from the exhaust goes into the condenser and is turned into water, which goes into these mill lodges and then of course the temperature of the boiling water is reduced as it goes into the colder water in the lodge outside. So a number of mill lodges had a wonderful trough coming from the engine house, and it would go all the way round the lodge. It was only about 2 or 3 inches (5 or 7.5 cm) deep and was always full. When the water came out it would be steaming from condensation. A number of the lodges had goldfish in, because the water was so nice and, warm. But those days are gone now.

My knowledge of steam engines really comes from those days, and it comes out of my being a bit of a burglar in a way. I lived at the bottom of a little lane, and in the olden days, if business wasn't very good, they would shut down the mill that was at the end of our lane and leave it idle for four or five years because they thought that good times would return and they would be able to start again. They left all the machinery in as well, and the engines were still there. I remember getting into Marsden's bleach-works and lifting up a dust sheet to have a look at the engine they'd got under it. When I lifted it up I found there was this beautiful British racing-green steam engine under it with all the brasses left on. The boilers were still there and there was plenty of grease on everything, all ready and waiting for the next job. It was a bit sad, really, to see it standing there idle like that.

There used to be lots of mills all over Bolton, but a number of them were already closing down when I was a lad. My dad worked in one of the bleach-works. He was always surrounded by bleach and steam, and he ended up with bronchitis. It's terrible, really; he spent his life working on this machine, and I don't think any examples of them have been preserved.

Bleach-works had lots of little steam engines that drove lots of individual machines, as opposed to just one great big one like the mills. The engine that I've got on the other side of the wall

out in the garden is out of a bleach-works. At the place where my dad worked the machines were so noisy it was frightening: they used to call the men who worked on them the ten loonies, it was so bad. Just after the war my dad used to come home from work and, even though I was only a baby then, I remember he used to be always shouting and swearing about the job, and those words ring with me for ever.

Years later, when I started steeplejacking, I was knocking a chimney stack down at an old mill in Farnworth, and an engineer who'd worked at the place came to me and said that the shaft used to come out of an engine house that he pointed out to me. And he told me how he remembered mending this engine in the middle of the night. They'd been working on it from teatime, and they worked right through until half-past three in the morning, when they stopped and decided to give it a run to see if it was all right. So they opened up the valve, the engine started going round and all the shaftings started working. The next thing they knew, all the operatives were outside waiting to start work. The thing was, in those days no one had any clocks. They relied on steam hooters and the noises that came from the engines. So everybody in the immediate neighbourhood who worked in the weaving shed jumped out of bed to go to work as soon as the engines started and they heard the wheels going round, because they all thought it was half-past seven even though it was still only half-three in the morning. Incredible, really.

The beauty of the big Lancashire boilers they had in these mills was that you could burn anything on them. All of the soot fell to the bottom, and you could go for twelve months without cleaning them. Then you'd have to sweep out the flues. For this the Black Gang would come in, and they'd have to get all the soot out of the tunnels. They only got a pittance for this work, and when they'd got the job done they'd go to the pub and get inebriated.

But big factories and dirty boilers like that are a far cry from the way the cotton and woollen industries got started. Spinning basically involves the drawing out and twisting of fibres to make a thread of yarn. It was originally done by the spinner twisting

fibres together with the fingers. The spindle and whorl was the first tool developed to do this and was used in Britain in the form of a drop spindle for hundreds of years to spin yarn for household needs.

Spinning on a wheel provided a way of turning the spindle mechanically. It was first developed in China or India, and the first spinning wheels were brought into Europe in the early fourteenth century by way of trade routes. The great wheel is a modified version of these original spinning wheels. On this, the large wheel carries a drive band to a pulley and spindle. To operate this, the spinner rotates the wheel with her right hand while drawing out the fibres from a mass of carded wool held in her left.

The Saxony or flax wheel was invented in the fifteenth century. This did continuous spinning by inserting twist into the fibres and winding the yarn on to a bobbin. With the invention of this wheel, production speeds doubled and even trebled, but it could be used only for certain types of fibres such as flax. The great wheel still had to be used for short fibres, and in Britain cotton and short-staple wool continued to be spun on the great wheel until the introduction of machine spinning in the eighteenth century.

Traditionally, cloth-making in Britain was carried out in the home as a cottage industry, and all the members of a family, including children, would be employed in the various stages of producing fabrics. At first the material produced was used solely to clothe the family and make bedclothes, but as some families got better at it they sold any extra fabrics they made at local markets.

Textile manufacture was well suited to mechanization, and it was this that led to the growth of the factory system. In the second half of the eighteenth century, a number of enterprising businessmen recognized that there was a good opportunity to be had by employing the home spinners and weavers as outworkers and collecting the yarn or woven material from them on a weekly basis by packhorse.

This was the beginning of the transition from a cottage industry to a factory industry. Instead of collecting the yarn produced by lots of different outworkers, who were scattered all over the

countryside, it made more sense to bring them all together under one roof and pay them a weekly wage. So purpose-built factories started to be erected to house the revolutionary new machines that were being invented from the second half of the eighteenth century. It was this that gave birth to what is now known as the factory system.

The spinning jenny was the first of these new machines. It was invented by James Hargreaves in 1764 and was the first successful multi-spindle spinning machine. Hargreaves, a cotton weaver from Lancashire, developed an eight spindle 'jenny', or engine. He based his innovative design on the spinning process that was performed on the great wheel.

The early jennies, though, were awkward to operate and needed a lot of skill. Within a few years, a number of improvements had been made to the basic design, and smaller versions started to be introduced into households. And although larger ones were used in the new factories, it was only with the development of water-powered spinning machines that the factory system really started to take off.

The man who did this was Richard Arkwright, the inventor of the water frame. In 1771 he went to Cromford in Derbyshire and established the world's first successful water-powered cotton-spinning mill. Arkwright is regarded as the father of the modern industrial factory system, and his mills are seen to have been an essential first phase in its development. It is because of this that Derbyshire's Derwent Valley has been called the 'cradle of the Industrial Revolution'.

Arkwright was born in Preston in 1732, and as a young man he worked as a barber in Bolton and travelled around the country making and selling wigs. It's not certain how he got involved in the cotton industry, nor how he came to invent a spinning machine, but in 1768 he moved back to Preston with John Kay, who had already been involved in trying to invent a spinning machine. Here they developed a roller spinning machine that produced a stronger yarn. This became known as the spinning frame and, later, the water frame.

Arkwright wanted to patent his machine, but he didn't have sufficient capital to meet the expenses, so he brought in two merchants, John Smalley and David Thornley, as partners. In 1769 he got the patent he wanted and moved to Nottingham, where the partnership was enlarged to include Jedidiah Strutt and Samuel Need, who between them brought in extra capital. The partners set up their first horse-powered mill in Nottingham.

But lack of power was the limiting factor for any further development of the spinning process. The rotary steam engine had not yet been developed, and initially Arkwright had only horses available to him. But horses were expensive to run, so Arkwright and his partners found the Cromford site, where there was a good supply of fast-flowing water, and together they built the world's first water-powered spinning mill.

As well as constructing a building, Arkwright had to find a labour force to operate his machines. Part of this labour force came from local lead-mining and farming families, but in December 1771 he put an advert in the *Derby Mercury* to recruit skilled workers from a bit further afield. By bringing in his workers from outside the immediate area of the mill Arkwright was committed to providing them with housing and other facilities, and the Cromford community began to grow. Rows of cottages were built, along with a hotel, a chapel and a Saturday market. He also built roads and provided schooling for the child workers. In fact, he provided so much for his workers that in 1781 a visiting doctor, Sylas Neville, wrote that Arkwright 'by his conduct appears to be a man of great understanding to know the way of making people do their best'. It was this that led Victorians to regard Arkwright as 'the father of the factory system'.

The machinery in the first mill was driven day and night to make the most economical use of the water. There wasn't enough water to drive all the machinery at the same time, so all the spinning was done at night and the preparation, such as carding and combing (cleaning and straightening the wool fibres), was done during the day.

This first mill was very successful, and the next step for Arkwright was to spend some of his time developing and perfecting his machinery. He'd already mechanized the final part of the spinning process, and now he started to mechanize all the other stages, such as carding and cleaning the cotton, in order to keep pace with the spinning. One invention followed another until he had changed the whole nature of textile production. In 1775 he acquired a second patent that extended his first to include carding and other machinery. By this time Arkwright's system was almost fully developed, and his success was now guaranteed.

Because of their success, Arkwright and his partners built more mills. Within thirty-five years, eleven had been erected in Derbyshire. Other factories were built in Lancashire, Staffordshire and Scotland. On the original site at Cromford, cotton-spinning had to be cut back around 1840 when the water supply was reduced as a result of lead-mine drainage. By this time many of the factories had been converted to steam power, and Lancashire had become the centre of the industry.

The Arkwright Society purchased Cromford Mill in August 1979. Since then a major restoration and conservation project has been put into place. This historic site has now been opened to the public and there are ambitious plans for it, though the three largest buildings are yet to be restored.

Arkwright had a huge effect on the growth of the cotton industry, and travelled far and wide looking for sites to build factories to house his new machines. In 1784 he went to Scotland and walked along a picturesque stretch of the River Clyde just south of Lanark in the company of a Glasgow banker and entrepreneur, David Dale. As they walked, Arkwright declared that no other place in Scotland afforded 'more eligible situations for mills of all kinds'. Dale agreed with him, so they formed a partnership and purchased some land by the side of the river. There they began to build what was soon to become the most famous cotton-spinning community in the country – New Lanark.

What made the Clyde so picturesque at this point was the way it narrowed to form a torrent of water that rushed through

a narrow gorge, and it was this that made it an ideal site for water-driven spinning mills. In a place like this, Arkwright's new machines, driven by a single giant water wheel, could do the work of thousands of individual spinners.

Dale dissolved the partnership with Arkwright in 1785 and began work on the first mill immediately. By 1793 four mills had been constructed, making New Lanark the largest single industrial enterprise in Scotland. What we'd find surprising about it today, though, was that most of the work was done by children. At first Dale drew on the nearby town of Lanark and the surrounding parishes for his labour force. But orphanages in Edinburgh and Glasgow also supplied children on the basis that Dale would provide for their upkeep.

While the use of child labour might seem harsh to us, it was quite normal in eighteenth-century Britain, and what his contemporaries remarked on was not Dale's employment of children but how well he treated those who were in his employment compared with the standards of the time. Their working day lasted from six in the morning until seven in the evening; after that the children were expected to go to school for another two hours. The only breaks they had were half an hour for breakfast and an hour for dinner.

The school that Dale established provided an education not just for the children who worked in the mill but also for the younger ones, who attended the school during the day. By 1796 it employed sixteen teachers, who instructed 507 pupils in reading, writing and arithmetic.

Although it was David Dale who established New Lanark, it is the name of Robert Owen that is forever associated with the community. Owen's arrival at New Lanark began a story of commercial enterprise spiced with romance – the romance of his courtship and marriage to Dale's eldest daughter, Caroline, and the romance of his visions for social reform.

Owen first came to New Lanark to see Caroline Dale after he had been introduced to her in Glasgow, and as he looked at the mills he said: 'Of all the places I have yet seen I should prefer this in which to try an experiment I have long contemplated and

have wished to have an opportunity to put into practice.' As the romance with Caroline blossomed, rumours grew that Dale was looking for a buyer for New Lanark so Owen decided he was going to go for it. Although he was only twenty-seven, he found himself two established business partners and put in an offer. Dale's initial scepticism about the seriousness of this young man, who was his daughter's suitor, was overcome, and New Lanark was sold for £60,000.

Caroline Dale and Robert Owen were married in 1799, and in January 1800 Owen took over the management of New Lanark. At first, however, he was far from popular with the workers. The problem was that Owen had his business partners to think about, and certainly the changes that he put into place during the early years were geared very much towards economic rather than philanthropic ends. Hours of work were increased, output was monitored and watchmen were employed to patrol the streets and control any drunk or disorderly behaviour. A worker found drunk on three occasions would be sacked.

Not until 1806 was there any softening in the attitude of the inhabitants towards him. It was during this year that an American embargo on the export of cotton forced prices up so much that spinning became uneconomic. The machines stopped and silence fell over New Lanark for a few months. For the whole of this time, however, Owen continued to pay the workers full wages.

By this time Owen's mind was full of ideas that would bring about a better organized and more benevolent system of management, and by 1814 it was time for him to put the first principles of his great experiment into action. These principles were quite simple. Basically, he felt that wonderful as all the technical developments of the previous half-century had been, they had ignored the most important element of any industrial society – the welfare of the workforce. He believed that the character of people was formed by their surroundings and that good housing, good education and disciplined, well-organized but benevolent working conditions would produce a contented and efficient workforce.

Owen thought that housing for the workers was a key link in the chain of production and that the quality of his workers' lifestyle and housing should reflect the quality of production that he wanted from them in his factories. He set up a savings account for the workers so that they could contribute a sixtieth part of their wages, and established a village shop where he bought produce and goods in bulk and sold them at almost cost price. This was the beginning of what became known as the co-operative movement.

Owen's greatest legacy, though, is in the field of education, and the system of infant education as we now know it in Britain began in the school that he set up in 1816. The basis of this system was the encouragement of an appetite for knowledge not through punishment and rewards but through nurturing the senses. Singing, dancing and the appreciation of nature all played a part in this process.

Robert Owen left New Lanark in 1825, but the great water wheels continued to turn right through the nineteenth century. Now nominated as a World Heritage Site, New Lanark can be seen today little changed from the period of the early Industrial Revolution.

At around the time that David Dale took his walk along the banks of the River Clyde with Richard Arkwright, Samuel Greg, a Manchester textile merchant, was looking around the countryside near Manchester for a site near a fast-flowing river where he could build a new mill. A site at Styal, just north of Wilmslow on the River Bollin, proved to be ideal. Here he constructed **Quarry Bank Mill,** a purpose-built mill with a weir and headrace channel and a water wheel to drive the revolutionary new spinning machines. The mill soon became a profitable concern and was extended between 1796 and 1801 and again between 1817 and 1822.

Power looms had been invented in 1785, but it was only around the 1830s that they were properly developed and installed in mills like Quarry Bank. It was this that finally led to the decline of the hand-loom weaver. Until this time the yarn that was spun at places like Quarry Bank had been 'put out' to hand-weavers, and it is possible that the cellars in the

houses Greg built at Styal village were originally intended for hand-looms. But in order to maintain his competitiveness, Greg had to build weaving sheds alongside the old spinning mill and install Lancashire overpick power looms in them. A good weaver was expected to operate four of these machines all at the same time – quite a feat. Some of the power looms can be seen in full working order at the mill today.

The machines in the mill would operate continuously for up to sixteen hours a day. The noise could be quite deafening, and it was practically impossible for the workers to hold even the simplest of conversations, so they all had to learn to lip-read.

For much of the eighteenth and early nineteenth centuries health and safety regulations were non-existent. Machinery was unguarded, which caused some horrible accidents, the most common being the loss of fingers and scalping when a worker's hair became entangled in the machinery. Most of the clearing-up work was done by the younger children, exposing them to great danger, especially when they got tired at the end of the long day, and fatal accidents were unfortunately quite common.

The early workers at Quarry Bank were unskilled farm labourers and the spinners and weavers who had worked at home before the mechanization of the textile industry. Working conditions in the cotton mills in the nineteenth century were harsh, brutal and often very dangerous but, faced with poverty and probably the workhouse, most people were prepared to accept such conditions in return for a regular wage.

As a result, employers had a strong hold over their employees, and they drew up strict rules and conditions of employment. Workers didn't have any rights, and anyone who was caught breaking the rules would be fined heavily or sacked. Training to use the machines was done on the job with an experienced hand supervising a trainee, but supervision was minimal because wages were based on piecework and any delays meant a reduction in income. Greg was well known for his insistence on punctuality in his workers, and every minute had to be accounted for. Money was deducted from the wages of any of his employees who were late for work.

Under this strict regime, the business prospered and between the years 1834 and 1875 the mill was extended and altered to accommodate power looms. The enlarged mill needed more power, so steam engines, which were first introduced from 1810, were brought in to supplement water power, especially during the drier summer months.

Quarry Bank Mill is now one of the country's major industrial heritage sites, and after extensive restoration is the only water-powered cotton mill in the world. Quarry Bank is also internationally renowned for its huge working water wheel that still powers mill machinery – the giant wheel measures 24 feet (7.3 m) in diameter and weighs 50 tonnes. And it is one of the few places in the world where water and steam power can be seen working side by side. Live demonstrations of spinning and weaving and costumed re-enactments of the lives of the mill workers and their masters give a good insight not just into textile manufacturing and into water and steam power, but also into social history and the history of the Industrial Revolution.

The iron water wheel can be seen in the site's Power Gallery. Although it is a replacement of the original, this wheel represents the peak of water-wheel design. It is the work of the Victorian engineer William Fairbairn and is used to power some of the working looms in the weaving shed above. It was essential to keep the wheel in operation at all times, as any delays would cost a lot of money. The millwrights who were employed to maintain and repair the wheel were the elite among the workforce. They installed a complex system of gearing and hanging line shafts to transmit the power from the water wheel and steam engines to the individual looms, spinning frames and other machinery.

In 1810 Greg installed a steam engine at Quarry Bank Mill, but, as in a number of the mills of the time, it was only to provide auxiliary power and act as a precaution against water shortages. By the 1830s, however, with the introduction of power looms, the mill was demanding more power, and steam became as important to Quarry Bank as water power had been. Steam power was still used at the mill well into the twentieth century.

In January 1905 the water wheel was replaced by two water turbines. Turbines are made up of a series of shaped paddles, or blades, arranged around the bottom of a wide, curving pipe. As it comes in, the water from the pipe turns the turbine, which in its turn drives a vertical shaft. Turbines are similar to water wheels, but they are usually more efficient.

As most early mills were established in rural locations to take advantage of water power, many of them had a problem with scarcity of labour. So, because many of the more menial tasks could be performed by children, Greg, like other mill owners, employed pauper children from workhouses.

Life inside the Apprentice House, where they lived, was highly disciplined. In spite of the fact that they worked very long hours in the mill, each child was also expected to work in the evening. Punishments for any wrongdoings were harsh and could include solitary confinement in the attic or loss of privileges. The idea behind employing children wasn't just to get them to work for little or no wages but also to give them a training for a worthwhile trade. Retaining a reliable workforce wasn't easy, and it made sense to employ people who had become disciplined to factory life from an early age.

The work the children did was menial and dangerous. They would have to clean under the machines while they were still in motion. This was known as 'scavenging'. Other jobs included 'piecing' – joining snapped threads together – and sweeping up. Older children were trained how to operate the machinery.

If it's spinning and weaving machines you want to see, two of the best places to go to are, as you might expect, in Lancashire. **Helmshore Textile Museum** is housed in two old mills in Rossendale. Higher Mill was built in 1789 as a woollen fulling mill by six members of a family called Turner. Their successors kept the old machinery working until 1967, and now Higher Mill's water wheel is working again and driving the old fulling stocks.

Fulling, which shrinks and thickens the woollen cloth, can be carried out by hand or, more correctly, by feet, when it is known as 'walking the cloth'. But the process was mechanized early on,

and by the time Higher Mill opened it had long been the practice to carry out the operation in mills driven by water power. The carding, spinning and weaving of wool was still very much a cottage industry. Since the open-weave woollen cloth produced in this had to be fulled to be of much use, fulling mill owners like the Turners were important figures. Soon they came to control the carding, spinning and weaving in the area even though these continued to be carried out at home. Later they began to invest in mills where these processes were water- and/or steam-powered.

The other mill that makes up the Helmshore Museum, Whitakers Mill, had a chequered history in the nineteenth century, but by the 1920s it had established itself as a cotton-spinning mill. The machinery that was installed at that time is all still in place and working today.

Helmshore also housed the research headquarters of the major firm of textile machinery-makers, Platt International, who built up a big collection of textile mchinery. This includes one of Arkwright's water frames from Cromford which dates from the 1780s, and an improved spinning jenny from about 1820. Much of the Platt Collection is now shown on the first floor of Higher Mill, including a complete range of Arkwright-type preparatory machinery. Through this collection it is possible to demonstrate the development of spinning from the early drop-spindle, via the great wheel to Hargreaves's jenny, and via the Saxony wheel to Arkwright's water frame. Arkwright's 96-spindle water frame is the most important machine in the collection; it is the only complete production machine of its type in the world.

Higher Mill puts a big emphasis on demonstrations of machinery for visitors. In Higher Mill the water wheel and fulling stocks run when the site is open. Upstairs, carding, spinning and weaving by hand can be seen. In Whitakers Mill daily demonstrations of the breaker carding engines, Derby doubler, and finisher cards take place. One of the highlights of a visit to Helmshore is the spectacle of the spinning demonstrations carried out on the 714-spindle Taylor Lang mules that were built in 1903. They spin miles of yarn in a few minutes. After that you can follow the yarn to

Queen Street Mill in Burnley, where there are hundreds of looms and, among them, some that will be weaving this same yarn from Helmshore into cloth.

At Queen Street Mill you step back a hundred years to see what it was like to work amid the speed and noise of a steam-powered weaving shed. The mill was built as a workers' co-operative at the end of the nineteenth century and very little modernization has been carried out there, so the working environment you see with its hundreds of Lancashire looms is very much as it was throughout the ninety years of its existence until it shut down in 1982.

It's good that some of these places were saved before the scrap men got at them. When the mills were all closing down, most of the scrap men round here had Rolls-Royces. But it was soul destroying, you know. They just smashed all the windows and threw all the machinery out before they loaded it on to their trucks.

There's one really grand band of men who've dedicated themselves to saving some of the lovely old engines they had in the mills. As the mills and all the machines in them started to disappear, a group of people realized that within a short time there would be no mill engines left, so they formed the Northern Mill Engine Society with the idea of doing what they could to preserve some of them. A number of these engines would be smashed up on the quiet without anybody advertising the fact, and the only guy who would be really upset would be the old boy who used to drive the thing, and he'd just keep out of the way when it was being smashed up.

The Northern Mill Engine Society would approach the people at somewhere like Courtaulds when they were closing a mill down and say: 'This engine is unique. It's made by such a body and there's only half a one left like it, so please, please don't smash it.' The problem the owners had when a mill closed was that the engine room was a space that couldn't really be used for anything else without having to face the difficulty and the great expense of removing the engine bed. You can't blow it up, because using dynamite blows all the windows out, so it's got to be a

jackhammering job. A number of engines disappeared in this way, and the engine rooms were never occupied again. They just had big blocks of stone in them where the engine had once stood, and the management would get the revenue from the scrap iron.

In the 1960s a certain gentleman in Bolton called Robert Mason, who'd made a lot of money out of builders' merchanting – cement, sand, chimneypots and downspouts and all that – bought this great complex of spinning mills and did the usual: let each floor of each of the mills to different individuals and businesses. At the site were two big engine rooms with nothing in them. In his benevolence he approached the Northern Mill Engine Society and told them they could have both of these engine houses. So the society took them; it started off about thirty years ago. I remember because I used to go up to see them, and I thought they will never get this off the ground. Anyway, they worked and worked, and were that busy talking and working that it went on for twenty years. Finally, they opened the place up to the public. They had a maple floor and one of nearly every type of mill engine that was available, like Uniflows and piston valves and weird connecting-rod arrangements. A particular one they had in there was a non-dead-centre engine made by John Musgrave & Company, who were very famous boiler-makers. These Northern Mill Engine men had really got it all right. They'd got the place open to the public and you'd see them running round in their best suits on a Sunday with their collection boxes. All round the walls they had pictures of safety valves and things, and they'd got all these lovely engines running off a gas boiler. But Mr Mason's empire was going the other way – it was sinking – so he sold the mill to Morrisons, the supermarket chain. When he sold it, though, he left in the deal the proviso that they would have to provide the Northern Mill Engine Society with enough money to be moved and rehoused in another place. I think they gave them £54,000 to put the foundations in a beautiful place with four times the room they'd had before. So they moved into this place, on the site of the old Atlas Mills, off Chorley Old Road, Bolton, and I think they are

now very close to getting it all back together again. So nearly thirty years on, with all their spare time spent on the engines, they're nearly getting there. That's the sort of dedication you've got to have. It's not yet open to the public, but they will show people around by appointment.

Another interesting thing happened to me one time when business was good and I was doing a job for Vantona textiles, who were very famous for bedlinen and things like that. I was speaking to the guy in charge of the mills, asking him if he'd got any steam engines hidden away in quiet corners. He said they'd all gone, but a voice suddenly called out from another office just round the corner: 'Oh yeah, we have.' And this guy appeared. He was called Harry Entwhistle and after that we got very friendly over the years. In fact, he's now deceased and his widow rang me up after he died and said: 'I'm cleaning out. I'm moving. Do you want his old tools?' So I went and got his callipers and engineering tools with his initials on, and it was all good stuff. Anyway, he said, 'Yes, we have got a steam engine left,' and the manager I'd asked looked amazed because he didn't know it existed.

Harry said, 'It's in Parrot Street. It's in the mill owned by the old Manchester City footballer Francis Lee, who now makes toilet rolls. It's on the top floor there.' Now you don't expect a steam engine to be on the top floor of a spinning mill, but it seems they'd built an extra floor there at one time and strengthened it with two great big iron girders so they could put this engine up there. Anyway, he said, 'If you've got an hour after dinner, I'll take you down,' and so we went to look at it. When we got up to the top of the mill he undid these two cupboard doors and there was this beautiful engine with about a 5-foot (1.5-m) flywheel. It was painted green and was all covered with cotton fluff and oil, and had never been rusted or anything. As soon as I saw it, I said, 'Tell the managing director that I'll have it. Tell him I'll knock a hundred quid off the job, if he'll give me it.' But nothing happened. I did the job, sent the invoice, and the next mill I did for them I asked him, 'What about that steam engine?'

'I'm going to take it myself,' he replied. 'I'm going to get it out and take it to a mechanics shop at Burnley, and I'm going to put it in my house at Boroughbridge.'

And I thought, You rotten sod. If I hadn't shown any interest in it, you would never have bothered. Anyhow, he got it out and put it in the mechanic's shop for all to see.

Then the company moved its headquarters from Manchester, where all the big spinning mills used to have an office, to Farnworth. When I went to look at it they were in a very modern office with rubber plants and sackcloth wallpaper: it wasn't the kind of place that you could erect a steam engine. They never did either. They kept it in a disused engine workshop at the back, and I kept going back to look at it. They didn't really know what to do with it, so in the end they gave it to the Northern Mill Engine Society and now it's in their hands. So since I blew the fluff off it about fifteen years ago, it's had a bit of a chequered career.

CHAPTER THREE

IRON AND STEEL

When I was a lad Bolton had its sprinkling of heavy engineering, and some of it is still there today. We've got places like Walmsley's, who make great big paper-making roll machines that they export all over the world. There are builders of steel engines and there are iron founders, like Hick Hargreaves & Company. Some of my earliest recollections are of Bolton's foundries. I used to think they were very interesting places. They always looked so dirty and unhealthy, but when you think of the end product, like liquid metal, that's something else.

Hick Hargreaves haven't got a foundry now, but in the days when they did have one they had four Cropolers, or blast furnaces, and if they were doing a really big casting, they blew all at once, which was fantastic. Compared with those in the real centres of cast iron and steel, these are minute little things, but places like Scunthorpe and South Wales were the other side of the world from Bolton as far as I was concerned, so my experience was all based on watching what went on in these little blast furnaces in Bolton. Here they'd spend three days loading them up with timber and coke. They'd load all the pig iron in and put limestone in the top. Then the great moment would come when a man with a big iron rod with a bit of clay on the end plugged the tapping hole and out would come this great stream of white molten cast iron, into an iron ladle similar to a crucible. The molten iron would run into this big ladle for a full ten minutes, and when it was nearly full up to the top they would hook it on the overhead crane and drag it across the shop before lowering it on to a great ancient cart

that looked as though it had come from some sort of medieval railway. It had iron wheels with no springs, and it didn't have any sort of suspension or steering. It had a big rope on the front of it, and about thirty blokes would all pull on the rope to get it out through the door into the yard. I'd be sitting on the roof on one of ten chimneys watching all this from above, and I could look down and see the scum on top of the metal, which went to about 3 inches (7.5 cm) off the top of the ladle. They'd manoeuvre the cart on to a turntable, which is still there to this day. Even then, though, it was a very rickety old thing; all the wheels underneath that kept it turning were knackered. When it was fair and square in the middle of this turntable, they'd pull on the rope to turn it round and then pull up the other way through another door and into another works. It was a really big bucketful; there must have been 4 or 5 tonnes of molten iron in this pot as they dragged it across the yard. What a fantastic vision!

When I started working I ended up painting the blast furnaces at Hick Hargreaves. One time when I was there, they were casting a big bed plate for some sort of engine and had four blast furnaces going at once. Very unusual that was – I never saw that again. Altogether there used to be about four conventional cast-iron foundries in Bolton that worked off coke, but they are all shut down now.

Iron smelting itself is a really ancient process that goes all the way back to the second millennium BC. What happens is that raw iron ore is converted to a workable and usable metallic iron by a process of reduction. The ore is heated and combined with carbon, and this releases the oxygen that's in it. The earliest method of reducing iron ores to a reasonably pure workable iron was in a primitive sort of furnace called a 'bloomery'. Bloomeries were fuelled by charcoal, which was burnt with layers of iron ore in between. Air from hand-powered bellows would provide enough heat to cause the oxygen in the iron ore to combine with the carbon in the charcoal fuel. This would leave a small spongy 'bloom' of nearly pure iron that had a fairly low carbon content. The bloom would then be hammered to forge a spearhead, an axe

or whatever other implement was required. As it was hammered, some of the other impurities would be removed to give the metal the tough and fibrous quality of what we now know as wrought iron. This method was used by the Romans, and survived well into the Middle Ages.

In Western Europe in the later Middle Ages it was discovered, almost by accident, that the blast from a sizeable furnace with mechanically operated bellows raised the temperature high enough to produce an alloy of iron and carbon. This could be run off from the base of the furnace in liquid form. The liquid could then be tapped from the furnace hearth into an elongated furrow that had been prepared in a bed of sand. This was called a 'sow'. The branches that ran from it were known as 'pigs', which is where the term 'pig iron' comes from. These rough bars of hard and brittle cast iron would then be sent to foundries and forges so that they could be refined into malleable or wrought iron.

These charcoal-fired blast furnaces continued to operate on simple, long-established lines, but as time went by, they were developed on a larger and more commercial scale. Although there are no real traces left there today, the Forest of Dean became a major centre of iron-making. In the foundries that grew up around there the furnace shaft or chimney was fed from above with measured proportions of charcoal, iron ore and limestone, and the chimney was flared so that this mixture, known as the 'charge', was always slowly but continuously descending. The limestone that they put in helped to remove non-metallic impurities. In the furnace a number of complex chemical reactions took place, and these were kept going throughout the process by an upward blast of air supplied by a pair of water-powered bellows. The aim was to allow the dense molten iron to trickle down through the charge to the hearth, where it would settle, with the slag floating on top of it, before it was drawn off.

By the early fifteenth century the process was made more efficient by the use of a water wheel to drive the bellows. This had the effect of speeding up the bloomery process. But it was water power that brought the next major step forward. This was

the invention of the water-powered tilt hammer, which made it possible to 'shingle' large masses or 'loops' of pig iron of up to 70 or 80 pounds (32 or 36 kg) in weight under the hammer. In this way they were able to produce wrought iron in quantity.

Until the eighteenth century, steel had been produced by the cementation process. This involved baking bars of wrought iron in beds of charcoal in a cementation furnace to absorb some of the carbon. Oxygen was not admitted, which caused some of the carbon in the charcoal to impregnate the surfaces of the bar. In this way the iron was 'converted' into steel, acquiring in the process a blistered surface – hence its name: blister steel.

The invention of the water-powered tilt hammer was of vital importance in the progress towards the mass production of steel. The tilt hammer made it possible to forge-weld together bundles or 'faggots' of blister-steel bars. The mass of carbon-impregnated iron that resulted from this could then be drawn out under the tilt hammer to form bars of 'shear steel'. It got this name because the material was suitable for making shears for dressing cloth in the woollen industry. If needed, the product could then be further improved by repeating the process, forging together faggots of shear steel to make bars of 'double shear steel' in which the carbon was evenly distributed.

If you want to find out about iron-making, head for the place that is regarded as the cradle of the Industrial Revolution. Coalbrookdale is in the Ironbridge Gorge in Shropshire. The whole area is probably the most important industrial archaeology site in Britain – so important, in fact, that it has been made a World Heritage Site. If there's one place you need to go to find out about our industrial past, this is it.

Early blast furnaces smelted iron twenty-four hours a day, requiring a continuous supply of raw materials. As well as the iron ore itself, wood was needed to produce charcoal, water to power the bellows, and limestone and clay for the furnaces. The furnaces also needed to be located close to transport. Coalbrookdale met all these requirements. The place had long been known for the wealth of its natural resources. Iron had been produced there

since the sixteenth century, along with coal and limestone, and mining in the rich seams of the East Shropshire Coalfield had taken place since the time of Henry VIII.

By the end of the seventeenth century Britain was facing a bit of a crisis. There was a huge demand for wood, and large areas of forests were being cleared to provide the timber that was particularly needed for shipbuilding. This meant that wood was becoming too expensive to be used as fuel for the iron industry. A cheap and plentiful alternative was needed. Coal seemed the obvious answer, but how to use it was a problem that nobody could solve. Ironmasters were busy searching for a way to perfect the use of coked coal as fuel for their blast furnaces, but it was a brass-maker, not an ironmaster, who finally succeeded where all others had failed.

Abraham Darby worked in Bristol before moving to Coalbrookdale to make cooking pots. The son of a Quaker locksmith, he was born in 1678 near Dudley, but when he was twenty-one he moved to Bristol, where he became a partner in a brass-works before setting up his own iron foundry in 1703. He realized that if he cast molten metal together with a metal that was cheaper than brass in sand moulds, it would make it possible to mass-produce pots. But it was Darby's young apprentice, John Thomas, who actually tried this for the first time and made it work. Darby then considered smelting his own iron rather than buying it. Bristol Quakers already had a brass-works in Coalbrookdale, and there's little doubt that Darby had made a number of exploratory visits to the area. He moved to the dale in 1708. Once he got there, he leased and repaired a disused seventeenth-century charcoal furnace and began to experiment with coked coal as fuel.

Until then the sulphur in most of the coal that had been tried in the smelting process made the iron too brittle, but in 1709 Darby succeeded in smelting iron with coke made from low-sulphur local coal. This released iron production from the limitations of an expensive fuel supply, but it wasn't until 1713 that he got it going as a profitable undertaking. In that year Darby again attempted to use coal for smelting iron in his furnace at Coalbrookdale. When

he did so, he started a dynasty of iron founders in the gorge who were to change the entire face of industry.

Abraham Darby didn't live long enough to see any real results from his discovery. He died in 1717 when he was only thirty-nine. His son, Abraham Darby II, was only six at the time, so while he was growing up, the works were managed by Thomas Goldney, a Bristol merchant, and Richard Ford, the son-in-law of Abraham I. During this period several major developments took place. Iron cylinders for steam engines were being cast at Coalbrookdale as early as 1722, and in that same decade cast-iron railway wheels were made for a local coalmaster. As the fame of Coalbrookdale began to spread, Abraham II concentrated on perfecting the forging of wrought iron using coke, and, as demand increased, other furnaces were built.

To begin with, water power was used at Coalbrookdale and continued to be used even after steam engines had taken over in other furnaces. The water was stored in a series of six pools that turned the wheels for powering the bellows, forging the hammers and powering the mills for boring. Only two of these pools now remain.

It was inevitable, though, that the advent of the steam engine would make its mark at Coalbrookdale. So, in 1742 Abraham Darby II replaced the old pumps with a Newcomen atmospheric engine, and with this innovation the growth of Coalbrookdale's iron industry began to accelerate. Abraham II leased mining rights in the East Shropshire Coalfield, and linked the mines and iron-works with a network of railways. Perhaps most important of all, he perfected the use of coke in making iron that was suitable for conversion into wrought iron.

Family history repeated itself when Abraham II died in 1763 because his son, Abraham III, was only thirteen at the time. In 1768, though, Abraham III took over the company at the age of eighteen. During the short period in which he managed the company, Coalbrookdale became the most famous and celebrated industrial development in the world, and many of the great engineers and inventors of the age went there to see what was going on.

It was the success of the Darby family that led to the great expansion of the iron trade in the eighteenth century. This in its turn was responsible for many of the changes in society which are now known as the Industrial Revolution. Later ironmasters in the gorge used iron to make the first iron railway wheels, the first cast-iron steam-engine cylinders, the first iron rails and the first steam railway locomotive. Eighteenth- and early nineteenth-century visitors came from all over the world to learn about the new technologies in iron-making, transport systems and other manufacturing industries.

The place became even more famous with the building of the Iron Bridge itself, and the area of Coalbrookdale became known as Ironbridge Gorge from the late eighteenth century onwards. It was Abraham Darby III who planned the construction of what was the world's first iron bridge. In the 1750s about six ferry crossings operated on the River Severn, each of them carrying raw materials for the industry and the workforce from one side of the river to the other. But as industry's requirements continued to grow, so did the need for a better way of crossing the Severn.

In 1773 Thomas Farnolls Pritchard, a Shrewsbury architect, wrote to John Wilkinson, a local ironmaster, suggesting that a bridge made entirely of cast iron should be built across the river. Wilkinson was a big iron enthusiast and was even nicknamed 'Iron Mad' because of his belief that iron could be used to make anything. He wasn't, however, an original thinker. Instead, he used other people's ideas, and was more of a good imitator than an inventor. As the main man in the gorge, Darby was brought in as the financial backer of the new bridge, and issued shares for the £3200 that he estimated the bridge would cost. In 1776 an Act of Parliament was passed that authorized the building of the bridge and prohibited any ferry operating within 500 yards (455 m) of the new structure.

But there were such doubts about whether an 'iron bridge' would work that advertisements appeared in local newspapers seeking tenders for building the bridge in 'stone, brick or timber' – anything, in fact, except iron. It's not very surprising that these

doubts existed because iron had never been used for such a big project. It was known that small iron bridges had already been built in China, but not of such a mass and size as the one planned to span the gorge.

Casting the parts must have presented some big challenges for the Coalbrookdale iron men. Quantities of iron as big as this would have taken one furnace three months to produce, so the Coalbrookdale furnace was enlarged in 1777 and, as far as we know, this was where the iron for the bridge was produced. Abraham Darby's workmen raised the huge arches of the Iron Bridge in the summer of 1779. Each of the ribs that made up the arches weighed 6 tonnes. Darby's Quaker beliefs are there for all to see in the footnote to the table of tolls, which says that the military and the Royal Family were most definitely not exempt from paying their toll.

The town of Iron Bridge became a prosperous industrial community in the late eighteenth century, and by the nineteenth century it had been visited by many famous people, including John Wesley and Benjamin Disraeli. Maori princes were sent to learn about ironworking, and Italian and Polish nobility, Swedish and German engineers, industrial spies from France, clergymen, writers and artists all marvelled at the new wonders of the world that were to be found there. The bridge itself certainly paid its way. Traffic continued to use it until 1934, when the road was closed. Today it's still in use as a footbridge and English Heritage is its guardian.

For many visitors the most interesting site in the gorge is **Blists Hill**. During the early period of the Darbys' development of Coalbrookdale into a major industrial area, Blists Hill was a bit of a backwater. Not much is known about it until the end of the eighteenth century. By this time coal-mining had become quite well established there. In 1786 the Quaker ironmaster William Reynolds tried to connect the mines at Blists Hill with the River Severn by tunnelling through the hill. When he did so, he discovered a source of bitumen that may still be visited today as the Tar Tunnel. A number of shafts were sunk at Blists Hill in

the late eighteenth century. These went through different seams of clay, coal and iron ore. In their time Blists Hill mines supplied the blast furnaces in the immediate area not just with the coal that was used in the forges and foundries of the valley, but also with supplies of the iron ore itself. To meet the demand, a constant supply was needed, and it was common practice for women and children to work long hours down the mines and up on the surface picking over the iron ore and the coal heaps.

But the pre-eminence of the Ironbridge Gorge didn't last. In Victorian Britain competition was growing and industry had to invest to succeed, but not all the industries in the gorge understood this. As a result, by the end of the nineteenth century Blists Hill was in decline. Although the brick-works and mines held out until the Second World War, the blast furnaces themselves were blown out in 1912. In the post-war years Blists Hill became derelict, leaving the abandoned remains of a once-thriving centre of industry. The only visitors it had were enthusiasts of 'industrial archaeology'. Today it's one of the most interesting and most visited industrial heritage sites in Britain. When you go there you can really step back into a bygone age. You can even exchange your money for the museum's very own pre-decimal token currency to be spent in the Blists Hill shops, workshops and pubs. These include a chemist, a tinsmith, confectioner, plumber, decorative plasterer and the New Inn public house.

There's one engine at Ironbridge that goes round every day to demonstrate how wrought iron is made, and that engine comes from Bolton. I went once or twice when they were restoring it, and I thought, I wonder if they'll ever get it going again. Anyway, they did ultimately, and they've got it rolling now. All the lads who worked at Thomas Walmsley's where it came from originally were on the wild side. Their wives would go down on Fridays to collect their wages so they could not go to the pub and spend it all, and to watch the sequence of events there was fantastic. I've got a real good mate, John Larson, who worked there. His dad had worked there before him, and they'd both worked on one of these steam hammers that are now at Ironbridge. When

they were at work in Bolton the bell would ring and the oven door would open. A guy would go in with his tongs, and they had this overhead traveller (like a track) on the ceiling. The large tongs were attached in the middle of this by a chain that could be moved around the factory. The chain supported the weight of the tongs so that it could be used as a lever when the guy was lifting the white-hot metal out of the furnace. The chain would then also support the weight of the tongs as he ran with the metal across to the rollers where there was another guy wearing a big leather apron and big hobnail boots. He would then lift the iron up and shove it through the rollers. When it went through on the first pass it didn't seem to make much difference. By the next pass, though, it was getting longer and thinner, until after about four or five passes it went from about 5 inches (12.5 cm) in diameter and about 3 or 4 feet (0.9 or 1.2 m) long and, this is the bit that never ceased to amaze me, down to about ½ inch (1.2 cm) in diameter and 25 feet (7.6 m) long. It was magic. This rolled iron was then used for making rakes, shovels and other tools, and for general construction.

I remember, they'd have two couches and easy chairs there because it was such a strenuous operation that they'd collapse in an easy chair while the other lot would get up and shove the metal up and down – it was all unbelievable to watch. What a fantastic place; it's so sad it's gone. At the end, me and the same lad, John Larson, felled the chimney there. It was the last thing left standing in the place, and when we'd done the job we went down to the pub and got pissed and that was the end of it. What a sad day that was.

But Bolton had only an odd few little foundries like this, and it was only very minor league when it came to steel manufacturing. It's the name of Sheffield that is associated with steel all around the world. The city is known for the manufacture of knives, razors, scissors, surgical and mathematical instruments, files, saws, engineering tools and heavy sheet metal. It was the fast-flowing water of Sheffield's many rivers and streams, together with the availability of iron ore, wood for charcoal, coal, clays, lead and lime that brought about the city's industrial development from a

very early date. The city's position, straddling five rivers, enabled it to make full use of water power. It was these natural resources, along with the availability of sandstone for making high-quality grindstones, that put Sheffield on the road to industrial growth. The earliest recorded water-powered workshop existed in 1496, and by the late eighteenth century records show there were over 150.

Water was the main source of power for the early cutlery industry, which is what made Sheffield world famous. Shepherd Wheel is typical of the many cutlery grinding shops that date from the late sixteenth to the late eighteenth centuries, when Sheffield cutlery achieved national recognition. With a history dating back over 400 years, it still demonstrates the way Sheffield's metal-working skills developed in rural settings along the local rivers; sadly, it is not open to the public. Water wheels also powered corn mills, fulling mills, forges, steel-rolling and slitting mills, smithies, paper mills and many other small industries. Some of the water mills were established as early as the twelfth century, but from the middle of the eighteenth century they began to be phased out by the arrival of the steam engine. Within 100 years of the development of the rotative steam engine by James Watt in 1782 there were between 400 and 500 steam engines driving grinding workshops in Sheffield alone.

The **Abbeydale Industrial Hamlet** is close to Shepherd Wheel. The original Abbeydale works was one of the largest water-powered sites in the area. Scythes, grass hooks, hay knives and other agricultural edge tools were manufactured here. There's a tilt forge that was built in 1785, and a crucible-steel furnace of the type invented by Benjamin Huntsman in 1742.

Water-powered workshops like those at Shepherd Wheel and Abbeydale made the grinding process for edge tools and cutlery much easier and faster. Water-powered forge hammers allowed the manufacture of larger edge tools like scythes. To improve the quality of their products, the cutlers and the tool-makers began to import a higher grade of iron from the Continent. But even the best wrought iron, obtained mainly from Sweden, contained some impurities, and these remained in the blister steel.

The big breakthrough in improving the quality of steel came in 1740 when Benjamin Huntsman introduced the process of making crucible steel from bar or blister steel. A resident of Sheffield who actually worked as a clock-maker in Doncaster, Huntsman developed the relatively simple method of purifying blister steel by melting it in crucibles and skimming off all the impurities that floated to the surface. The liquid steel was then poured into a mould and left to solidify. This process produced an ingot of cast or crucible steel that had a uniform high degree of purity. High-quality steel like this had never been produced before, and so, with both his technique and his product, Huntsman not only laid the foundations of the steel industry in Sheffield but of the whole of the steel industry as it has developed around the world to this day.

For the tool and cutlery industries of Sheffield, steel was required in small rods. These were generally produced in a rolling mill invented by Henry Cort in 1783. In the rolling mill a large piece of hot steel was passed between grooved rolls. This gradually reduced it to the size and shape required. The process was known as hand-rolling because the steel was moved about by hand as it passed between the rolls.

By the end of the eighteenth century Sheffield tools and cutlery had already received national recognition, but it was the nineteenth century that saw the beginnings of a great new era of steel-making for the city. At this time some companies developed from steel- and tool-makers on a small scale into engineering steel-makers on a huge scale, and names such as Firth, Vickers, Cammell & Brown began to emerge. And as the methods of large-scale production were developed, so too were the techniques for turning large masses of steel into something that could be used by engineers.

Until 1839, when James Nasmyth invented the steam hammer, the capacity of the old water-powered hammers limited the forging of larger pieces of steel. Nasmyth improved this in 1843 so that steam was also used to force the hammer down with tremendous force as well as to lift it up. But as the scale of engineering grew, even larger pieces of steel needed to be shaped, which soon made

the newly introduced steam hammer inadequate. To overcome the problem, Charles Cammell installed the world's first hydraulic forging press at his works in Sheffield in 1863. Unlike the hammer, the press squeezed the steel to shape, and gradually the machine was improved and increased in size and capacity.

Crucible steel, however, could not be produced cheaply in bulk. In 1856, though, Henry Bessemer overcame these difficulties. Although the steel produced by the process that he developed was not of the same quality as crucible steel, it gave the engineer a material that he could use. Bessemer established his first steel-works in Sheffield and was soon producing steel in vast quantities.

Until the nineteenth century, carbon steel was the only type of steel available. Then it was discovered that many of the properties of carbon steel could be improved by adding other elements. These new steels became known as the alloy steels that have become the most important product of the steel-making industry.

Many of the biggest contributions to the development of alloy steels took place in Sheffield. In 1882, for example, Robert Hadfield produced manganese steel. This was far stronger than the toughest carbon steel and, because it was so hard-wearing, it was ideal for railway and tramway lines. Hadfield also discovered silicon steel, which had magnetic properties greater than iron itself. This was quickly adopted for making electromagnetic equipment, such as transformers. But the most important discovery in the history of steel-making came in 1913 when Harry Brearley first produced stainless steel. Brearley recognized its potential for making rust-proof knives, and gradually the cutlery trade began to adopt it.

John Brown opened up a whole new field for the steel-maker when he produced the first armour plate in Sheffield in 1861. Other companies, such as Vickers, Firth and Cammell & Brown took up production, and their names soon became synonymous with the heavy armaments industry. Such was the extent of the industry in Sheffield that by the beginning of the twentieth century Sheffield had become known as 'the arsenal of the world'.

In the domestic market, because of the great growth in manufacturing in the tool and cutlery trades, it became impossible for a single craftsman to make a complete item from start to finish. So the different stages of manufacture started to be done by a range of self-employed specialist craftsmen, who became known as 'Little Mesters', who passed the finished item to the master manufacturer, who in turn sold them under his own name and trademark. At one time there were hundreds of these Little Mesters operating from workshops all over Sheffield. Today, though, the mechanization of the industry has eliminated all but a handful, who remain to carry on the centuries-old tradition of Sheffield's earliest industries. At the **Kelham Island Museum**, visitors can still see three or four of these Little Mesters at work. Each of these craftsmen has his own business on the museum premises, and they all continue to use the traditional skills that helped to build Sheffield's reputation for quality.

It was the exploitation of coal and iron that brought work and prosperity to another part of the country in the last century, when Coatbridge was Scotland's 'iron burgh'. The burgh's industrial heritage is preserved today at the **Summerlee Heritage Centre**. Summerlee was the third set of hot blast furnaces to be built by the side of the Monkland Canal in Coatbridge. They were built by Wilson & Company, whose founders were John and George Wilson together with their cousin Alexander Wilson and John and Walter Neilson. The Neilsons were relatives of James Beaumont Neilson, who had invented the hot blast method of iron production, a process he patented in 1828. This involved supplying hot air to the blast furnace, where the fuel, ore and limestone flux were burnt to produce iron. The method was an advance on the old one of supplying cold air, as the higher temperatures took away the need to coke the coal used as fuel, so the output of iron per furnace was increased, thus reducing overheads. It was an innovation that was quickly adopted by other Scottish ironmasters.

By July 1836 two furnaces were in blast at Summerlee; these increased to four by 1839, six by 1842 and eight by 1868. The name of the company was changed to Summerlee Iron Company

in 1906, and continued to flourish until the late 1920s. But then it ran into financial difficulties and by 1932 had debts of £190,000; its blast furnaces were closed, and in 1938 the works were demolished. The remains of the iron-works, especially the massive blast furnaces, have now been excavated and are once again on view to the public at the Surnmerlee Heritage Centre. As an independent charitable trust, it has been set up to record and display the history of the iron and steel industry, of heavy engineering, and of the communities that depended on those industries for a living.

One of the other great areas of metal working in Britain was in the Midlands. The name of the Black Country is not one that you'll find on any map. It is the name that has been given to a region of industrial activity, originally based on coal-mining and iron-working, that lies to the west of Birmingham. It got its name in the middle of the nineteenth century when thousands of furnaces and chimneys filled the air with smoke, and the mining of the coal, ironstone, fire clay and limestone turned the ground inside out, creating vast expanses of industrial dereliction. Underneath the Black Country lay the 'Staffordshire thick coal'. This seam averaged 30 feet (9 m) in thickness, and it was often only a few feet from the surface. Because of this, large amounts of small coal that had been left under ground caused fires that turned vast areas of the Black Country into sulphurous, smoking wastelands.

The **Black Country Living Museum** is a place where craftsmen and demonstrators re-create the activities of the time when the Black Country was the heart of industrial Britain. The region is renowned for its production of iron and steel goods, including chains, nails, tubes, forgings, rolled products and castings. In the Castlefields iron-works, which is part of the museum, many of the iron-working processes of the area can be found, and the Nail Shop just outside the gate is a reminder of the earliest 'metal-bashing' industry of the region. Nail-making was well established in the Black Country by the Middle Ages, and at its peak in about 1820 over 50,000 nailers were at work in the area. As the trade in hand-made nails declined due to

the mechanization of the industry, the Black Country turned to the production of chains, for which it was to develop an international reputation.

The Chain Shop in the iron-works was built using two hearths from one of the last firms in the area to make hand-made chain. The smaller hearth was set up to make chain with the iron about ½ inch (1.2 cm) in diameter, while the larger one was used to produce heavier chain that needed two men to make it. Next to the Chain Shop is the Blacksmith's Shop with its 'Goliath' forging hammer used to produce tools and small forgings for the rolling mill. This is in a large open-sided shed by the canal, and it has been set up as a typical Black Country re-rolling mill in which iron or steel bars can be reduced in size or changed in section.

The other large building in the iron-works, with its cast-iron columns and wooden roof trusses, houses the Anchor Forge. The furnace is similar to the one in the rolling mill, but the iron billets heated in it are much larger and are suspended from a crane so that they can be manipulated beneath the steam-powered hammer. The heat from the furnace also raises steam in the boiler, and this steam powers the hammer to reduce the size of the iron and forge it into the shape that is needed.

The ground that lies underneath the museum was once mined for coal, fire clay and iron ore. More than forty mineshafts can be found on old plans, and around one of these shafts, Racecourse Colliery, a typical small Black Country coal-pit has been built. Because the coal was so close to the surface and because so much of it was easily accessible from one shaft, the pits here had only simple winding engines and timber pit-frames. Racecourse Colliery has a single-cylinder steam winding engine. This provides enough power to serve two shafts, one for raising coal and the other for removing water. It's a layout that is similar to that of many Black Country pits. The colliery is shown as it would have been in about 1910.

When you're tracking down our industrial history you don't have to go just to the traditional, built-up industrial areas such as the Black Country. Some industrial history can be found in

surprising places, in some of our most picturesque bits of the countryside. When you talk about forges and foundries and all that goes along with iron and steel, you think of big, grimy industrial areas. You certainly wouldn't think of going into a lovely national park.

But, because water continued to be used as the source of power for rural industries long after the introduction of steam, one of the best examples of a tilt hammer that you can see at work today can be found in the heart of Devon cream-tea country in the lovely old village of Sticklepath, which is near Okehampton on the edge of Dartmoor. Built in 1814, Finch Foundry is a perfect example of an early eighteenth-century forge producing agricultural tools, such as scythes, sickles, billhooks and shovels for both agriculture and mining.

The machinery, most of which is still in place in its original setting, was driven by three water wheels powered by the River Taw. A pair of 'trip' or tilt hammers, together with some ancillary machinery, were powered by one of the water wheels. A second water wheel then powered a fan that blew air through a system of underground pipes to the various forges, while the third water wheel drove the grinding mill where the tools were sharpened and finished. The big object of interest in the grinding mill is a large sandstone grinding wheel running in water. Here you can see demonstrations of the way in which the operator lay face down on a bench to sharpen the tools.

The actual water wheel that drives the tilt hammers and shears is an overshot wheel, 12 feet 6 inches (3.8 m) in diameter and 5 feet (1.5 m) across the breast. It has forty wooden buckets and requires about 700 cubic feet (20 cu m) of water per minute to drive it at full power. And when you've seen the forge and the demonstrations of the machinery, there are lots of country and riverside walks that set off from the foundry if you're feeling energetic.

CHAPTER FOUR

MINING

The little village where I live, Darcy Lever, was once a mining village, and it's sad, because what Joe Public doesn't know is that at the turn of the century there were nine collieries all within a mile or so of the village, and now they've all disappeared.

The earliest memory I have of coal-mining around here is as an eight-year-old riding along the canal towpath on my bike with my dad, when half my concentration was on making sure that I didn't ride off the path.

Ladyshore Colliery, which was a bit further up the canal, was quite a splendid place. I never actually saw it working because it was shut down in 1949 by the National Coal Board, but it was all still there and it was something else, that place. The canal was quite wide there, and it was full of sunken canal boats. The prows and the sterns were sticking out of the water, and you could see the rest of them below. It was lovely and clean because there was no more activity there. They all had 'LMS' on or 'Ladyshore Coal Company, Little Lever', and the handsome boat-building shed, which looked rather like a railway station with beautifully cut timber boards, was still there.

There was quite an interesting sprinkling of collieries along the Bolton-Bury-Manchester Canal, and as well as that there were all sorts of coal-mining oddities around Burriden Park, Bolton Wanderers' old football ground near where I was born. My auntie used to say that there was a coal-mine underneath her house. When she popped her clogs and went upstairs, these houses actually fell empty because they never resold them and

they were then demolished. I don't know why but there's a fence around them now, as if the council knew something and smelt danger. So they never built anything on that spot, and it's still like that to this very day, so it must have been right what my auntie said.

Within a couple of hundred yards of where I live now there are mineshafts that half the people who actually live in this neighbourhood don't know about. Some of them are still open, with just concrete slabs over the top. The last working mine in Bolton was known locally as the Three Pigeons (its official name was Victoria Colliery) and, of course, Westhoughton just down the road was literally built on coal-mines. England's third worst mining disaster happened near there at the Pretoria Pit, Atherton, in 1910, when 344 men got blown to bits on 21 December. What a horrible way to die, that was! They didn't shut the pit down because of it, though; they kept going until the 1930s. In the next little town, Farnworth, the coal-mines ran right until the mid-1960s, places like the Wheatsheaf, Sandhole, Newtown, Astley Green and the North West Area Workshops at Walkden Yard. This last place was where they repaired all the locomotives and pit-cages. This came in very handy for me when I was making a steamroller. The guy in charge had a bit of a soft spot for me, and he lent me lots of tools that would have been very hard to get. Round that area you could descend a shaft and get near the Duke of Bridgewater's underground system, which is reputed to have 40 miles (65 km) of underground canals.

I remember as a kid wandering about all these valleys. I've always been a bit weird, you know; other kids would be playing cowboys and Indians while I would be finding pieces of piping sticking out of the ground and be thinking, What the hell is that? It must be some sort of mechanical interest. I would find interesting things, and as a kid it made me wonder what they were doing there. I once rode a bike down a sewer with no mudguard on. The sewer was only about 6 feet (1.8 m) in diameter and was called Jenny Beck. I was with my mate Alan Hepe, and when we got to the end of the pipe we couldn't turn our bikes round, so had

to back-pedal all the way back to where we'd started from. That was an interesting tunnel. We could have got gassed down there, I suppose, but we never thought of things like that at the time. The only thing I worried about when doing this crazy deed was that if it rained and we were playing around the entrance to this tunnel – it was more of an open sewer really – it would go from 3 inches (7.5 cm) of water to over 4 feet (1.2 m) after a heavy downpour. That was the scary bit. But that didn't stop us. As we went up this tunnel, it was brick for maybe 800 to 900 yards (730 to 820 m), then it went into the most wonderful cobblestone bottom with an arched roof. After that it went underneath Burnden Park Football Ground and then underneath the main railway line that runs from Bolton to Manchester. Then we were getting on for Great Lever, and were getting scared so we climbed up some metal rungs on the tunnel wall to a manhole. It must have been about 50 feet (15 m) and when we reached the grid at the top we spied the street sign for McKeen Street, which was miles away from where we lived. We couldn't get the lid off, so we had to go all the way back down the tunnel.

I don't think I'd have liked to be a hewer of coal, but I'd have enjoyed the problems of starting a new colliery off. They used to have these royal battles, and a lot of them went bust. Nobody got paid and everything got tragic, and you can see why they have gone in for oil and gas now. It's a lot easier to drill a hole than to send a lot of men down and get the black stuff out that way.

For one of the most interesting coal owners you've got to go back to the eighteenth century. They reckoned the Duke of Bridgewater was thwarted in love, so he spent all his energies on a grand plan to get coal to Manchester for all the spinning wheels that were starting to appear there. The Bridgewater Canal was his baby but, of course, there were some interesting civil engineering things on it, and he employed a very clever engineer called James Brindley to do the work. One of Brindley's greatest engineering feats was to build an aqueduct that jumped over the River Irwell. But he also helped design over 40 miles (65 km) of underground canals to transport coal from the Duke of Bridgewater's mines in the Manchester area.

One of the lesser known collieries was the **Wet Earth Colliery** at Clifton in the Irwell Valley and there are few photographs of it when it was working, but the artist L.S. Lowry, who used to live nearby, did some drawings of it. When it shut in 1928, the whole place was flattened and nothing was left on the surface.

Wet Earth Colliery is important because of the work that James Brindley did there. His solution to water problems at the colliery was unique, and it provides us with an insight into his engineering genius. In the late 1980s steps were taken to excavate some of the surface remains, which had been hidden since the colliery closed. The work that is still going on there gives a real taste of industrial archaeology. When the exploration and excavations started, the site was derelict and abandoned and much of it overgrown. Early excavations revealed that all the underground workings of Brindley's eighteenth-century pumping scheme had been seriously neglected. To try to do something about the situation, a group of enthusiasts carried out an investigation into the potential for long-term exploration of adits that were below the surface but far above the actual mine workings. An adit, by the way, is a mining term for a horizontal shaft from the surface that reaches the mineral seam. It was a common method of mining in hilly districts, and was also used to drain water. The mineral-bearing rock is then excavated by digging horizontally into the side of a valley. If you go to visit old mines, particularly tin-, copper- and lead-mines, you'll be shown adit workings.

A group of enthusiasts whose members included archaeologists, geologists, engineers and miners got together to form the Wet Earth Colliery Exploration Group. They soon established a link between a known adit and the colliery loading basin, where the barges loaded up with coal, which had been constructed in the 1790s, and they realized that the underground aspect of Brindley's scheme had been neglected and also misinterpreted over a long period of time.

What they found was that the scheme at Clifton had basically relied on water power to drive a wheel, which in turn operated pumps to drain the mine. Surplus water was discharged via a tailrace

tunnel back to the River Irwell. The concept was straightforward enough, but all traces of Brindley's designs had disappeared, and it was only by excavating 1000 feet (300 m) of silted passage that the route of the tailrace tunnel was discovered.

The news of the search for Brindley's tailrace soon got around. Mine officials, speleologists, historians, scouts and guides and even octogenarians have come along to the site and been escorted around it. Selected visitors who have a real interest in seeing such a significant industrial archaeology project have been given access not only to the tailrace portals and surge chamber but also to a scour mark gouged out when the original water wheel drifted on its bearings. A mixture of blockwork and brickwork, the chamber's sheer size and its proximity to the eighteenth-century shaft that had been associated with the original pumping scheme provides a fascinating experience that will bring industrial archaeology to the notice of all.

But old colliery sites can be inherently deadly. Old shafts contain very little oxygen and their cappings may not be safe. It is imperative not to smoke close to old shaft cappings, as methane gas might be at just the right percentage to present an explosive surprise! Because of this, Alan Davies from the **Lancashire Mining Museum**, who runs the project, has been having a bit of a bother about allowing people to see Brindley's underground tailrace and water-feeding channels. The problem seems to be that gas has been detected coming up a shaft, and it's coming into waterways that are connected to the mine. This means that for the general public access to the workings has been restricted, but there's still plenty to see, and for anybody who is interested the Wet Earth Colliery Exploration Group meets every Saturday morning at the visitor centre. New members have use of the group's equipment. All that's required are full-size wellies and old clothes, no recent heart attacks, a good back and a sense of humour!

What you'll see when you get there are the remains of pumps and piping from the mining operations, and in the shaft itself some interesting brickwork. The wheels for the underground

haulage system, like the one I want to do in my back garden, all still work. You can hear water from way down below where you are standing

A colliery site never fully loses its past identity, and exploring this site can be a real adventure. The group has prepared a little leaflet to help you find your way around. You can see an old oval shaft, which probably dates from the 1720s, and the sunken boilerhouse, which dates back to around 1900. This contained ten Lancashire boilers that fed the steam winding engines at both shafts and also the steam-powered compressors in the next building. Steam power arrived at Wet Earth around 1805, when a Newcomen-type steam winder was introduced opposite the sunken area where the old stone engine bed still stands.

Wet Earth is good for a real sense of what industrial archaeology is all about, and there are few places where you'll see coal-mine workings as old as this. But before the time of Brindley and the Duke of Bridgewater, early methods of coal-mining were crude and ineffective. Pits were shallow and, owing to the impossibility of drainage, had to be abandoned after a very short period of working. But as restrictions on the use of wood for smelting iron began to be imposed, efforts were made to use coal for this purpose. In the reign of James I and Charles I, many unsuccessful attempts were made to smelt iron with coal instead of wood and, because of the lack of smelted iron, many iron-works had to be closed down.

It was Dud Dudley of Worcester who, in 1610, first successfully smelted iron with coal, but it was only with the development of Abraham Darby's iron smelting-works at Coalbrookdale that demand for coal started to grow significantly. By this time improved agricultural methods were increasing the amount of land under cultivation and sweeping away the tracts of forest that had formerly kept the blast furnaces fuelled.

As more coal was needed, the depth of the pits had to increase, and the difficulty of keeping them free from water was growing greater. It was the huge increase in demand for coal and other minerals that brought about the improvement of pumping

machinery. The development of pumping machinery, however, is due not to coal-miners but to the adventurers in the Cornish tin- and copper-mines, who had experienced difficulty with water much earlier. The credit for the introduction of various types of power from complicated windlasses to the steam engine itself must go to them.

At the time that the Cornish tin-miners were struggling to find ways to keep their mines free from water, similar problems were being faced by lead-miners in other parts of the country. The **Killhope Lead Mining Centre** is probably the best-preserved lead-mining site in Britain. It is situated on the site of the Park Level Mine and Crushing Mill in the heart of the North Pennines, which was Britain's major producer of lead in the nineteenth century. The mining, dressing and smelting of lead ore employed many hundreds of men and boys in these isolated hills and valleys. (Dressing, by the way, means separating the ore from the waste.)

Until the eighteenth century lead-mining was still only being done on a very small scale in this area. In 1696, though, Sir William Blackett took two major Weardale mining leases and for nearly 200 years his family dominated the industry there and turned it into one of the country's major lead-mining areas. They employed up to 1200 men and boys when the industry was at its peak in the mid-nineteenth century. At other places in Britain, lead-mining was done mainly by small speculative companies that often had short and disastrous lives. The industry held great appeal for gamblers and crooks, and it aroused similar passions to gold-mining.

Early North Pennine workings were in shallow pits dug along the line of a vein of ore. The pits had hand-rollers mounted over them for winding up kibbles – that is, iron buckets of the ore. Once a shaft had been worked out, another would be sunk further along the vein. Eventually, there would be a line of abandoned shafts marking the course of a vein.

By the eighteenth century another form of mining had been introduced. This was large-scale opencast, working along the line of the veins, using water power to strip off the overburden. The

technique, known as 'hushing', involved building a small earth dam on the hillside above the line of a vein. The surface would then be loosened below the dam, and when sufficient water had built up, the dam was breached and a torrent of water swept away earth and boulders. Gunpowder was then used to loosen the rock ready for the next torrent of water. When this process was repeated over and over again an artificial valley was created along the line of a vein, and men were able to pick the lead ore out of the bottom of the hush. The power of the water to make these hushes could be awesome, and boulders weighing several tonnes could be rolled hundreds of yards with its force.

As with the tin-mines, though, when underground workings became deeper, drainage became a bigger problem. Small amounts of water could be wound up the shafts in buckets, but this was slow and arduous work. The solution devised for 'unwatering" mines was to make a tunnel just big enough for a man to work in from a lower point further down the hillside to the bottom of the mining shaft. This allowed the water to drain away freely. In the mid-eighteenth century these water-level tunnels, or adits, were made larger and driven, where possible, in soft rock with hard rock above as a roof. These adits became known as 'horse levels' in which ponies could haul tubs of ore out of the mine. The horse-level mouth is the characteristic mine entrance in the North Pennines, and many, all over the Pennines, have survived and can still be seen today.

Horse levels acted as drains, but workings below a horse level still had to be pumped dry. Pumps were powered by a variety of methods, and, although it is Cornwall that is associated with the inventions that helped to keep the mines free from water, a lot of pioneering work was done in the North Pennines as well. In 1765 the hydraulic engine was first developed, just 2 miles (1.6 km) from Killhope at Coalcleugh. A hydraulic engine was installed 120 feet (37 m) below Park Level in 1867. As the mine was extended, this equipment proved to be inadequate for draining the lower workings, so in the 1880s a steam pumping engine was installed. Three miles (5 km) down the valley from

Killhope, at Burtree Pasture Mine, the solution to their pumping problems was to use two massive underground water wheels to keep the mine dry. The trouble with using water wheels in mines, though, was that in very dry weather there was not enough water on the surface to power and drive the water wheel, and, as a consequence, the mine could flood.

The entrance to Park Level Mine is next to the shop at Killhope. It was started in 1853 and last worked in 1916. Like many horse levels, it is a 'cross-cut': it does not follow along the line of a vein, but intercepts veins nearly at right-angles, with workings branching off the main level to follow the veins. The nearest vein, Himer's, is just over 325 feet (100 m) from the entrance; Killhopehead vein is about a mile away. All the veins cut by Park Level had previously been worked from the surface by hushing.

After five years working the Level, it was still only 1650 feet (500 m) long and little ore had been recovered from the first four veins. Only after more than twenty years did the miners reach veins that yielded a lot of ore. Increased production from these veins led to the decision in 1876 to build a new crushing and separation mill, fully mechanized and powered by a large water wheel. Two reservoirs were built on the hillside above to store the water to power the wheel.

The Killhope wheel is now the only surviving water wheel connected to a North Pennines lead-mining site. In its day the wheel was in the engine room of the mill. It hauled tubs of ore by rope to be crushed; it also drove the crushing rollers and all the machinery in the jigger house, where the lead ore was separated from the rock.

The miners themselves worked in groups of between four and six men. They were paid for the ore that they produced. Every three months each group made a 'bargain' with the mine agent to work at a set price for their ore. Very often, though, the miners would lose out badly and would find themselves stuck with poor rates.

Coal-mining differs from lead-, copper- or tin-mining in that the coal comes in thicker seams than the relatively thin veins

found in these other mines. There are two quite distinct types of coal-mine and ways of mining coal. Drift mines are made where coal seams either outcrop at the surface or rise very close to the surface in such a way that a sloping incline, or drift, can be driven down along the dip of the seam to get at the coal. This method of mining is not as expensive as the other, which involves sinking shafts to reach deeper, concealed seams in a pit mine.

Caphouse Colliery near Wakefield was a traditional pit mine in the heart of the Yorkshire coalfield. The pit closed in the 1980s, and it is now home to the **National Coal Mining Museum for England**. It's one of two places in the country where you can experience getting into the pit-cage and going down the shaft to the bottom of a coalmine. The other one is at the **Big Pit Mining Museum** in Wales.

Although work has stopped at Caphouse now, this is a real coalmine and everything is very much as it was when it was still working. A helmet and a miner's lamp must be worn, and as you leave the lamp-room at the start of the tour, you see the winding house that was built in 1876. The old steam winder, built by Davy Brothers of Sheffield, was in regular use at the pit until 1980, and a new boiler is being made that will enable them to run it again. The new winder is an electro-hydraulic engine similar to those that are now in use in the Selby coalfield. The tour at the bottom of the pit is conducted by an ex-miner, who has worked at different collieries in Yorkshire. The tour shows how coal-mining was carried out in Yorkshire from the early years of the nineteenth century until the pit closures of the 1980s.

As well as the problems caused by water, which were common to all mines, coal-mines had additional hazards that the miners had to face: dangerous gases. To counter the build-up of these gases, fresh air had to be circulated around the mine. The fan-room, therefore, was one of the most important places in any colliery. The fan drew stale air out of the mine, allowing it to be replaced by fresh air. This prevented the accumulation of pockets of dangerous gas, such as explosive firedamp, and would clear the suffocating stale air that would build up. The ventilation current was forced

to circulate through all parts of the mine by using airtight doors that stopped the fresh air escaping out of the shortest route and leaving sections of the mine unventilated.

The miners travelled to the seams, and between the different seams they were working on, in man-riding cars. These cars were operated by a small, compressed-air winch. Compressed air was a popular form of power in the mines from the 1860s onwards, as it was easier to handle than steam over long distances and a lot safer than the early applications of electricity. Sparks from early signalling and electrical equipment were to blame for several violent explosions. Even an isolated spark could ignite a pocket of firedamp, which could start off a coal-dust explosion.

As a rule, there would always be a blacksmith's workshop and forge within a colliery because a skilled metalworker would be required to make immediate on-the-spot repairs if, for example, a haulage chain snapped, and delay would halt production. He also kept the miners' picks and drills sharp. With a large amount of coal won by hand in the early days of mining, a hewer would take perhaps six pick-heads down with him and change them during the shift as they became blunt. At the end of the shift he would pay the blacksmith to sharpen them ready for the following day.

Every miner was given his own number when he joined the pit. This number would be stamped on his battery cap-lamp and self-rescuer – a small breathing device introduced in the 1960s which, after an explosion, converted poisonous carbon monoxide into carbon dioxide. The number was also on the two tallies that he always had to take off the lamp-rack with his cap-lamp. The miner would then go to the pit-cage at the top of the shaft. Before entering the cage he would be searched by the banksman, so called because he 'banked' any contraband, such as cigarettes, matches and foil wrappings, which could cause sparks and hence an explosion. The miner would then be allowed into the cage, after he had given the banksman one of his tallies. These were used for identifying who was underground – vital information in the event of an emergency in the mine. When all the men were in the cage the banksman used the signal bell by the pit-cage to indicate to

the winding engineman that the cage was clear to descend, and also to let him know what load he was winding – coal, materials, equipment or men. (In the early days of coal-mining it was also the banksman's job to grab hold of the baskets of coal as they were winched up to the surface.)

Go to any mine now and you should see the codes (rules for going down the mine) on a board on the wall. The speed of descent of the pit-cage in the shaft never exceeded 27 mph (43 kph) to avoid the unpleasant effects of the extra air pressure at the pit bottom. Coal and other materials, such as mining equipment, would be wound at speeds approaching 50 mph (80 kph). As the cage went down the shaft, the air temperature would rise as it got nearer to the bottom. When the cage got to the bottom, the banksman went back to the lamp-room at the pithead and replaced the tallies: this gave an accurate guide as to which miners were still under ground if an accident occurred.

Depending on the individual pit, the cage might descend as much as 3000 feet (915 m) to the bottom of the shaft. The coalface itself might have been well over a mile away from here. No coal was mined too close to the bottom of the shaft, except to make the roadways, as the surface colliery buildings needed to be supported without risk of subsidence or damage to the shaft.

To create the ventilation system, every colliery had to have at least two shafts. One was the upcast shaft. At the top of this were the large fans that drew the stale air out of the mine. This shaft is the one that was usually used for man-riding. The other shaft was the downcast shaft. This one was open at the top, allowing fresh air to be drawn down into the workings. The second shaft, which had rungs up it, also provided an escape route if the other was damaged in an accident. In January 1862, 204 men and boys were killed at New Hartley Colliery, Northumberland, because the pit had only one shaft for pumping and for winding. On the day of the accident the beam of the large pumping engine broke in half and fell down the shaft, taking with it all the pumping rods and the cloths which divided the shaft for ventilation purposes. The huge amount of debris completely blocked the shaft and sealed

the ventilation current. The shift was just about to change under ground, so the maximum number of men and boys were trapped by the accident. Without the ventilation system, gas built up quickly, and all those who were entombed died of suffocation.

One of the most significant developments that ever happened in the history of mining was the change made in the level of lighting available for doing the job. Early miners had only the light of a Davy lamp, the first successful safety lamp, invented in 1815 by Sir Humphry Davy, a noted chemist. The trouble with it was that the light it gave out was poorer than the light from a single candle and, in its earliest forms, it could still ignite firedamp if there were a strong enough current of air because dangerous gas could be blown through the gauze. In its early days, therefore, just after the introduction of the lamp, accidents tended to increase rather than decrease as miners were sent out to work in dangerous areas where, until then, it was thought they would not be able to work. Working in this still poor light also gave rise to the eye complaint that affected many miners – nystagmus – and only with the introduction of the battery cap-lamp did this condition disappear.

As mining engineering progressed throughout the twentieth century, modern machinery was introduced which travelled along the coalface and tore the coal out mechanically, eliminating the need for hand-cutting. But traditionally coal was cut by a hewer, and this continued to be the case in those mines where the seams were not wide enough for machines. The miner would use a small pick and lie on his side to undercut the bottom of the coal seam as far as he could reach. This was called 'holing under', and the coal overlying his cut would be temporarily supported by small sprags or props to prevent it from collapsing on top of him. A hand ratchet drill was then used to bore holes into the top of the coal seam. These were then packed with black powder and ignited with a powder-filled straw. This was very dangerous, as the flame from the explosion might well ignite any firedamp released from the coal. Soft coal could be brought down by hammering wedges into breaks in the coal.

A hewer in the nineteenth century was paid according to the number of full tubs of coal he mined. These were weighed at the surface, and if the manager decided that a tub was fractionally underweight or contained too much dirt, then the hewer would not be paid for that tub. For many years the 'butty' system operated. The hewer was paid according to the amount of coal he cut, and he, in his turn, employed and paid other workers to haul the coal and put up his pit props. Until 1842 a hewer could often increase his family income by employing his wife and children. In some mines just one single 'butty' hired and paid for all the workforce.

A lot of the history of coal-mining and the methods of mining coal are covered in the tour at the National Coal Mining Museum. The equivalent **Scottish Mining Museum** is based at Lady Victoria Colliery at Newtongrange, which is about 10 miles (16 km) south of Edinburgh. Although there is no underground tour here, the surface workings that have been preserved are very impressive.

The entire colliery complex is listed 'A' Grade and is recognized as the best surviving example in Europe of a pre-1914 colliery. In 1991 John R. Hume, principal inspector of historic buildings and monuments to the Scottish Office, said that 'Lady Victoria Colliery is without question the finest surviving late nineteenth-century colliery in Britain and, so far as I have been able to ascertain, the finest in Europe. It is still largely as it was first conceived in the early 1890s, as a major new sinking designed for a long life, and it has lost no important features.'

The giant winding machine engine, a scheduled Ancient Monument, is the largest steam engine to survive in Scotland. It is still in operation, although it is now driven electrically. The tour of the colliery takes you round the once-busy pithead. From here, miners plummeted over 1500 feet (460 m) into the vast underground workings of 'The Lady', and a record-breaking 40 million tonnes of coal rolled off the huge cages during the mine's ninety-year history. The guides for the tour, which also includes a full-scale reconstruction of the underground workings, are all

ex-miners, who bring a wealth of real knowledge and experience to the job as they share some fascinating stories of their working lives in the mine.

It's the engines and all the machinery that had to be used for mining that I'm particularly interested in, though, and there's a pit near me, at what is now **Astley Green Colliery Museum,** that has a winding engine that is definitely worth going to see. The pit itself has been closed for years now, but a lot of it has been left standing, and a group of enthusiasts is trying to restore the pithead machinery. What a task they face. I know how much time it takes for me to try to get my steam engines done, but a whole pit – well, that's really something else.

If you go there, just stand and look at the huge winding engine. It was built for this pit by Foster, Yates & Thorn in 1911, and it's very photographic, making the perfect colliery picture. It's just a pity there aren't any steel cables on it; that makes a difference. The actual shaft here at Astley Green was over 800 yards (730 m) deep, and the engine is a four-cylinder compound engine with a drum that the steel cables go round weighing 100 tonnes. It's over twenty-five years now since the mine was shut, and at one stage it was so sad because there wasn't a complete pane of glass left in the engine room, and the rain just went straight in at one side and out the other. The engine inside there had just turned to red rust.

But now, thanks to the work of all these enthusiasts, it's almost ready to run. They've got a Lancashire boiler for it, and have a grand collection of odds and sods. They've got the wheels going round now, but they don't really do anything. They've also got a steam hammer, which I've had a bit of a play with, and about five or six steam engines, all connected up to a big vertical boiler. It's similar to the one that I've got, but it's a lot bigger. The pipework they've got is so long that everything works hydraulically, with lots of water coming out of pipes all over the place. They've also got a bit of a circular saw, which they use for sawing up pallets to fire the boiler and keep the whole thing going. Then they have a nice display of mining memorabilia in what used to be the office.

They've got a little winding engine made by John Woods, salvaged from another pit, but you can't get near the top of the pit for railings and safety wire and all of that. There is an interesting tale about the shaft here at Astley Green, though, about a miner who was doing some work on the shaft when he fell off the top of the cage. By pure chance he landed on top of the other one that was coming up just as the two cages were nearly level in the middle of the shaft. Lucky, eh? But they reckon he never went down again.

I've got lots of mining books and some lovely pictures of the main winding engine at Astley Green being put up. It's so big they must have built the engine house around it. And I've got a picture of the men who did the job, all standing there, capped and very proud. When they'd done it, those men must have had an unbelievable sense of satisfaction as they watched the engine go round. There were sixteen Lancashire boilers in a row that drove it all, and the poor lads struggling there now have only one package boiler not that much bigger than the one I've got.

There were a lot of pits round here. In fact, a number of people are surprised at how big Manchester Collieries Ltd were. When you talk about coal-mining, people always think of places like Yorkshire and the north-east. But it's the name Rhondda that is, for most people, synonymous with that of coal. Just over a century and a half ago, though, the Rhondda Valleys were almost unknown, and they existed only as a sparsely populated rural wilderness.

It was in the second half of the nineteenth century that a great change took place in the Rhondda with the discovery of coal, and by the end of that century the Rhondda had become one of the most important coal-producing areas in the world. At its peak, the coal industry employed one in every ten people in Wales and a lot more relied on the industry for their livelihood. At one time the Rhondda alone contained fifty-three working collieries in an area only 16 miles (26 km) long. It was the most intensely mined area in the world and probably one of the most densely populated. From a rural population of around 950 in 1851, the population

reached 169,000 by 1924; approximately 20,000 people to the built-up square mile (2.6 sq km).

Although coal had been mined in the Rhondda as early as the seventeenth century for domestic purposes, 1855 is the year that marked the change from a rural scene in the Rhondda to one of heavy industry. The first real industrial pioneer in the area was Walter Coffin, who sank the first pits there. With the discovery of rich and prosperous steam-coal seams in the valley, many more were to follow.

One of the biggest groupings of mines was Lewis Merthyr Consolidated Collieries Ltd, which, at the peak of its productivity, employed around 5000 men and produced almost a million tonnes of coal a year. As many as thirteen seams were once worked at Lewis Merthyr using the advanced long wall method of working with most of the coal being won with pneumatic picks and hand loaded on to conveyors.

Although work was plentiful in the early years, working conditions and pay were poor. The cramped towns and bad sanitation led to ill health, poverty, injury and death. Between 1868 and 1919, shocking statistics show that a miner was killed every six hours and one injured every two minutes. As a result, South Wales was at the forefront of political strife as the miners sought to ensure improved working and living conditions.

Until the 1950s the coal industry in South Wales maintained a steady level of production and employment, but then the number of miners in work started to decline. At Lewis Merthyr, production came to a halt on 14 March 1983. By 1990, not one productive colliery existed in the Rhondda, but the spirit of the past has been preserved at the Lewis Merthyr Colliery, which is now named the **Rhondda Heritage Park**. An audio-visual exhibition tells the story of the people who lived and worked in the Rhondda. A tour includes a cage ride down the shaft to a re-created pit bottom and a journey along the underground roadways of the colliery to a working coalface.

That's about all that's left of our pits now – tourist sites where you can see a bit of our industrial heritage. Even though there's

still coal in the pits, we've lost nearly all of them. I think we've lost them because of the ease of drilling holes in the North Sea and getting that invisible stuff up: gas, I mean. The government must know things we don't know about the abundance of gas, and that's why they shut all the coal-pits. If there were any thought of its running out within our lifetime, they wouldn't have shut the pits. I think it's very interesting; it was coal that made the Industrial Revolution, and it was the Industrial Revolution that made Britain great. We've shut all our coal-mines down and what do we do now? There's a lot of brains around and we are world leaders in computers, so they tell me. But all that's left of coal-mining is the tourist industry part. I think that is sad.

CHAPTER FIVE

RAILWAYS

One of my earliest childhood memories – one that still springs vividly to mind right up to this day – is the sound I'd hear on dirty, windswept nights in winter of the steam-engine whistle and the mainline locomotive. From my bedroom window you could see through a gap in between my Uncle Fred's Temperance Bar and Mr Oliver's, the barber. When I looked out I could see the greeny, yellow glow. I don't know whether it was oil or gas or whether it was the oil and soot that were on the windows of the signal box. In the middle of the night there would be the whistle of the express train going by the end of this backstreet. The fire-hole door opened, and there would be a flash of light shining into the sky. What an unbelievable feeling of power and excitement it must have been to stand on the footplate in the middle of the night on one of them things. In later life I found out what it was like, and it wasn't too bad either.

I was born more or less next to the engine sheds in Bolton. The shed number was 26C, and on a summer evening it was much nicer to do a detour on my way home and go to the engine shed. It was only a matter of a few hundred yards, but you could see all the engines with fires and smoke in them, and coal and dust were everywhere. The engines were black, the floor was black, and when it was winter and they had the lights on, there were wonderful yellow corners where the man who cleaned everything did it with an oily rag that left the corners all yellow. And then there was the smell of the coal; the sulphur always attracted me. It's been gone quite a while now, you know, and they had a fair

old marshalling yard that I could hear all through the night, clang, clang, clang, all the buffers banging together just like you get on films with Alec Guinness and Alastair Sim.

It was that sort of era I was born into: lots of smoke and clanging, and on summer evenings you could go on the most wonderful footbridge that is still standing there on the same spot. It spans no man's land now, with just two tracks underneath it, but in those days there must have been twenty, one by the side of the other. There was a great big signal box that was about 100 feet (30 m) long, and there were three stoves in it and three chimney stacks and you could see the levers through all these little windows. You could almost touch the signal box from the bridge.

All night long and all day long, trains would arrive and depart with wagons, and they detached them and shunted them around, and blokes would unload them and store their contents in a big warehouse. From there everything was loaded on to little three-wheel Scammell lorries, and all day long, from dawn until teatime, they'd be coming and going – big convoys coming out of this marshalling yard to fill every shop in town. There were lines that came into Bolton from the east out of Yorkshire, one from Manchester and the other ones from Preston, Blackburn and the north, which came in from the other side of town. You could stand on the bridge and breathe in the smoke and the fumes, and you could tell when the mainliners were coming even though they were still a long way off. All the right signals went up; then all of a sudden there'd be clouds and steam and the lovely smell of burning coal and then it had gone.

It's a bit sad when I stand on that same bridge now and look down and all I can see is a collection of sheds, bits and bobs of little tinpot businesses. Anyway, when the marshalling yards were there, there used to be a saddletank locomotive with millions of wagons. It was a six-wheel inside-cylinder job, and as kids we used to call it 'Fat Nancy'. It was a wonderful thing that squealed when it went round bends, that wonderful squealing noise that steam locomotives made in them days that you never hear now. People rant and rave about noise pollution today and about anybody

making a noise after seven o'clock at night, but when I was a child you'd have the noise of the shunting engines at the end of the street all night long. A terrific noise it was. After being born into it, you become acclimatized to it and you don't hear it any more.

Everybody's got an uncle who's not really his uncle and, as a little 'un, there was this guy who was called Uncle Dan. He lived quite a way off from where I lived, but my mum was friendly with his wife. He was an engine driver. Whether he'd ever been a top-link driver I don't know. I didn't ask him about things like that; you're not really interested in things like that as a kid. Anyway, if he had been a top driver once, he'd been relegated to driving an Aspinall, a six-wheel inside-cylinder shunting engine with a long, thin, flat tender. I always liked it when it was raining because they had a piece of tarpaulin that fitted over the cab, and it was like being in a tent with a big fire in front of you. It was such a lovely engine, and there has only been one of these preserved. It's at the **East Lancashire Railway** depot at Bury, saved by a man called Fairclough, a civil engineer from Chorley. I think he must have had a soft spot for them.

They were bonny engines. I think when they were originally built, because they didn't have a cab they were very ancient-looking right from the start, with a big tall funnel, a tall steam dome, Ramsbottom safety valves just in front of the cab, and windows that were perfect circles.

My Uncle Dan drove one of these engines every Saturday, it seemed to me. I used to go up every week to my auntie's and climb up the embankment to the railway line and put a couple of shovels on for him. He seemed to be on his own driving this thing. There was never anybody else there to do any lifting or shovelling or anything. But then, with retirement, he just seemed to disappear and the next I heard he had died.

My Uncle Fred had a Temperance Bar – an alternative to the pubs just up the road where people drank heavily. There were three pubs, all within walking distance: the King Bill facing Burnden Park, the Wagon and Horses, which was up the hill and had a very big railway influence, and Rose Hill, which was the top one.

There'd be all these boozers in my Uncle Fred's Temperance Bar at a quarter to twelve every Sunday, having a half of hot bitters to get themselves ready for the pub, and a lot of them were engine drivers of various shapes and sizes. By this time my interest in engines had become quite good – I'd be about fourteen, and I used to ride on the engines up there whenever I could. They had trains for journeys for trainee engine drivers, and they'd let you go on them.

One particular journey I remember going on quite a lot was up to a pipe factory that's completely gone now. Markland & Schocrofts Pipe Works, it was called, and there'd be about ten wagons going to this place and probably a big locomotive pulling them that was always good to go on. I went on a few of those journeys.

My favourite engine driver was one who used to frequent the Wagon and Horses, and he gave me a go. I never knew how he got away with it, though. Those were the days when you went up the yard to the toilet. Anyway, in the yard of the pub there was this iron ladder that came off the wall and up the embankment near the railway bridge. This was a big railway bridge, but the iron ladder was permanently fixed to the wall – it wasn't temporary; it was bedded into the stonework. I think it had been nicked off a signal or something like that because I always remember the two curved bits on it, and the rungs were all shiny, and never went rusty. You'd go to the pub and it was literally full of railwaymen, all with LMS on their hats. It was like a sort of canteen-cum-ale-house, with all these railwaymen any time you went in there. So if you went in during the afternoon there would be engine drivers and anybody to do with the railway.

Old Walter Bamber was a regular customer in there, and I was talking to him one evening and he said, 'Buy a penny platform ticket, I'm on the 9.30 train to Oldham.' The next time I saw him, he'd say, 'Why didn't you come?' Then one night I thought I could be doing with this, so I bought a platform ticket and hung about just like he told me at the end of the platform. I sat down just

where the engine stops, where it's dark as night, when in comes this black thing snorting and blasting out steam. I got up on to the footplate and it was fantastic all the way to Oldham; it was about 15 miles (24 km) away. The thing is, I did that journey loads of times after that , and the funny thing is we always left the wagons at Oldham and came back light engine – backwards. Of course it wouldn't have done for me to turn up at the engine sheds in this engine, so I got dropped off at Burnden Park right on the spot where Arthur Askey made that film *Up for the Cup*, where he pretended to be an engine driver. On a cup day there always used to be five locomotives in a row up there, and the drivers would all be in their cabs nice and warm, all leaning out and watching the match.

The other thing that was interesting was when a mainliner came through that didn't stop at Bolton. It used to come thundering through and we used to put pennies on the lines and watch the wheels dance over them. We'd be on the track putting them on the line minutes before they came. That was an exciting period.

In the end, Bolton and the surrounding districts were among the last places for steam, and a lot of engines that were once mainline good 'uns ended up on the goods job up here. Near the end you used to be able to see engines that were once painted maroon or green with that much muck on them that you couldn't tell what colour they were.

They were wonderful things, steam engines, and it's amazing, isn't it, when it totally relies on a man to keep it going. If it comes to any big hills, tonnes of coal have got to be shovelled because it gobbles it up. Even *Betsy*, my Aveling & Porter steamroller, in its humble way needs a shovel of coal every other lamppost when it comes to a hill, and by the time you get to the top, the coal's gone. It's amazing the power that they woof.

You know, they started to build steam engines to go on the road before they built the first railway engines. William Murdock was a Scottish inventor and technician who had been employed by Boulton & Watt to build steam engines. He was also the first to develop gas lighting on a commercial scale and used it to light

his home and eventually Boulton & Watt's Birmingham factory. Murdock made significant improvements to Watt's steam engine and ran a model steam carriage on the roads of Cornwall in 1784. But he wasn't able to convince Watt or Boulton that a steam carriage was a practical idea.

The 'father of the locomotive engine', Richard Trevithick, was the first engineer to apply steam power to the haulage of loads on a railway. Trevithick was a Cornishman by birth, a native of Redruth. He was a skilful mechanic, but he was just as famous for quickness at figures and for his Herculean strength. He was placed by his father with Watt's assistant, Murdock, who was superintending the erection of pumping engines in Cornwall.

Trevithick was soon entrusted with the erection and management of large pumping engines himself. In 1784 Murdock had built a three-wheeled model of a steam carriage. Trevithick was Murdock's friend and pupil, and he built three other models in 1796 and 1797. Eventually, he went into the business of constructing steam engines. He quickly introduced several improvements and, after preliminary experiments, he completed the first steam carriage to carry passengers at Redruth in 1801. This road locomotive was named the *Puffing Devil*, but unfortunately it burnt out while Trevithick and his friends were celebrating their success at a nearby inn. Trevithick soon entered into partnership with a relative, Andrew Vivian, who was also a skilled mechanic, and together they designed and patented the steam carriage just one year later in 1802.

The first carriage of full size was built by Trevithick and Vivian at Camborne, in 1803, and after trials it was taken to London. Here it was exhibited to the public. En route, it was driven under its own steam to Plymouth, which was 90 miles (145 km) from Camborne, and then it was shipped by water. This was the first successful high-pressure engine constructed on the principle of moving a piston by steam against the pressure of the atmosphere. The piston was not only raised but also depressed by the steam.

They had a reasonable amount of success running this kind of carriage on common roads, but it soon became obvious that the

roads in England were too rough and uneven for the successful use of such machines, and Trevithick abandoned his steam carriage as a practical failure. It wasn't long before he dismantled the machine, sold the engine and carriage separately, and returned to Cornwall, where he began work on a railway locomotive to run on the tram-roads that by then were in general use in England.

In 1804 Trevithick won a £500 bet for building the first locomotive in the world, his 0-4-0 Pen-y-Darran, which ran at the Merthyr Tydfil Railway in South Wales. The 0-4-0 refers to the wheel arrangement. The first number represents how many wheels there are on the front; the second, how many wheels in the middle; the third, how many at the back. This engine had a cylindrical-flue boiler and a single steam cylinder. It was not entirely successful, but may be considered as the first attempt to adapt the locomotive to run on a railway.

In 1808 Trevithick built a railway in London on what was known later as Torrington Square. Here he put to work a steam carriage, giving novelty rides on an engine that he called *Catch-Me-Who-Can*. It was a very plain and simple machine. The steam cylinder was set vertically in the after-end of the boiler, and the cross-head was connected to two rods, one on either side, driving the back pair of wheels. The exhaust steam entered the chimney, aiding the draught. This engine, weighing about 10 tonnes, travelled at 12 to 15 mph (19 to 24 kph) on a circular track. Eventually the engine was thrown from the track because of a break in the rail and, as all of Trevithick's funds had been spent, it was never replaced.

A few years later, in 1816, Trevithick left England for Peru. When he returned, after making and losing a fortune all over South America, he found that steam transport had become a thriving concern. Trevithick, though, had been overtaken by events, and died in extreme poverty in April 1833 at the age of sixty-two.

It was the quest for coal to fuel the Industrial Revolution that played a central role in the development of the railways. Originally, packhorses pulled heavy wagons of coal across open land, prompting landowners to increase rents payable to them

by the collieries. To avoid paying the increased charges, colliery owners responded by building special wagonways to move the coal from the mines to the nearest navigable rivers.

These wagonways of wooden rails and sleepers were the forerunners of the railways. The rails had the effect of reducing friction, and this enabled larger loads to be transported cheaply and quickly. Some of the earliest of these wagonways were built to transport coal from the mines of north-east England to the sea. In 1609 the first horsedrawn wagonway in the north-east is said to have carried coal from the mines near Bedlington in Northumberland to the harbour at Blyth. As the North Eastern Coalfield opened up, wagonways criss-crossed the region, connecting the mines to the rivers.

But the first railway in the world to be established by Act of Parliament was the **Middleton Railway** in Leeds. Coal-working in the Middleton area dated back to at least 1202, when William Grammary, Lord of Middleton, was described as a 'coal owner'. Wagonways were already a familiar sight in the Shropshire and Tyneside coalfields, and as mining activities expanded at Middleton, they were an obvious way of cutting transport costs and, therefore, the price of the coal.

The 1758 Middleton Railway is the direct descendant of a wagonway that was constructed between Middleton and Casson Close, near Leeds Bridge, following authorization by the first railway legislation and Act of Parliament in 1758. As well as being the first actual railway, it also had the first commercially successful revenue-earning steam locomotives, which entered service there in 1812.

John Blenkinsop came to the Middleton collieries from the north-east, and these first locomotives to run on the Middleton Railway were developed by Blenkinsop with the Leeds engineer Matthew Murray. In 1811 Blenkinsop took out a patent for a rack-and-pinion form of propulsion for his steam locomotives. The idea was to have a cogged wheel, attached to the side of the engine, that would pull it along by engaging in teeth cast into the side of the rails. The boiler of his engine was supported by

a four-wheel carriage, which was independent of the working parts of the engine. In 1812 this engine began running on the railway from the Middleton collieries to the centre of Leeds, a distance of about 3¼ miles (5.2 km). For a number of years it was an object of curiosity, visited by crowds of people from all parts. Six or seven locomotives in all were constructed to this design, and they pulled thirty fully loaded coal wagons at a speed of 3¼ miles (5.2 kph) per hour. They were in use for many years, and, although other railways that came later have become more famous, these engines can be considered as the first instance of the employment of locomotive power on a railway line for commercial purposes.

The Middleton Railway gave a great impetus to the growth of Leeds and of the city's industries. It gave Leeds a good supply of cheap coal, which was to benefit the developing use of steam engines in textile mills and other factories in the city. Its successful pioneering use of steam locomotives proved to the world that they were commercially viable, and led to the development of an extensive Leeds locomotive building industry.

In more recent times the Middleton Railway became the first standard-gauge railway to be run by volunteer enthusiasts when it was taken over by a preservation society in 1960. The Middleton Railway Trust has, over the years since then, acquired an extensive collection of industrial locomotives and rolling stock in keeping with the railway's long history of industrial service. The trust currently operates passenger services over approximately 1 mile (1.6 km) of the original route of the line between its headquarters at Moor Road, Hunslet, and Park Halt, on the outskirts of Middleton Park.

The Middleton Railway can claim to be the first regularly operated steam railway, but it's in Northumbria that we find the 'great men' of the railways, in particular at Wylam, where the **Wylam Railway Museum** shows the importance of the village in the history of the railways. As early as 1813, William Hedley, the manager of Wylam Colliery, designed and built two engines, *Puffing Billy* and *Wylam Dilly*, which were used to haul coal from Wylam to Lemington Staiths.

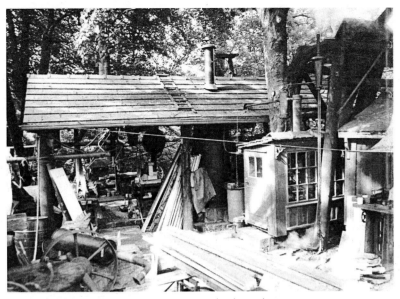

The engine house and boiler house in my back garden.

Raising steam in the garden. My fascination with all kinds of machinery began at an early age and has dominated my life ever since.

(*Right*) Passing on the Dibnah passion to another generation – with my youngest son, Roger, in the garden in front of my pit winding gear.

(*Below*) Saxtead Green Post Mill, near Framlingham, Suffolk.

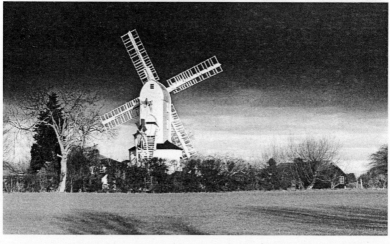

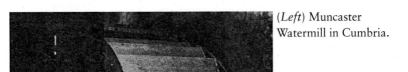

(*Left*) Muncaster Watermill in Cumbria.

(*Right*) Restoring the water wheel at Coldharbour Mill in Devon.

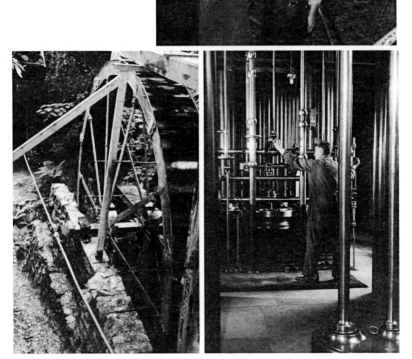

(*Above, left*) The 18-feet (6-m) working water wheel at Wheal Martyn China Clay Heritage Centre, near St Austell in Cornwall.

(*Above, right*) An engine driver operating the valve gear of the magnificent Grand Junction 100-inch Cornish beam engine in 1946. You can see it in London's Kew Bridge Steam Museum. Its sister engine, the Grand Junction 90-inch, is in steam regularly.

(*Right*) New Lanark World Heritage Village on the banks of the Clyde, the site of what was once the most famous cotton-spinning community in the country. In this fine memorial to the pioneer social work of Robert Owen, you can see working textile machinery, restored mill workers' homes and his great educational innovation – the New Institution for the Formation of Character.

(*Below*) The fast flowing river Clyde provided power to drive New Lanark's machinery.

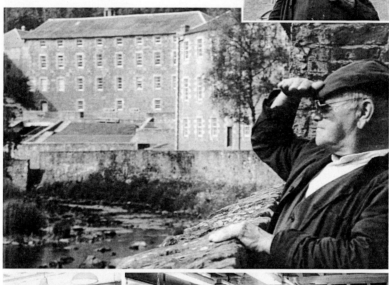

(*Above, left*) A power loom at Quarry Bank Mill, Styal, near Manchester.

(*Above, right*) Coldharbour Mill, Uffculme, Devon. This picture shows workers in the mill, which closed in the early 1980s.

(*Above*) Fulling stocks and water wheel at Helmshore Textile Museum, Lancs.

(*Left*) The Weaving Shed at Queen Street Mill, Burnley.

(*Right*) The tilt hammer in the iron works at Blists Hill Victorian Town, Ironbridge. In the late eighteenth century, the town became a mecca for engineers wanting to learn about the iron smelting process, which was to change the face of industry worldwide.

(*Below*) The iron works at Blists Hill Victorian Town, Ironbridge.

(*Bottom*) Workers in the foundry at Blists Hill.

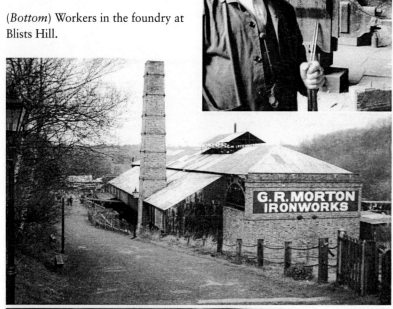

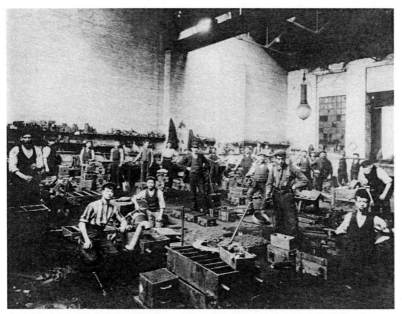

An old photograph from The Long Shop Museum, in Leiston, Suffolk, shows the workers in the foundry of Richard Garrett and Sons Limited.

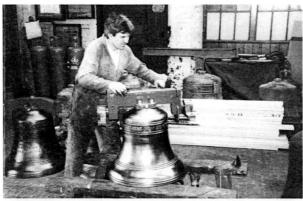

You can see the techniques of bell making at the Bellfoundry Museum, Loughborough.

Learning about their water-powered tilt hammer from a friend in the forge of the Finch Foundry, Sticklepath, Devon.

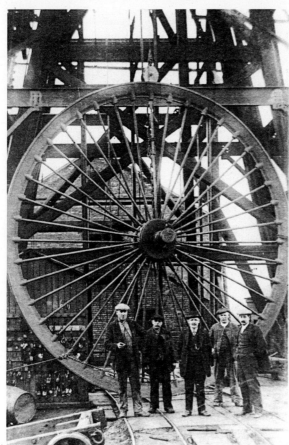

(*Left*) A proud moment for the pit head builders when they sank the shaft at Astley Green pit in 1916.

(*Below*) Climbing the winding gear at Astley Green – hard work but I think it's still easier than getting to the top of a chimney!

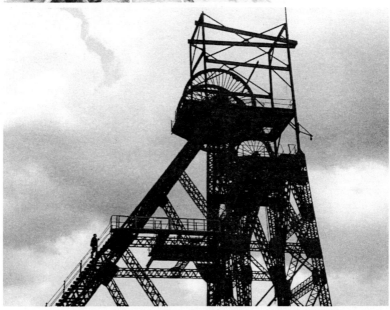

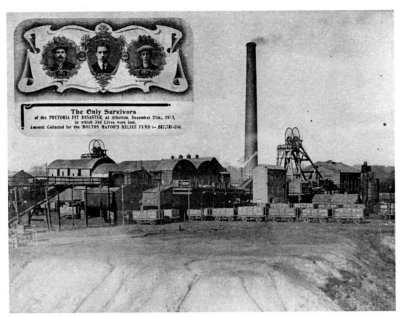

The Only Survivors
of the PRETORIA PIT DISASTER, at Atherton, December 21st, 1910,
in which 344 Lives were lost.
Amount Collected for the BOLTON MAYOR'S RELIEF FUND :- £47,731-2-0.

The Pretoria pit, scene of England's third worst mining disaster. In 1910, just before Christmas, 344 men lost their lives. Despite the scale of the tragedy, the colliery remained open until the late 1930s. Inset: A memorial postcard depicting the three survivors of the explosion.

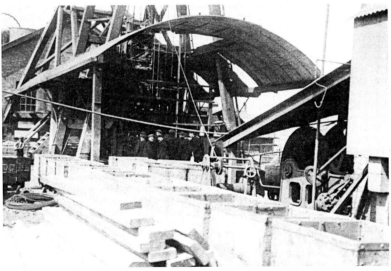

Despite its longevity (1748-1928), this is one of the only photographs of the Wet Earth Colliery, Clifton, Greater Manchester, when it was working.

The Electric Winding Engine, Geevor Tin Mine, Pendeen, Penzance, Cornwall.

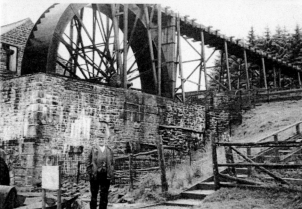

The big water wheel at Killhope Lead Mining Centre, North Pennines.

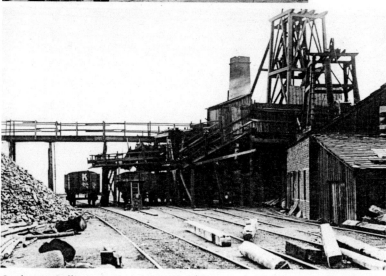

Caphouse Colliery, Overton, near Wakefield is now the home of the National Coal Mining Museum for England.

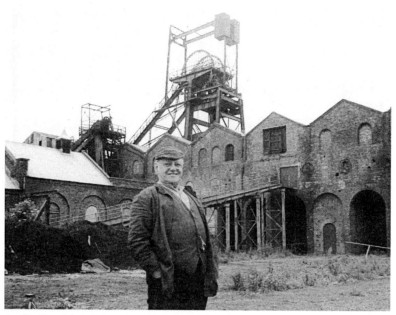

At the Scottish Mining Museum, the Lady Victoria Colliery, Newtongrange, Edinburgh.

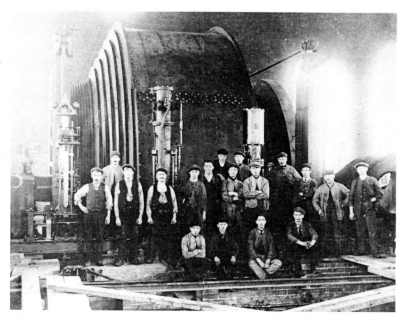

All capped and very proud, the men who put in Astley Colliery's great winding engine in 1911.

The smell of the coal and the sulphur bringing back old memories – all aboard on the Llangollen Railway, Denbighshire.

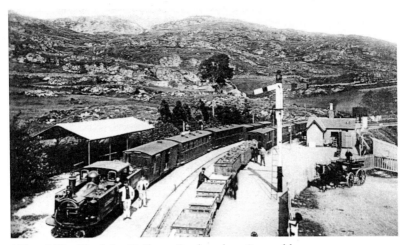

(*Above*) The Ffestiniog Railway, Porthmadog, Gwynedd.

(*Below*) Enjoying my visit over a century later.

(*Left*) Trevithick's engine – you can see a working replica at Blists Hill Victorian Town, Ironbridge, which is where the engine was built.

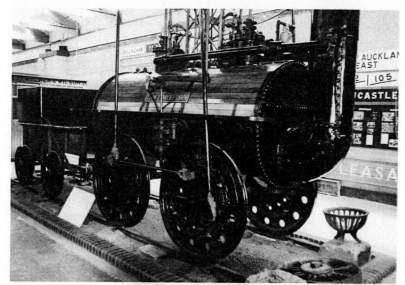

(*Above*) You can see Stephenson's *Locomotion* at Darlington Railway Centre and Museum.

(*Right*) An Ivatt Class 2 engine runs on the East Lancashire Railway from Bury to Rawtenstall.

(*Bottom*) On board the *Maid of the Loch* which was being restored on Loch Lomond during my visit there.

(*Left*) On the SS *Great Britain*, which is now back in Bristol where she was built. The top hat is in honour of my all-time hero, Isambard Kingdom Brunel.

(*Right*) In the engine room of the *Waverly* while cruising the Clyde.

(*Below*) At the Windermere Steamboat Museum alongside the cargo boat *Raven* and Schneider's steam yacht *Esperance*.

The paint shop of the famous engineering works of Richard Garrett and Sons of Leiston.

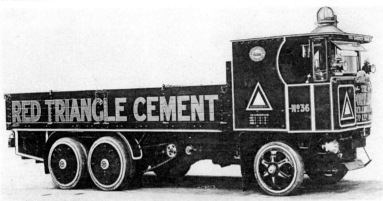

The Garrett Rigid Six-wheel Undertype Steam Wagon.

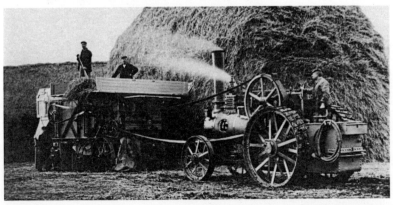

A Garrett threshing machine and tractor. There's a great collection of Garrett's machines at the Long Shop Museum, Leiston.

The colliery owner who employed Hedley had applied to Trevithick for a locomotive engine to haul wagons of coal at the Wylain Colliery, but Trevithick was either unable or not inclined to build him one. So in October 1812 Hedley was authorized to attempt the construction of an engine. It was at about this time that Blenkinsop was trying the toothed rail.

Hedley now started to build an engine with smooth wheels, patenting his design on 13 March 1813, a month after he had put his machine to work. The locomotive had a cast-iron boiler and a single steam cylinder 6 inches (15 cm) in diameter, with a small flywheel. The boiler of this engine was too small, so he had to build a bigger one with a return-flue boiler made of wrought iron. This pulled eight loaded coal-wagons at a speed of 5 mph (8 kph) at first. A little later Hedley got the speed up to 10 mph (16 kph). Hedley's engines continued in use at Wylam Colliery for many years, but in the very early days there was a lot of trial and error.

When Hedley's first engine was ready, the go-ahead was given but the engine wouldn't move an inch. When it was finally set in motion, it blew to pieces, and the workmen and spectators, with Blackett, the mine owner, at their head, scattered and fled in every direction. The machine, or what was left of it, was taken off the railway, and afterwards part of it was used as a pump at one of the mines. Hedley's second engine wasn't much more successful. It crept along at a snail's pace, sometimes taking six hours to cover the 5 miles (8 km) to the landing-place. It was continually coming off the track and horses were needed to put it back on. The engine often broke down; its pumps, plugs and cranks would often not be the right ones; and the horses would again be needed, this time to take it back to the workshop. In fact, it eventually became so unreliable that the horses were frequently sent out to follow the engines in readiness for its eventual breakdown. At last it was abandoned. But Hedley and Blackett persevered, and, despite all the early problems, it was their efforts that paved the way for the future labours of George Stephenson.

George Stephenson is credited as being the 'father of the railways'. He was already active as an engine-builder at about the time that Blenkinsop and Hedley started to build their engines. Stephenson built his first engine, *Blücher*, in 1814 while he was working at Killingworth Colliery. At this time he was already being acclaimed as a brilliant and ambitious engineer. Stephenson's great talent, though, was that he combined all the advantages of great natural inventive talent with an excellent mechanical training and an entrepreneurial spirit.

Stephenson was born on 9 June 1781 in Wylam on the north bank of the River Tyne. While he was still a child he showed that he had great mechanical talent and an unusual love of study. When employed as a herd-boy, he amused himself making model engines in clay, and as he grew older, he never lost an opportunity to learn about the construction and management of machinery.

The first work he did in the mines was as what is known as a picker. His duty was to clean the coal of stone, slate and other impurities. His starting wages were sixpence a day. At fifteen years of age he was promoted to the position of fireman. His attention to duty and his intelligence soon brought him rapid promotion, until, when only seventeen years old, he was placed in charge of the engine at Water Row Pit, with his father serving under him as fireman.

In 1812 Stephenson was made engine-wright of the Killingworth High Pit. By this time he was earning £100 a year, and it was made his duty to supervise the machinery of a group of collieries. While he was here he began a systematic course of self-improvement, and was soon recognized as an inventor of some note. His cottage was like a curiosity shop, filled with models of engines, machines of various kinds and novel pieces of apparatus.

Hearing of the experiments of Blackett and Hedley at Wylam, he went over to their colliery to conduct a study of their engine. He also went to Leeds to see the Blenkinsop engine at its trials, when it pulled a load of 70 tonnes at a speed of 3 mph (4.8 kph). When he was there he expressed his opinion in the characteristic

remark, 'I think I could make a better engine than that to go upon legs.' Very soon he was able to make an attempt.

Having seen the Blenkinsop and Hedley engines, Stephenson was determined to build his own, so he spoke with Lord Ravensworth, the mine owner, of the advantages to be gained from using a travelling engine. Ravensworth was convinced; he advanced Stephenson the money that he needed, and work started on his first locomotive engine in his workshops at West Moor. This first engine, *Blücher*, proved to be defective, and the cost of using it was found to be about as great as that of using horse power. Stephenson was determined to build another engine, this time to a different plan, and patented his new design in February 1815. It proved a very much more efficient machine than *Blücher*.

In 1823 Stephenson was made engineer of the Stockton & Darlington Railway, which had been planned to transport coal from the Durham coalfields to the sea. Edward Pease, a Quaker industrialist from Darlington, was one of Stephenson's main backers, and he was a big advocate of the Killingworth engines and their work, and of the immense advantage to be gained from using them on the new line. He was so keen on getting steam locomotives to provide the power for the line that he not only supported Stephenson's argument, but advanced £1000 to help him begin the business of locomotive engine construction at Newcastle. The building of this workshop, which went on to become one of the most famous establishments in the history of railways, was begun in 1824.

On 27 September 1825 a train with a strange-looking engine pulling thirty-four wagons filled with passengers, flour and coal behind steamed into history. The locomotive ran on four wheels, with a four-wheel tender to carry the coal and water. The driver had to balance precariously on a platform on the left-hand side of the engine, where he could control the supply of steam to the cylinders and operate the primitive valve gear. The fireman rode on the front of the tender, although when he was not stoking the fire he could ride on the platform on the opposite side of the engine to

the driver. The engine, like many of the early locomotives, was not fitted with any brakes. On the opening day the driver was George Stephenson and as firemen he had two of his brothers.

On the way to Darlington from the start of the line at Shildon the train frequently reached a speed of 12 mph (19 kph), and on one occasion it got up to 15 mph (24 kph). People on horseback and on foot tried to race the train as it passed triumphantly along. Spectators came out in their thousands to line the track, waving and cheering as this strange contraption went past. When they got to Darlington it seemed that the whole town had turned out to see the train arrive, and then steam off towards Stockton, to arrive there in just over three hours.

After the events of the opening day the railway had to settle down to work to earn money and to do what it had been planned to do. A second locomotive was delivered on 1 November 1825. It was built by Stephenson's son's company, Robert Stephenson & Co., and two more followed in 1826. The first two locomotives cost £500 each, and the second two cost £600 each. Although, inevitably, there was some trouble with these early engines, the steam engine soon proved its superiority over horse-drawn transport, particularly because of the much greater loads it could handle. As a result, the company persevered with steam locomotives and, largely thanks to Timothy Hackworth, their faith in steam was eventually realized.

Hackworth had been appointed locomotive foreman on the Stockton & Darlington Railway in May 1825 at the age of thirty eight. He started on a salary of £150 a year plus a free house and coal, and it was on his shoulders that the task of keeping the engines in running order fell. To do this he had only very primitive facilities and just a few staff. He established workshops at the terminus of the line in Shildon and gradually built them up to such a high standard that new engines could be constructed and major repairs undertaken there.

In 1833 the Stockton & Darlington Railway Company decided that the locomotives should be looked after by contractors, and Hackworth agreed with others to take on the work. At the same time he was able to establish his own locomotive building works

at Shildon. He lived nearby in a house that still exists today. Soho Cottage was Timothy Hackworth's home from 1831 to 1850. It is now open as the **Timothy Hackworth Victorian and Railway Museum**, with part of it furnished as it would have been when Hackworth and his family lived there and part of it devoted to the story of his involvement with the Stockton & Darlington Railway. Next to the house is the engine shed where he had his locomotive works. Today this houses a full-scale working replica of *Sans Pareil*, the locomotive that he built to run in the Rainhill Trials for the Liverpool & Manchester Railway.

Hackworth gave up the locomotive haulage contract in 1840 to devote all his time to his own engine-building operation. He built engines not only for the Stockton & Darlington Railway but for other British companies and railways in Russia and Nova Scotia. He died in 1850 at the age of sixty-three, and in 1855 his premises were taken over by the Stockton & Darlington Railway and used as an extension to the main Shildon works.

Dating from 1842, North Road Station in Darlington is on the original route of the Stockton & Darlington Railway. The major part of it now houses **Darlington Railway Centre**. Here you can see Stephenson's *Locomotion*, which hauled that first train when the line was opened in 1825. The former Stockton & Darlington Railway goods shed adjacent to North Road Station is now used as a locomotive restoration workshop by the Darlington Railway Preservation Society. Also within the site is the former Hopetown Carriageworks of the Stockton & Darlington Railway, which is now being used by the A1 Steam Locomotive Trust to construct a new Pacific locomotive, *Tornado*. (Pacific was the name given to locos with a 4-6-2 wheel arrangement.)

The A1s were designed by Arthur H. Peppercorn, the last chief mechanical engineer of the London and North Eastern Railway (LNER). They were the last in a line of famous express passenger steam locomotives for the east-coast main line. In the years since the last Peppercorn A1, *60145 Saint Mungo*, was scrapped in 1966, the railway preservation movement has manufactured

most of the components needed to build a new mainline steam locomotive as part of different restoration projects. It was logical, therefore, that the next step should be to build a complete mainline steam locomotive from scratch. The idea was that building new locomotives like this would safeguard the future of the nostalgic steam railtours business and provide the motive power for the country's preserved railways as the existing locomotives became too fragile to be used on a regular basis. It's very nice to go there and see the old locomotive building skills being kept alive.

Back in the 1820s, though, the founding fathers of the Stockton & Darlington Railway couldn't have foreseen that within fifteen years of the opening of their railway, the whole country would be feverishly building lines, or that within forty years rail transport would have become the principal means of moving passengers and goods. The line that really set the ball rolling was the Liverpool & Manchester Railway. A railway between these two developing cities had been projected at about the time that work on the Stockton & Darlington had started, and the Liverpool & Manchester bill had been carried through Parliament. Stephenson was involved from the outset, and, not surprisingly, he urged the use of locomotives rather than horses.

The line was built with Stephenson as chief constructing engineer. As it approached completion, the company needed to settle the long put-off question of what sort of motive power was going to be used on the line. Some of the directors and their advisers were keen on the use of horses; some thought stationary hauling-engines were preferable; the remainder were undecided. Stephenson was almost alone in backing the locomotive, but after long debates he persuaded the board to give the travelling engine a chance and a competition was set up with a prize of £500 for the best locomotive engine.

This reward was printed, published and circulated throughout the kingdom, and a considerable number of engines were constructed to compete at the trial. Only four engines, however, were finally entered for the trial, which took place on a stretch of the new line at Rainhill. The entries included Timothy Hackworth's

Sans Pareil, but it was Stephenson's *Rocket* that outperformed them all. He'd come up with a revolutionary new design that increased the power and speed of the engine relative to its weight. *Rocket* ran at speeds of between 25 and 30 mph (40 and 48 kph), drawing a single carriage carrying thirty passengers. This success settled completely the whole question, and the Liverpool & Manchester Railway was at once equipped with the locomotive engines that Stephenson had favoured.

The new features that Stephenson had put into his engine were to become standard for all steam locomotives. In the boiler, hot gases from the burning coal were drawn through twenty-five tubes that were surrounded by water. This helped to boil the water faster, which in turn made faster running possible. His biggest innovation, though, was direct drive from the cylinders and pistons to the wheels, which eliminated the need for the complicated gears and levers of every locomotive that had been designed up to that point. Until Stephenson came along with *Rocket*, everything else had been a beam engine on wheels. *Rocket* was the first steam locomotive as we know them, and it paved the way for every other steam loco to be constructed, right up to *Tornado*.

For some years after this, his first great triumph, George Stephenson gave his whole time to the building of railways and improvements to the design of his engine. He was assisted by his son Robert, who eventually took over the business from him. In fact, *Rocket* itself had been built at the works of Robert Stephenson & Co. at Newcastle upon Tyne. After the death of his father, Robert continued with the business of building locomotives and constructing railways. The work of locomotive engine-building was done at Newcastle, and for many years those works were the principal engine-building establishment of the world.

Since much of the early development of the railway took place in Tyneside, the gauge of local coal-wagons, 4 feet 8½ inches (1.45 m) – was adopted in 1824 for the Stockton & Darlington Railway, and most other early railways followed suit. The main exception was the Great Western Railway (GWR) of Isambard Kingdom Brunel.

As well as having one of the most unusual names of all time, Brunel is famous for his technological achievements as an engineer. He was a man who had very wide interests, but what made him outstanding was his all-round ability at everything he turned his hand to. For his Great Western Railway, for example, he designed the track layout, the track itself, the rolling stock, the tunnels, the bridges, and the ship – the *Great Western* – to carry passengers to the United States from the end of the line at Bristol. He even designed the lampposts for the stations, was a director of the station hotel at Paddington, and when the going got tough was not above getting down to doing some of the actual digging on the line himself. He was truly a great all-round engineer.

The range of his work made Brunel the most famous and influential of all the great engineers that the nineteenth century produced. His projects were astonishing for their scale, their versatility and their daring. The son of French-born engineer Sir Marc Isambard Brunel, he was born in Portsmouth in 1806 and educated in both England and France. In 1825 his father was engaged to construct the Rotherhithe Tunnel under the Thames by means of a new tunnelling shield that he had invented. Dad had to go off to Canada to work on a project there, so he left Isambard in charge of the tunnelling project even though he was only twenty-one. It was the first time anybody had ever tried to tunnel under such a wide expanse of water, and the whole project was beset with problems. The construction men were working only about 8 feet (2.4 m) below the bed of the river, which meant they had trouble with leaks, at a time when the Thames was like an open sewer. A lot of the time they were working in silt, and on two occasions the workings flooded. Many men were washed away, and doubtless many others suffered from diseases contracted from the sewage.

When Brunel finally completed the job, he held a candlelit dinner in the tunnel. A couple of years ago somebody from the Brunel Society rang me up one evening and said they were going to put a great big table down into the tunnel with all the candelabra on and have a dinner down there to re-enact the event. Can you imagine the modern Brunel fanatics down there dressed up with

all the gear and big tall hats? But somebody in authority said they couldn't do it because it was too dangerous so it never came off.

Brunel was injured the second time the tunnel flooded, and during his recuperation filled his time by submitting some designs for a competition to build a bridge across the Avon Gorge at Bristol. His graceful suspension design, with a record-breaking main span of 630 feet (192 m), eventually won the competition, and work began on the piers. Lack of money, however, meant that the Clifton Suspension Bridge was not finally completed until 1864, after Brunel's death, with chains taken from Hungerford Bridge over the Thames – another of Brunel's designs.

The turning point of Brunel's career came in 1833 when he was appointed engineer to the new railway to be built between London and Bristol. The route that he surveyed for the Great Western Railway was exceptionally level, and, ignoring the gauge of 4 feet 8½ inches (1.45 m) which had become standard by then, he decided that the best and most efficient gauge was 7 feet ¼ inch (2.14 m). Although track at this broad gauge used more land, the trains designed to run on it gave a faster, smoother and more fuel-efficient ride. By 1838 the line was open from London to Maidenhead, where the railway crossed the Thames over the longest and flattest brick arches ever built – a record that still stands.

Great stations were built at each end of the line – Paddington in London and Temple Meads in Bristol. These two stations set the style for the high-vaulted glass canopies that became the standard for nineteenth-century railway architecture. Perhaps the most difficult single construction of the line was the tunnel at Box in Somerset. With a length of about 2 miles (3 km), it was by far the longest tunnel of any kind to have been built at that time, and for two and a half years its construction consumed a tonne of gunpowder a week. It was completely straight and, in a final touch of virtuosity, it was designed so that the sun shone through it from end to end at dawn on Brunel's birthday, 9 April.

By June 1841 the whole line was open, and Brunel began to plan numerous branches to towns and cities near its route, such

as Oxford and Cheltenham, as well as an extension to Exeter that would span the River Tamar at Saltash. Brunel's Royal Albert Suspension Bridge was built at Saltash between 1854 and 1857. The soundness of his engineering means that even today, although the broad gauge has long disappeared, trains speed over a virtually unchanged railway at 125 mph (200 kph).

Didcot lies on the original mainline of the Great Western Railway designed by Brunel and is today home to the Great Western Society. The society moved into the railway sheds there with three locomotives and a number of carriages in 1967, and since then the area has been transformed into **Didcot Railway Centre**. The aim has been to keep as much as possible of the original engine shed in its original condition while adapting it to its present role as a place for people to see some of the great locomotives of the Great Western Railway. The exhibits and facilities, such as the branch line with its stations and signal boxes, the broad-gauge demonstration, museum, locomotive and carriage works have been lovingly developed by the society and its members to keep alive for future generations just a small part of the Great Western Railway.

Unless you've had a ride on a steam locomotive travelling at speed, you have never lived. It's a very exhilarating business. I've had a few goes on various occasions and actually done a bit of driving myself. It's a great feeling – the whole thing develops a rocking motion when it's working, and you've got to have your sea legs to stay vertical. One of the most exciting things I ever did was one time when I went to do a talk and part of the deal was a ride on the engine. It was a Great Western engine and it was fairly old, from about the 1890s I think. The tender on it was gi-normous but very low. We were going backwards, but you could see straight across the tender. They gave it to me to drive, and we were really belting along. I had to shout to them: 'I've never been on here before. If we're getting too fast, you'll have to give me a nod.' We were shoving the tender, of course, and we went down this hill and through a tunnel and it was fantastic. It was one of the most exciting things I've ever done.

CHAPTER SIX

STEAM SHIPS
AND STEAM ENGINES

Brunel is my hero. If it was anything to do with engineering, he'd have a go at it. While he was building the Great Western he began to develop the idea of linking the railway with a series of ships in a combined land and sea transport system. His dream was to link a service to New York with the Great Western Railway at Bristol so that you could buy a through ticket from Paddington to New York.

At the start of Victoria's reign the paddle steamer had proved its viability on shorter coastal routes, but the lucrative transatlantic trade was dominated by American sailing packets. Brunel decided that his ships were going to be powered by steam. Until that time it had been thought that, although small steam ships could be used on coastal routes, they were not practical for ocean crossings because they would need so much fuel that there would be no room left on board for any passengers or cargo. Brunel was a bit of a mathematician, though, and he worked out that while a ship's carrying capacity increases by the cube of its dimensions, its resistance, and hence the force needed to propel it, increases by the square of its dimensions. As a result of this, he calculated, ships would need less energy per tonne to propel them the larger they were.

In 1836, the year before Victoria came to the throne, Brunel persuaded the directors of the Great Western Railway to form the Great Western Steamship Company and began work on the

Great Western, the first of three ships he built. A 1320-tonne paddle steamer, the *Great Western* was launched in 1837, and when it sailed to New York it proved that a steam ship could cross the Atlantic without running out of coal. For speed, reliability and comfort the steamer was a big improvement on the packets, but the ship had some serious weaknesses. Her sails had to be used in conjunction with her engines, and paddles did not perform well under ocean conditions. But the biggest drawback was the fact that the ship was built of wood, and it was costly to build wooden ships strong enough to withstand the stress from the engines.

Brunel knew that the *Great Western* represented the limit of what was possible with wood, but the size of iron ships was restricted by problems in using magnetic compasses. Fortunately, at this time a system of correcting magnets was devised by the Astronomer Royal, Professor Sir George Biddell Airy, and his new system was installed on *Rainbow*, an iron paddle steamer that visited Bristol in 1838. Two of Brunel's colleagues, Captain Christopher Claxton and William Patterson, reported favourably on the new system after joining *Rainbow* on a voyage to Antwerp. This made Brunel's mind up, and he decided to build a new ship of iron. She would incorporate the largest paddle wheel ever built. The Great Western Dock at Bristol was extended, warehouses and workshops were built, machinery was installed and construction got under way.

Ten months after the keel was laid on 1 July 1839, another experimental ship, the *Archimedes*, arrived in Bristol and demonstrated her revolutionary propeller, designed by Francis Pettit Smith. Brunel chartered her for six months, and this convinced him that the propeller system represented a huge advance on the paddle wheel. The engine that had been originally planned couldn't be adapted, so a design based on the Triangle engine patented by his father, Sir Marc Brunel, was substituted. The ship was named the *Great Britain*, and Brunel, Claxton and the consulting engineer, Thomas Guppy, formed a building committee. The launch of the *Great Britain*,

or rather the first flooding of the dry dock, took place on 19 July 1843 in the presence of Prince Albert, who travelled down from London by train.

The *Great Britain*, having been hauled into the harbour by a steam tug, had to be hauled back into her dock for the installation of her engines and was not ready for sea trials until late in the following year. Then, because the locks of the Cumberland Basin had not been widened as the Bristol Dock Company had agreed, on 10 December 1845 she stuck fast three-quarters of the way through the lock. Brunel worked all day, 11 December, altering the masonry so that she could be hauled back and released in time to catch the night tide. It was this difficulty in getting the ship out of port that signalled the decline of Bristol as a great maritime centre and the end of Brunel's dream of the Paddington–New York link. The *Great Western* had already been transferred to the more convenient port of Liverpool in 1843, and it was decided to base the *Great Britain* there as well. The ship still had to overcome people's fears about her safety so, on 26 July, the *Great Britain* sailed for New York with just fifty passengers and 600 tonnes of cargo. She crossed the Atlantic in just under fifteen days at an average speed of 9.4 knots (17.4 kph) and received a huge welcome as she steamed up the Hudson and into the port of New York.

The SS *Great Britain* was one of the outstanding engineering achievements of the Victorian age: the first sizeable ship to be constructed from iron and driven by a propeller. In the second phase of her long career, the ship played an important role in building the nation of Australia. But she ended her working life as a store ship in the Falklands before being beached and abandoned there. (She was towed back to Bristol subsequently for restoration.)

In 1851 Brunel began designs for a ship four times the size of the *Great Britain*. His plans were for a ship that would be capable of taking a year's exports to India in one trip and of returning without refuelling. This was the *Great Eastern*, which Brunel designed with a double iron hull split into twenty-two compartments. This great monster of the oceans was to have

three sources of propulsion: two paddle wheels each 58 feet (17.6 m) across and a single screw propeller that was 24 feet (7.3 m) across, which would be driven by a separate engine. To save fuel when possible, the ship was built with six masts, giving it 58,500 square feet (5435 sq m) of sail. Nothing bigger was constructed for over forty years. The huge and costly effort of launching the *Great Eastern* sideways from the Isle of Dogs into the Thames in January 1858 and preparing it for its first sea trials the following September proved to be too much for Brunel. The strain he was under caused him to suffer a stroke, from which he died on 15 September 1859.

I've read the whole saga of the building of the *Great Eastern* and the problems it caused Brunel in some old copies of the magazine *The Engineer* that I've got upstairs at home. I got them from my old mate Alan Davies at the Lancashire Mining Museum, and when I first got them I couldn't believe it. I used to lie there in bed with my lamp on and a pint of Guinness and read them until I fell unconscious. I liked the adverts especially; you'd see things like iron headgears, steel coal tubs, steam engines, locomotives and traction engines all being advertised. Then they had all the inventions in them, who invented what, the patents and all that, the latest in the iron and steel and other industries, share prices and which company was doing well – all really interesting stuff. When I went on *Desert Island Discs* with Sue Lawley and had to choose my favourite set of books to take with me, I chose these volumes thinking it was a publication of a million years ago. But after the programme had been on I got a phone call from the editor of *The Engineer*, which, as it turned out, was still running today, and he said, 'We will send you collections of the highlights of *The Engineer* in a bound volume,' which was lovely. There was some pretty interesting reading in there; things like the latest armour-plated battleship and the latest armoured man-of-war, and the plating being 8 inches (20 cm) thick and the guns and armoury on it and all the new inventions that came up, and the mad inventors that there were then. It's interesting to read in it what the views of Brunel were at the time, and they didn't half

slag him off when he was building the *Great Eastern*; about all the delays in launching it and it being six months before he could get it into the water on the Isle of Dogs. I've always wanted to get to that spot where he launched it. To me it's as good as a good war spot because that boat killed Brunel; it ended his life.

I've not been there, but where I have been, because it's open to the public now, is on the SS *Great Britain*. It's the only one of Brunel's ships to have survived, and it's currently being restored in the same Bristol dry dock in which it was built. In 1970 she was salvaged and brought back from the Falklands to the Great Western Dock in Bristol where she was built. When they got her back after an epic tow from the South Atlantic, it was decided to reconstruct her as closely as possible to the way she was when she was launched because Brunel's bold concept was such a revolutionary departure in ship design that affected all subsequent marine architecture. Limited resources have meant that progress has been slow, but the exterior of the *Great Britain* now appears much as it did in 1843, and they are doing a terrific job on restoring the engine to make it look just the way it did when the ship was built. It's certainly worth going to see. Restoration and conservation work on it is going on all the time, and future plans include the restoration of much of the interior to its former splendour.

You can't go out to sea on the *Great Britain*, but if you want to experience what it was like to travel on a steam ship, see the Gazetteer for details of the trips you can take on *Waverley*, the last sea-going paddle steamer in the world. This lovely little ship carries on a very long tradition of paddle steamers being used both for pleasure trips and, particularly in Scotland, as an important commuter link. She was built in Glasgow in 1947 for the old London & North Eastern Railway and operated commercially in the waters off western Scotland until 1973, when it looked as though her days were over. Fortunately, she was saved through the efforts of the Paddle Steamer Preservation Society, and since 1975 she has continued in service, not only in her familiar Scottish waters but around the coastline of most of the United Kingdom.

Back in 1845, the year SS *Great Britain* first sailed from Liverpool to New York, an event took place on Lake Windermere which must have been just as significant for the local inhabitants. On Saturday 31 May 1845 the 49-tonne steam launch, *Lady of the Lake*, was launched. It had been commissioned by Mr J.B. Fell of the Windermere Steam Yacht Company and built by Richard Ashburner, a Greenodd shipwright. The launch, which took place at Newby Bridge, was a great, festive occasion. After the traditional bottle of champagne had been broken against the boat's wooden hull, the first steamer ever to sail on an English lake glided into the water.

By 26 July 1845 the fitting-out of the *Lady of the Lake* had been completed, and steam was raised for the first trip up the lake. Regular public services started straight away, twice a day during the summer months and once a day in the winter. With a top speed of 9 mph (14.5 kph) it must have taken the *Lady of the Lake* at least an hour and a quarter to cover the 11 mile (17.7 km) journey to the top of the lake. Fares were the same as for the passage boats from Ambleside – three shillings (15p) for the full distance and one shilling and sixpence (7½p) to go as far as the ferry.

The *Lady of the Lake*'s first season was so successful that the Windermere Steam Yacht Company decided to order another paddle steamer, to be ready as early as possible the following year. This was the time that, throughout the country, railway mania had caught hold, and soon the railways would be extended to Windermere and Newby Bridge. When the railways came, tourists expected to flock to the Lake District in their thousands and the new steamboats on the lake would cater for them. Steam had come to stay on Windermere.

Just over a year after the *Lady of the Lake* had gone into service, the *Lord of the Isles* was launched. Between them the two boats managed to overcome all competition on the lake. But this domination was only short-lived because a new rival company was formed called the Windermere Iron Steam Boat Company. The new company commissioned MacConnochie & Claude of Liverpool to build a paddle steamer with an iron hull.

She would be manned by half the crew required for the *Lord* and *Lady*, use only a quarter of the quantity of coal, and steam at 12 mph (19 kph) without any effort. It was not until August 1849 that *Fire Fly* was launched, but as soon as she went into service, bitter rivalry grew between the two companies. On the piers pandemonium broke out as stewards, skippers and busmen all scrambled to get passengers from each other amid the hiss of steam and clouds of smoke coming from the steamers as they prepared to cast off. On the lake the vessels of the competing companies manoeuvred to get in each other's way and hinder each other's movements as much as possible until the inevitable happened and *Fire Fly* and *Lady of the Lake* collided. In August 1850 there was another disaster when *Lord of the Isles* caught fire while secured for the night at Bowness Steamer Pier. Suspicion fell on the fireboys of the *Lord* and *Lady*, who were charged with wilfully setting fire to the steamer, but when the case came to trial it was dismissed by the judge.

Development of steamboat transport continued to be closely linked to the expansion of the railways. In 1865 the Furness Railway bill provided for the construction of a new branch line that would extend the Arnside–Ulverston line to a new pier at Newby Bridge. The bill gave the Furness Railway Company a controlling interest in the Windermere United Steam Yacht Company, and in 1869 the railway was built as far as Lakeside, where it ended at a grand Victorian train and steamer terminus.

The arrival of the railway line at Lakeside gave another boost to tourism on Windermere. Round trips were now offered, and holidaymakers could take the train to the southern end of Coniston, where they boarded the passenger steamer *Gondola* and steamed to the top of the lake. They were then taken by charabanc to Waterhead, at the top of Lake Windermere, where a Furness Railway steamer was waiting to take them to Lakeside. From here they returned home by train.

But Windermere wasn't used only by tourists. Roads in the Lake District were still in a poor state and, apart from the railways, horse and cart was the fastest way of getting around on

land. Boats on the lake were the easiest and most efficient way of transporting cargoes. *Raven* was a Windermere cargo boat that was usually loaded on Mondays, Wednesdays and Fridays for deliveries around the lake the following day.

In the Victorian age factory owners prospered and many of the wealthy industrialists of the north-west started to visit Windermere for longer periods than the tourists. Some bought their own houses on the lake shores, while some of the more adventurous kept their own private steamer in a boathouse at the end of their garden. One of the first to experiment with the new technology was Charles Fildes, a Manchester businessman who had interests in tin plate. In 1850 he built the *Fairy Queen*, which, according to records, was the first private paddle steamer to have been used on Windermere. Charles Fildes was a steam fanatic, and it is said that he used to take the boiler and engine out of the *Fairy Queen* during the winter and use it to steam a miniature locomotive in his garden in Sawrey.

Henry William Schneider was a Barrow-in-Furness industrialist who moved to a big house (now the Belsfield Hotel) overlooking Bowness Bay in 1869. In the year he moved to Windermere, he commissioned the 65-foot (20-m) screw-driven steam yacht *Esperance*. The boat was built on the Clyde from the highest-grade iron supplied by one of Schneider's companies. Schneider used to use the boat to commute to his office in Barrow each day. Every morning he left home with his butler carrying his breakfast on a silver tray. He boarded *Esperance* and ate his breakfast as the boat steamed down to Lakeside, where he was met by a special train. *Esperance* is one of the exhibits in the **Windermere Steamboat Museum**.

Another boat of this period was the steam launch *Dolly*, which was built about 1850. This Windermere boat sank in Ullswater during the great frost of 1895 and lay there until she was discovered by divers in 1960. Divers from Furness Sub-Aqua Club successfully raised the boat in 1962. After the boat had been recovered, she was taken to Windermere for restoration. The boiler was overhauled and was in use for ten years before a replica

boiler became necessary. The engine was cleaned down and still works with its original piston rings.

This little steamer is a fine example of craftsmen's work during the early days of steam and provides a living picture of a facet of life about the time of the Great Exhibition of 1851. The *Guinness Book of Records* lists *Dolly* as the oldest mechanically powered boat in the world.

Dolly, *Esperance* and *Raven* can all be seen at the Windermere Steamboat Museum along with other historical boats. The museum is located on a former sand wharf site, where for many years barges unloaded gravel dredged from the bed of the lake. The Steamboat Dock has been built over the original quay and accommodates up to fifteen boats all in working order.

The massive expansion of railways that took place in the nineteenth century coincided with a development of metal-working and mining that was without precedent. In 1815 Britain's output of iron was little more than a quarter of a million tonnes a year; by 1835 it was 1 million, and by 1848 it was 2 million tonnes. Coal output increased in proportion from some 16 million tonnes in 1815 to 30 million by 1835 and 50 million by 1848. But engineering proper and the industries devoted to making machines were still only small scale. The main progress in engineering technique came only after 1848, and with it the rise of big engineering and the machine-tool industry. This was the process that turned the average Englishman from a countryman into an urban industrial worker.

Richard Garrett & Sons of Leiston in Suffolk was one of Britain's pioneering heavy engineering companies. Today the **Long Shop Museum** in Leiston has a very interesting collection of various engines that were produced by the company, and that are now all displayed on the site where they were made.

The story of the Garretts goes back to 1778, when Richard Garrett arrived in Leiston to work at the forge of William Cracey. In the same year he married Elizabeth Newson and she gave birth to a son, Richard. When William Cracey died in 1782, Richard Garrett bought the forge. His son took over the business in 1805,

and a year later he married Sarah Balls, whose father, John, had developed the first threshing machine. Soon the company was manufacturing threshing machines.

Richard Garrett III was born in 1807 and took over the running of the company in 1826 when he was still only nineteen. This was the start of a period of rapid growth, and by 1830 the company was employing sixty men and using eight to ten horses to supply the power. Over the next twenty years it manufactured threshers, seed drills, ploughs, winnowing machines and a range of agricultural tools and implements, and by 1850 it was employing 300 men.

By this time the steam locomotive had been developed, and the company saw there was a market for a similar but lighter machine for small factories, sawmills and farms. Once they saw this opening, they started to manufacture what they called the small portable steam engine. When they exhibited the engine at the Great Exhibition they took so many orders that the existing facilities they had at their works were totally inadequate. To meet the huge increase in demand for their engines they had a building constructed that was designed specifically for the mass production of these engines on an assembly line. In 1853 the Long Shop, as it became known, was completed, one of the first flow-line production assembly halls in the world.

Engines were constructed in the centre aisle, moving along on their wheels as assemblies and machined parts came in from either side and the wide galleries above. Two gantry cranes ran on rails that went the full length of the building, lifting and lowering heavy sections. Originally, the building was lit by gas flares from gas produced by the firm's own gasworks. Machines were driven from continuous lengths of shafting by lay shafts, pulleys and belts. The main shafts were driven by a horizontal steam engine just outside the west end of the wall.

Boilers were brought in at one end on wheels and were moved, manually or by horses, in stages along the floor of the building. Parts were assembled on to the boiler, and the complete engine was left at the far end of the works to be taken

to the paint shop. In 1858 they launched the first 'self-moving' portable, which became the first production-line traction engine. Heavy engineering developed still further with the design and manufacture of steam winding engines, road rollers, steam road locomotives and steam tractors.

Then throughout the second half of the nineteenth century the firm continued to expand and prosper, and by the beginning of the twentieth century the workforce exceeded 1000. Overtype steam wagons were now in production, along with a range of stationary power plants. With the beginning of the First World War the buildings were used for the production of aircraft, aircraft parts and shells, and for the design and manufacture of shell-turning lathes.

The end of the war brought industrial recession, and a new generation of Garretts attempted to compete in a depressed world market. They decided to join a group of companies that included such famous names as Burrells, Aveling & Porter, Davey Paxman and E.R. & F. Turner – a total of fourteen in all. The group was called Agricultural & General Engineers Ltd, or AGE for short. In the lifetime of the group, Garretts produced in 1922 their first undertype (Sentinel pattern) steam wagon, in 1926 the first 'O'-type trolleybus (for Ipswich Corporation), followed by diesel tractors in 1929. Other products included bakers' ovens, dough mixers, turbines, pumps, ice-cream freezers and in the early 1920s, a batch of steam wagons for Aveling & Porter.

Locally, the Long Shop was known as the 'cathedral'. Among the things to be seen are the 'Suffolk Punch' – an agricultural traction engine, the road roller 'Consuelo Allen', and the 4CD agricultural tractor 'Princess Marina' considered by many to be the most successful Garrett traction engine ever. (The 4 in the name refers to the nominal horsepower; CD means compound.) This one was built in 1916 as works number 32944 and was sold to Charles Abbott & Sons of Saxtead and used by them for many years of agricultural work. It develops about 25 brake horsepower and weighs around five and a half tonnes when fully laden.

There are two Garrett fire engines in the museum, one dating from 1846, the other from 1901, and a threshing machine. This threshing machine preceded the combine harvester for separating corn from its straw and removing dust and weed seeds. The machine was used in a stationary position and usually driven by a steam engine or tractor, while the modern combine harvester is self-propelled. The living-van you can see is typical of the vans that Garrett manufactured. Their living-vans had accommodation for anything from two to six men. They were used by road construction and threshing gangs travelling around the country carrying out their trade and living on the job. The gang was normally accompanied by a cook-boy. Living-vans were generally manufactured and supplied by all makers of traction engines and threshing sets.

Restoration work is also carried out at the Leiston museum, not only for the museum itself but for other museums, societies and individuals who own traction engines, steamrollers and other steam-powered vehicles. The museum's own collection of steam engines is maintained in the workshop, and jobs from minor packing repairs to major servicing and boiler surveys are carried out in winter, when the traction engines are off the road.

I don't send mine there, though, because I do all the work on them myself. You've got to have a laugh, though: it's meant fourteen years and two divorces for me. Any man who has a steam engine will tell you: you've got to have an understanding woman, otherwise you're in big trouble. Look at the engine that I've got in the shed that I'm still working on. I remember the man who bought it thirty years ago, and I went to look at it and was like a man with a new toy. He'd put in a sealed tender for a steamroller to Devon County Council. When it came through that his tender has been accepted he went to look at it, expecting to see a steamroller, but it turned out to be a tractor. It was termed a 'convertible', one you can make into a steamroller or a tractor. Anyway, this same gentleman who had his tender accepted, the late Mr Peter Froud, already had in his possession a fire roller, a Sentinel steam wagon and a big Burrell locomotive on permanent

loan, so he didn't need the hassles of a steam tractor. But some of his sidekicks decided to dismantle this engine so they could see what really wanted doing to it. When they got the lagging to it, it was a bit of bad news: the boiler was absolutely goosed, with a big patch on the side. There was no way it would ever have passed a boiler inspection.

When they found this out, rumour had it that it was for sale, so I went to have a chat with him and got it and brought it back to Bolton. Within the first three or four months, I'd de-boilered it and got a new boiler barrel, put the boiler barrel in and the front tube plate. By this time all the boiler installation was done apart from the fire box, which I'm purposely saving until last. So, slowly but surely over the last four years I've been getting it done.

It's really hard to reckon up the actual time I've spent on it because there can be a period of six or seven weeks when I'm working away from home and there's no time to bother with it. You get people writing these articles on how they did their traction engines up and they say they spent 29,000 hours on it, but it's a bit of a weird thing how they can get it dead right down to the exact hour. Then there's the cost of it. Sometimes you go and get a price for something, and it's an arm and a leg and you think it's going to bankrupt you. So you chew it over in your mind for three months and finally you come up with a solution. Necessity is the mother of invention, and I've saved myself literally thousands of pounds. If I'd had to pay for a lot of things it would have been a fortune. For the rubber tyres alone you are talking £1000 on each wheel if you pay for them at Dunlop, but there are ways that you can find these things and get them practically given to you.

O'Donnell, who helped me put the front on, would say, 'How long will it be now?' And I'd say, 'I don't know. What will it be next? Divorce? Mortgage that I haven't got? Who knows the future?'

I could go out, knock a chimney down for a few hundred quid, have three weeks off and get on with working on it. Anyway, at least it looks more like an engine now. The grand plan is to move the wheels out of the kitchen in the near future. I did the riveting

in there because it's not even part of the house yet, and I put the rubber tyres on in there and painted them in there, too. But now they are all very much in the way of our new fitted kitchen.

The biggest collection of steamrollers and traction engines that I know of belongs to George Cushing from Norfolk. I first heard of Mr Cushing when I was a young man when my interest in steam engines first developed. The fact that there was a gentleman who lived in Norfolk who had a field full of traction engines and steamrollers was wonderful. Originally, the house he lived in must have been a farmhouse, but he seemed to be a contractor of sorts, general dogsbody sort of thing. One of the jobs he used to have was running sugar beet to the station with a steam tractor, and he's got pictures of two of the surviving Aveling ploughing engines that he used.

Anyway, he started this collection. Steam engines, steamrollers, traction engines, fairground engines, every sort of road engine you could buy, and there were two or three of every type and he would not sell any of them. Everybody said he was nuts, but his grand dream was to have a collection of these engines, so he started off and built a shed and put a few of them in and eventually it got to be a visiting centre with the fairground organs and a Wurlitzer organ crammed into this shed. Now it's known as the **Thursford Collection,** and they have put purpose-built buildings there, and the whole place is really quite splendid. They have a resident organist who plays things like 'I Do Like to Be Beside the Seaside' on the Wurlitzer. But the engines are my particular interest there. They have all been done up to quite a splendid standard. They look brand new and they stand around in this big building and you can walk around and touch them.

Mr Cushing's a great Aveling & Porter man, and swears by them. That's the same make as mine. And he's got three colonial tractors that are the same as the one we are doing up in the shed. He was saying to me lately he's got the oldest example of a roundabout from Queen Victoria's time. It's steam driven and in wonderful condition. All the carriages are like gondolas

and they all have royal heads on top – Victoria and Albert and things like that. They are really ornate, the likes of which you would never see again.

I wonder sometimes how he managed to amass so many engines, but a lot of the things he's got are things that he used to use himself and he'd never throw anything away. If you want to see his collection, it's down at Thrusford in Norfolk, and Mr Cushing's steam collection is without a shadow of a doubt very wonderful.

It's also worth a lot of money. A tractor engine that you could buy in the 1940s for the princely sum of £200 is now almost priceless. For a decent model and a genuine one you might have to pay maybe £150,000 – prices have gone out of the window. Last time I spoke to him about one of my engines he advised me it would be worth £50,000 when I'd got it finished.

The steamroller is a bit sad really because it was the last commercially used steam vehicle to be used on the road. It lasted until the late 1960s in rural areas, and now there are diesel rollers. At the end of its period you could purchase a steamroller for maybe £60 or £70 – just what the scrapman would give in the late 1960s or early 1970s. Before they decided to cut the things up and get the pittance from the scrapman, quite a lot of councils decided they would make them safe and put them in the park so kids could play on them. So they would take all the sharp bits off and make it so you couldn't turn the steering wheel. Now these are being bought from the councils. They don't want them in the playgrounds because modern kids prefer to play with a computer; they are not interested in steamrollers. So lots of councils decided to get rid of them because a steamroller is a bit of a white elephant; you've got to keep painting it and looking after it. Some councils didn't want to go to the trouble of moving them and destroying the parkland around them when they were getting them out, so they left them where they were, burying them right on the spot. But there's such a demand for them now that the councils are starting to dig them up to sell.

But everywhere it's the same story: coal-mines round where I live and tin-mines in Cornwall; mills and factories that were full of lovely old engines; steel mills with great big rolling mills and tilt hammers – all of them suffered the same fate when they were closed down, and the scrapmen got in as soon as the last shift was finishing. And so we lost so much of our industrial heritage. And it's only because of the efforts of people like George Cushing, who nearly everybody regarded as loonies, that we've got anything left at all. If you want to do your bit to try to preserve what is left, most of the places listed in the Gazetteer that follows rely on volunteers. If you want to have a bit of fun excavating a mine or driving an engine, and want to preserve a bit of our history, these people would be glad to hear from you. And if you get only half the pleasure I've had from helping to keep these bits of our history alive, you'll find it well worth the effort.

GAZETTEER

The following pages are a guide to industrial places around Britain, though for various reasons not all are currently open: some are undergoing restoration, and others are simply closed to the public. The entries have been grouped by region and, for ease of use, have been categorized under eight headings: windmills; watermills; stationary steam engines; mills and factories; iron-, steel- and metal-working; mining; railways; and ships and engineering. Each entry is listed alphabetically and contains the full address with a contact telephone number, directions from a main road to the site and a brief description of what there is to see once there. The entry numbers in the gazetteer correspond to the numbers on the maps, so you can see where each site is in relation to the others. The maps give approximate locations of all the entries in the gazetteer, and are meant as a guide only. When planning a trip, use a good road atlas or website that shows more local detail than it is possible to show here. The maps are also useful as they show other sites that may be local to you. The entries state opening times, too, where it's been possible to list them but, as many of the sites are staffed by volunteers, they often have irregular opening hours or ones that change from year to year. It is always best to telephone or check the websites before visiting any site in order to avoid disappointment. For current admission fees (some places offer concessions for OAPs, children and parties), contact the sites.

SOUTH-WEST
(Map 1)

WINDMILLS

1 Wilton Windmill

Wilton, Marlborough, Wiltshire SN8 3SW

01672 870266 www.wiltonwindmill.co.uk

Off A338, about 5 miles SW of Hungerford

Open Easter–end Sept: Sun and Bank Holiday Mon 2–5

A five-storey tower mill built in 1821. It worked until the 1920s and is now fully restored and operational.

WATERMILLS

2 Burcott Watermill

Near Wells, Somerset BA5 1NJ

01749 673118 www.burcottmill.com

2 miles W of Wells centre, on B3139 to Burnham

Open Easter–end Sept: Sat and Sun 11–5

A stone-built working watermill. The wheel and two pairs of stones date from 1864. Mill on site for 700 years; current structure dates from 250 years ago.

3 Mangerton Watermill

Mangerton, near Bridport, Dorset DT6 3SG

01308 485224 www.nationalmillsweekend.co.uk

Leave Bridport on A3066, turn right to Powerstock. Follow brown signs

Open Easter–mid Oct: Tues–Sun, 11–5.30 and Bank Holiday Mons

A grist and flax mill that worked commercially until 1966. Now it has been restored as a working grist mill with all its machinery, including overshot water wheel.

4 Otterton Mill Centre

Near Budleigh Salterton, Devon EX9 7HG

01395 568521 www.ottertonmill.com

Milling times: 11–12.30 and 2–3

Turn off A3052 (Exeter to Lyme Regis road) at Newton Poppleford

Open mid-Mar–Oct: daily 10.30–5.30; Nov–mid-Mar, daily 11.00–4

Working watermill with two 10-foot (3-m) breast-shot water wheels fed by a

man-made leat from the Middle Ages. The machinery dates from the eighteenth and nineteenth centuries, and three sets of stones remain; two of them are French burr and have rhymed dedications carved on them.

STATIONARY STEAM ENGINES

5 Cornish Mines and Engines at Pool

Agar Road, Redruth, Cornwall TR15 3EB
01209 315027 www.nationaltrust.org.uk
From A30, take Pool exit, turn left at lights, follow A3047
Open March–end June and Sept–Oct: Mon, Wed, Thurs, Fri and Sun
11–5; July–Aug: Wed, Thurs, Fri, Sat and Sun 11–5.
The mining machinery on display includes Michellís winder, built in 1887 to raise iron ore and miners from over 1640 feet (500 m) below the surface, and now electrically powered. Across the road at Taylor's Shaft is a pumping engine with a 90-inch (2.3-m) single cylinder and a 52-tonne beam engine. Heritage Centre next to Taylor's Shaft details the industrial history of the region.

6 Crofton Beam Engines (formerly Crofton Pumping Station)

Crofton, Marlborough, Wiltshire SN8 3DW
01672 870300 www.croftonbeamengines.org
Just off A338 between Burbage and Hungerford
Open Apr–end Sept: every day except Wed 10.30–5
Contact for steaming times
The pumping station houses two Cornish beam engines, the 1812 Boulton & Watt and the 1845 Harvey's of Hayle. Both are steam driven from a coal-fired boiler to pump water into the summit level of the Kennet & Avon Canal.

7 Levant Beam Engine

Trewellard, Pendeen, St Just, Cornwall TR19 7SX
01736 786156 www.nationaltrust.org.uk
Follow signs from B3306, St Just to Zennor road, 1 mile W of Pendeen
Open Apr–May: Wed, Thurs, Fri, Sun 11–5. July–end Sept: Tues, Wed, Thurs, Fri, Sun 11–5. Also Bank Holiday Mons 11–5. Oct: Wed and Fri 11–5. Nov–Feb: Fri 11–4. Mar: Fri 11–5
Telephone for details during rest of year. For steaming days see National Trust Handbook
Built in 1840, the 27-inch (69-cm) whim engine hoisted ore from the Levant Mine. It is in its original engine house, perched on the edge of a cliff.

8 Newcomen Memorial Engine

The Engine House, Mayers Ave, Dartmouth, Devon TQ6 9YY
www.dartmouth.org.uk
Signposted in Dartmouth town centre
Open Good Friday–end Sept: daily 9.30–5.30, Sun 10–4;
Oct–Mar: Mon–Sat 9–5
The building was erected to commemorate the 300th anniversary of Newcomen's birth in 1663 and houses one of his atmospheric pumping engines of 1725.

9 Westonzoyland Pumping Station

Hoopers Lane, Westonzoyland, near Bridgwater, Somerset TA7 0LS
01275 472385 www.wzlet.org
N. bank of River Parrett, E of Bridgwater on A372. Signposted from Westonzoyland
Open all year: Sun 1–5. Check for steaming times
The first mechanized site for draining Somerset Levels and powered by an 1861 Easton & Amos engine restored to working order. There is also an exhibition of other stationary steam engines.

MILLS AND FACTORIES

10 Coldharbour Mill

Uffculme, Cullompton, Devon EX15 3EE
01884 840960 www.coldharboursteam.org.uk
2 miles from M5 junction 27, off B3181. Follow signs to Willand, and from there to the museum
Open: Mon–Fri 10–4. Check for steaming dates
This woollen mill was built in 1797 and it continued production until 1981. It was originally driven by water power, and the breast-shot suspension wheel along with the gearing and line shafting to the factory machinery remain. In 1865 the water power was supplemented with steam. A 1910 steam mill engine is in full working order and also an 1867 beam engine.

11 Trowbridge Museum

The Shires, Court Street, Trowbridge, Wiltshire BA14 8AT
01225 751339 www.trowbridgemuseum.co.uk
Signposted in Trowbridge town centre
Open: Tues–Fri 10–4; Sat 10–4.30
The museum is located on the spinning floor of the last mill in the town. It has displays about the woollen industry in the area, along with working textile

*machinery, including a spinning jenny and Dobcross power loom. The displays
are in various room settings, including a weaver's cottage, a shearing workshop
and a draper's shop.*

12 Wookey Hole Paper Mill

Wells, Somerset BA5 1BB
01749 672243 www.wookey.co.uk
2 miles from Wells. Follow signs from A371. Access to the mill is via
Wookey Hole Caves
Open all year: daily Easter–Oct: 10–5; Nov–Easter: 10–4; Dec and Jan:
weekends and school holidays
*A mid-nineteenth-century paper mill that continues to make hand-made paper
by traditional methods. Visitors can make paper themselves.*

IRON-, STEEL- AND METAL-WORKING

13 Finch Foundry

Sticklepath, near Okehampton, Devon EX20 2NW
01837 840046 www.nationaltrust.org.uk
Off A30, 4 miles E of Okehampton
Open Easter–Oct: daily except Tues, 11–5
*A nineteenth-century water-powered forge that produced agricultural hand
tools. Three water wheels power the machinery, which includes a 250-year-old
tilt hammer, drop hammer, shears and grinding wheel.*

MINING

14 Geevor Tin Mine

Pendeen, Penzance, Cornwall TR19 7EW
01736 788662 www.geevor.com
By B3306 from St Just to Zennor, or follow signs on A3071 from
Penzance bypass (A30)
Open all year: Sun–Fri 9–5 (Nov and Feb 9–4). Also Sat in July and Aug
*Geevor was an amalgamation of many small mines that were restarted around
1911 and continued production until 1990. The site includes a museum with a
3-D model of the underground workings, compressor and winder houses, and
an underground tour of the adit mine.*

15 Morwellham Quay

Morwellham, near Tavistock, Devon PL19 8JL
01822 832766 www.morwellam-quay.co.uk

From main Tavistock to Liskeard road (A390) turn left 2 miles W of Tavistock
Open Mon–Fri 10–5 until end Oct

*The site of a Victorian copper port by the River Tamar, which is now a large
open-air museum. There is an underground tour of the nineteenth-century
copper mine, a miner's cottage, a blacksmith and a lime kiln. Of four working
water wheels on site, one is 38 feet (11.5 m) in diameter and was used in a
Dartmoor clay-works, while another is 18 feet (5.5 m) in diameter and 100
feet (30 m) under ground, is fed from the surface and works a pump at a lower
level. In winter only grounds and copper-mine open.*

16 Poldark Mine Heritage Complex

Wendron, near Helston, Cornwall TR13 0ER
01326 573173 www.poldark-mine.co.uk
On B3297 between Redruth and Helston in village of Trenear
Open Easter–Oct: daily 10–5.30 (Apr–mid-July and Sept–end Oct not Sat)
*A Cornish tin-mine that was first worked in the late seventeenth century. The
mine has four levels that are open to the public, and the complex includes an
eighteenth-century village and a museum heritage collection. There is also a
collection of static engines and a locomotive displayed around the site.*

17 Wheal Martyn China Clay Heritage Centre

Carthew, St Austell, Cornwall PL26 8XG
01726 850362 www.wheal-martyn.com
Follow brown signs from A391 at Stenalees to Carthew, on B3274, 2 miles
N of St Austell
Open Jan: daily 10–2; Easter–end Oct: daily 10–5. Ring for other times
*The open-air site includes a restored nineteenth-century clay-works and a 220-
foot (67-m) pan kiln used to dry the clay. Water power was originally used to
lift the clay slurry from the pit, and two working water wheels on the site are
run for demonstration purposes. There are also two steam locomotives that
were used to transport the clay.*

RAILWAYS

18 Bodmin & Wenford Railway

Bodmin General Station, Bodmin, Cornwall PL31 1AQ
01208 73555 www.bodminandwenfordrailway.co.uk
On B3268 Lostwithiel road near centre of Bodmin
Open Jun–Sept: daily 9–5; Apr, May, Oct and Dec, selected services.
Telephone for daily train timetable
The Great Western Railway station at Bodmin General houses a collection of

locomotives undergoing restoration. A 6-mile (10.4-km) branch line connects to the main line at Bodmin Parkway.

19 East Somerset Railway

Cranmore Railway Station, Shepton Mallet, Somerset BA4 4QP

01749 880417 www.eastsomersetrailway.com

Off A361 Shepton Mallet to Frome road, about 3 miles from Shepton Mallet, signposted East Somerset Railway

Open Apr–Dec (not Nov): Tues–Sun 9.30–4; Jan–Mar and Nov: Tues, Thurs, Sat and Wed (in Nov) 9.30–3. Telephone for daily timetable

The original East Somerset Railway was opened in 1858 as a broad-gauge line running from Witham Junction to Wells. The present railway was opened in 1974 and the replica Victorian engine shed houses a display of historic locomotives and tank engines.

20 STEAM – Museum of the Great Western Railway

Kemble Drive, Swindon, Wiltshire SN2 2TA

01793 466646 www.steam-museum.org.uk

Signposted on all major routes into Swindon

Open all year: daily 10–5

This museum, *in the heart of the former Swindon Railway Works has archive film footage, stories of ex-railway workers, hands-on exhibits and interactive displays. There are famous locomotives and GWR memorabilia.*

Among the locomotives are the historical Dean Goods *and* King George V *and a replica of the broad-gauge locomotive the* North Star.

21 Lappa Valley Steam Railway

St Newlyn East, Newquay, Cornwall TR8 5LX

01872 510317 www.lappavalley.co.uk

Signposted from A3075 Newquay to Redruth road

Open Mar–Oct: daily 10.30–5; July and Aug: 10.30–6; Oct: 10.30–4

The railway was originally opened as a mineral line from Newquay to East Wheal Rose and later became part of GWR's branch line. The 15-inch (38-cm) gauge railway runs for 1 mile (1.5 km) from Benny Halt to East Wheal Rose, where the Woodland Railway runs to Newlyn Halt.

22 Launceston Steam Railway

St Thomas Road, Launceston, Cornwall PL15 8EX

01566 775665 www.launcestonsr.co.uk

Signposted off the A30; follow A3254 to Launceston town centre

Open Easter, Whitsun, then Sun, Mon and Tues in June; 5 July–end Sept
Sun–Fri. Contact for more details
*The railway runs through the beautiful Kensey Valley on track gauge of
1 foot 1½ inches (34.3 cm), following the track bed of the old North Cornwall
line. Launceston station contains a museum of vintage cars, motorcycles and
stationary steam vehicles, which are demonstrated at work.*

23 Paignton and Dartmouth Steam Railway
Queen's Park Station, Torbay Road, Paignton, Devon TQ4 6AF
01803 555872 www.pdsr.co.uk
In Paignton town centre
Open Apr–Oct: 10–5 (9.30–5 in Aug); telephone for other dates
*Steam trains run for 7 miles (11 km) from Paignton to Kingswear on this former
Great Western Railway line.*

24 Swanage Railway
Station House, Swanage, Dorset BH19 1HB
01929 425800 www.swanagerailway.co.uk
In town centre, signposted from A351
Open daily Apr–Oct and selected dates throughout rest of year. Telephone
for train timetable
*The railway from Swanage to Wareham was closed in 1972. In 1976 the
Swanage Railway took possession and has restored the line, which now runs
for 6 miles (9.6 km), passing the ruins of Corfe Castle, on to Norden, where
there is a park-and-ride facility.*

SHIPS AND ENGINEERING

25 Bath Industrial Heritage Centre
Julian Road, Bath BA1 2RH
01225 318348 www.cityofbath.co.uk
Above the Assembly Rooms
Open daily: 10–5.30
*The centre houses the Bowler Collection, the entire stock-in-trade of a
Victorian brass founder, general engineer and aerated water manufacturer. Also
displays about Bath's industrial heritage.*

26 Bristol Industrial Museum
Princes Wharf, City Docks, Bristol BS1 4RN
01179 251470 www.bristol.gov.uk

Signposted in city centre

Due to open on Harbourside in 2011

*The museum, a converted dockside transit shed, has motor and horse-drawn
vehicles from the Bristol area and locally built aircraft and aero engines.
Railway exhibits include locomotives* Henbury *and* Portbury. *There is also a
steam tug, the* Mayflower. *One of these is steamed every weekend.*

27 SS *Great Britain*

Great Western Docks, Gas Ferry Road, Bristol BS1 6TY

01179 260680 www.ssgreatbritain.org

Signposted on all major routes into the city; from motorways follow
brown signs to Historic Harbour

Open daily all year: summer 10–5.30; winter 10–4.30

The SS Great Britain *was designed by Isambard Kingdom Brunel and launched
from Bristol in 1843. She was the first ocean-going propeller-driven iron ship
and was used during her career as a luxury liner, troop carrier and cargo vessel.*

SOUTH-EAST
(Map 2)

WINDMILLS

28 Cromer Windmill

Cromer, Hertfordshire SG2 7QE
01279 843301 www.windmillworld.com/uk/cromer.htm
½ mile E of Cromer on B1037
Open mid-May–mid-Sept: Sun, Bank Holidays and second and fourth
Sats 2.30–5

A white-weatherboarded post mill with an octagonal brick house. Built in the early eighteenth century, the mill is balanced on a main post over 18 feet (5.5 m) high, around which turn the four shuttered sails. The mill has two pairs of millstones, which are located on the second floor and driven by the gearing below.

29 Outwood Windmill

Old Mill, Outwood Common, near Redhill, Surrey RH1 5PW
07760 194948 www.outwoodwindmill.co.uk
Turn off A25 Godstone to Reigate road at Bletchingly. Outwood is about
3 miles S
Telephone for visiting arrangements

A post mill built in 1665, which is still in working order and producing flour.

30 Pitstone Windmill

Ivinghoe, Buckinghamshire
01442 851227 www.nationaltrust.org.uk
½ mile S of village of Ivinghoe near junction of B489 and B488
Open May Bank Holiday and June–Aug: Sun and Bank Holidays
2.30–6

An early form of post mill that was built in around 1627 with a brick roundhouse. It has been restored to working order but cannot turn to face the wind. It has two pairs of millstones, one set made of Peak stone for coarse meal and the other made of French burr for milling flour.

WATERMILLS

31 Bourne Mill

Bourne Road, Colchester, Essex CO2 8RT
01206 572422 www.nationaltrust.org.uk
1 mile S of Colchester, off Mersea Road (B1025)
Open Bank Holiday Suns and Mons, and Jun: Sun and July–Aug: Sun and
Tues 2–5
*Built in 1591 as a private fishing lodge by Sir Thomas Lucas, and later
converted into a watermill with an 18-foot (5.5-m) overshot wheel. Until 1833
it was used for making bay (a thin woollen fabric), and from then until 1936 it
was used as a flour mill.*

32 Calbourne Watermill and Museum of Rural Life

Calbourne, Isle of Wight PO30 4JN
01983 531227 www.calbournewatermill.co.uk
On B3401 between Freshwater and Newport
Open Good Friday–31 Oct: daily 10–5
*A seventeenth-century watermill with overshot water wheel. The old wooden
wheel was replaced by the present iron wheel in 1894, and a roller mill was
installed in 1894. This was originally driven by a steam engine that was
replaced by the present suction gas engine in 1920.*

33 Eling Tide Mill

The Toll Bridge, Totton and Eling, Southampton SO40 9HF
02380 869575 www.elingtidemill.org.uk
W of Southampton. Follow brown signs from A35 and A326. Mill is in Eling
Open all year: Wed–Sun and Bank Holidays 10–4. Check for milling times
as they are tide-dependent
*The present mill was built in the eighteenth century and contains
nineteenth-century machinery. The mill has two sets of cast-iron machinery,
each driven by a Poncelet 12-foot (3.6-m) water-wheel and each running two
sets of stones. One of the wheels and its machinery has been restored to full
working order and produces flour, while the other provides a static display.*

34 Ford End Watermill

Ford End Farm, Station Road, Ivinghoe, Buckinghamshire
01442 825421 www.fordendwatermill.co.uk
600 yards from the church, along B488 to Leighton Buzzard
Open 1 May–30 Sept: Sun and Bank Holidays 2–5;

FOUNDRIES AND ROLLING MILLS

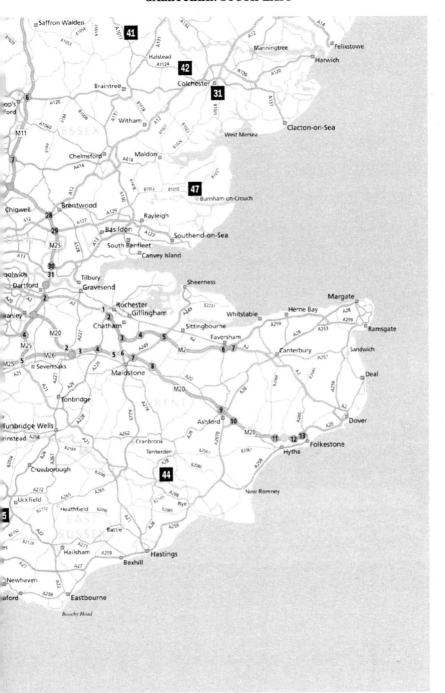

by appointment at other times

Recorded in 1767 and in use until 1963, the watermill is driven by an 11-foot (3.3m) overshot wheel with cast-iron axle and spokes. It has a mansard roof and two pairs of millstones, and demonstration milling takes place on certain days.

STATIONARY STEAM ENGINES

35 Kew Bridge Steam Museum

Green Dragon Lane, Brentford, Middlesex TW8 0EN

0208 5684757 www.kbsm.org

100 yards from the north side of Kew Bridge, next to the tall Victorian tower

Open Sun and Bank Holiday Mons; 11–4 Sat, and by prior appointment

Located in a nineteenth-century pumping house, the museum has a collection of water-pumping machinery. The exhibits include the Grand Junction 90-inch, a working Cornish beam engine that pumped water to west London. There is also a complete ball engine on its original site, a gallery showing the history of water supply and a narrow-gauge steam railway.

36 Markfield Beam Engine and Museum

Markfield Road, South Tottenham, London N15 4RB

www.mbeam.org

M25, Junction 25, museum is off the A10

Open Mar–Dec: 11–4

Built in 1886, this beam engine has been restored to working order in its original Victorian building. The engine was used to pump sewage, and the museum has a small exhibition on public health engineering. When in steam, it pumps clean water around the original 20-inch (51-cm) diameter cast-iron inlet and outlet pipes in the basement of the pumphouse. When not in steam, a video is shown.

MILLS AND FACTORIES

37 Whitchurch Silk Mill

28 Winchester Street, Whitchurch, Hampshire RG28 7AL

01256 892065 www.whitchurchsilkmill.org.uk

Half-way between Winchester and Newbury on A34; follow brown signs

Open all year: Tues–Sun and Bank Holiday Mons 10.30–5; last admission 4.15

The mill was built on the River Test 200 years ago, and silk has been woven here since 1820. Now a working museum, the mill's weavers still produce a small quantity of silk fabrics to order. The winding and warping machinery and nine of the looms date from the early twentieth century.

38 Bluebell Railway

Sheffield Park Station, East Sussex TN22 3QL
01825 720825 www.bluebell-railway.co.uk
On the A275, 4½ miles east of Haywards Heath off A272
Trains running daily Apr–mid Nov; weekends in Feb and Mar
The railway was reopened on part of the Lewes to East Grinstead line in 1960 and includes four stations. The Horsted Keynes station houses a carriage exhibition and workshop, while at the Sheffield Park station is a locomotive collection and small museum.

39 Buckinghamshire Railway Centre

Quainton Road Station, Quainton, Aylesbury,
Buckinghamshire HP22 4BY
01296 655720 www.bucksrailcentre.org
Signposted off A41 between Bicester and Aylesbury
Open Easter–end Oct: Sun and Bank Holidays 11–5.30; plus Wed during July–Aug 11–5.30. Recorded timetable: 01296 655450
Full-size and miniature railway in steam on selected days. There is also a collection of locomotives, carriages and wagons dating from 1870.

40 Chinnor and Princes Risborough Railway

Station Road, Chinnor Station, Oxfordshire OX39 4ER
01844 353535 www.chinnorrailway.co.uk
Just off B4009 in Chinnor, M40 Junction 6 is 3 miles away
Open Mar–early Oct: Sat, Sun and Bank Holiday Mons only; Oct and Dec: Sun only
The line formed part of the Watlington branch built in 1872 and now runs from Chinnor to Thame Junction. The railway has two locomotives and other items of rolling stock.

41 Colne Valley Railway and Museum

Castle Hedingham Station, Yeldharn Road, Castle Hedingham,
Essex CO9 3DZ
01787 461174 www.colnevalleyrailway.co.uk
On A1017, 7 miles NW of Braintree
Open mid-Mar–Oct: Sat and Sun and Christmas specials
The rail track, platform and buildings have been built from scratch on the site of the former Colne Valley Railway, which was closed down in 1965. The stock includes ten steam locomotives, carriages, wagons and a variety of other engines.

42 East Anglian Railway Museum

Chappel and Colne Station, Wakes Colne, Essex CO6 2DS
01206 242524 www.earm.co.uk
Off A12 at Junction 26, take A1124 towards Halstead, under railway
viaduct and turn right for station
Open all year: daily 10–4.30

*The museum has a comprehensive collection of period railway architecture
and engineering from East Anglia. The station buildings were built in 1890
and essentially remain in their original state, complete with waiting-rooms,
booking-hall and booking-office.*

43 Isle of Wight Steam Railway

The Railway Station, Havenstreet, Ryde, Isle of Wight PO33 4DS
01983 882204 www.iwsteamrailway.co.uk
Havenstreet is 4 miles W of Ryde. Station is in village
Open Jun–end Sept: daily 9.30–5.30; Apr, May, Oct and Dec: on
certain days. Check website or telephone for opening times. Timetable
information: 01983 884343

*The track runs for 5 miles (8 km) and has four stations: Wootton, Havenstreet,
Ashey and Smallbrook Junction. Three of the operational steam locomotives
were used on the original railway, while the range of carriages dates from 1864.
The museum at Havenstreet displays artefacts from the original railway.*

44 Kent & East Sussex Railway

Tenterden Town Station, Tenterden, Kent TN30 6HE
01580 765155 www.kesr.org.uk
Tenterden and Northiam Stations are on A28 between Ashford
and Hastings
Open Mar: last two Sats and Suns of month; July and Aug: daily; ring for
dates in rest of year. Recorded timetable: 01580 762943

*The engines and carriages that run on this 7-mile (11-km) railway date from
Victorian times to the 1960s. The railway was engineered and managed by
Colonel Stephens and was first opened in 1900. The railway museum adjacent
to the station recounts the stories of the seventeen minor railways that Stephens
built or managed.*

45 The Lavender Line

Isfield Station, Isfield, East Sussex TN22 5XS
01825 750515 www.lavender-line.co.uk
Off A26 midway between Lewes and Uckfield
Open every Sun and Bank Holidays 11–5, plus other days throughout
the year

*A working railway museum with small artefacts displayed in the former goods
office that dates from 1860. Isfield Station has been restored to the early
Southern Railway colours of the 1920s.*

46 Leighton Buzzard Railway

Page's Park Station, Billington Road, Leighton Buzzard,
Bedfordshire LU7 4TN
01525 373888 www.buzzrail.co.uk
On A4146 Hemel Hempstead road, about 1 mile from town centre
Telephone for daily timetable

*This narrow-gauge railway was built in 1919 to transport sand. The track runs
for 2½ miles (4 km), and the railway has a collection of steam locomotives.*

47 Mangapps Railway Museum

Southminster Road, Burnham-on-Crouch, Essex CM0 8QQ
01621 784898 www.mangapps.co.uk
On B1021, 1 mile N of Burnham, signposted from town
Open 11.30–5 every Sat and Sun and Bank Holiday Mons all year except
Nov and Jan.
Steam days first Sunday of the month

*A collection of restored railway buildings that have been recovered from sites
across East Anglia. The museum houses a variety of steam locomotives and
over fifty carriages that date from the 1890s.*

48 Watercress Line

The Railway Station, Station Road, Alresford, Hampshire SO24 9JG
01962 733810 www.watercressonline.co.uk
Alresford and Alton Stations signposted off A31 Guildford to Winchester road
Open every day.
Telephone 01962 734866 for timetable information

*The railway line between Alton and Winchester was opened in 1865 and was
in service until 1973. This preserved steam railway runs for 10 miles (16 km)
of the line between Alton and Alresford.*

SHIPS AND ENGINEERING

49 Amberley Museum and Heritage Centre

Amberley, near Arundel, West Sussex BN18 9LT

01798 831370 www.amberleymuseum.co.uk

On B2139 between Arundel and Storrington

Open mid-Feb–late Oct: 10–5.30. Closed Mondays except Bank Holidays

A working museum that reflects the industrial history of the south-east. The site has a wide variety of exhibits, including a blacksmith's shop, printing works, ironmonger's, steam road vehicles and a narrow-gauge railway.

50 British Engineerium (Closed)

Off Nevill Road, Hove, East Sussex BN3 7QA

01273 559583 www.britishengineerium.com

From A27 take A2038 and follow brown signs

Presently closed. Check updates on website

A restored working Victorian pumping station that houses a collection of steam engines. In the main hall is a 16-tonne Corliss engine. An underground tunnel leads to an original working boilerhouse complete with four Lancashire boilers. In number 2 engine house is the nineteenth-century Easton & Anderson beam engine.

51 Hollycombe Steam Collection

Iron Hill, Liphook, Hampshire GU30 7LP

01428 724900 www.hollycombe.co.uk

2 miles from A3 London to Portsmouth road on the Midhurst road to Hollycombe. Follow brown signs

Open Apr–early Oct: Sun and Bank Holiday Mons 1–6; last week of July and last two weeks of Aug: daily 1–6

A varied collection of steam-powered machinery. The working exhibits include an Edwardian steam fairground, traction engines, steam-powered farm machinery, a narrow-gauge railway and a steam-driven sawmill.

52 Science Museum

Exhibition Road, London SW7 2DD

0870 8704868 www.sciencemuseum.org.uk

Nearest tube station is South Kensington

Open all year (except Christmas): daily 10–6

The collections cover the application of science to technology and illustrate the development of engineering and industry.

EASTERN
(MAP 3)

53 Alford Five-Sailed Windmill

East Street, Alford, Lincolnshire LN13 9EQ

01507 462136 www.fivesailed.co.uk

E side of Alford on A1104

Open Nov–March: Tues, Sat and Sun 10–4; Apr–June and Oct: Tues, Fri, Sat and Sun 10–5; July–Sept: daily, except Mon

Built in 1837, this six-storey, five-sailed tower mill is in full working order and produces organic flour on a commercial basis.

54 Berney Arms Windmill

Near Great Yarmouth, Norfolk NR30 1SB

01493 700605 www.english-heritage.org.uk

About 4 miles NE of Reedham, across Halvergate Marshes by foot, or take the train to Berney Arms Station, on N bank of River Yare. No road access

Check website for opening times

A seven-storey red-brick tower mill that stands 70 feet (21 m) high. It was originally used to grind cement clinker from the chalky mud dredged from the river but operation for this purpose ceased in 1880. From that time on the mill has been used for draining the marshes, although two of the original grindstones remain in the mill.

55 Billingford Windmill

Billingford, Billingford Common, near Diss, Norfolk IP21 4HL

01603 222705 www.norfolkwindmills.co.uk

3 miles E of Diss on A143 Bury St Edmonds to Great Yarmouth road

Call for opening times

A five-storey brick tower corn mill with a Norfolk boat-shaped cap and a six-bladed fantail. Built in the mid-nineteenth century, the mill retains most of its original machinery.

56 Bircham Windmill

Great Bircham, King's Lynn, Norfolk PE31 6SJ

01485 578393 www.birchamwindmill.co.uk

6 miles from Sandringham and 8 miles from Hunstanton. Follow brown signs from Bircham village

Open Easter–30 Sept: 10–5

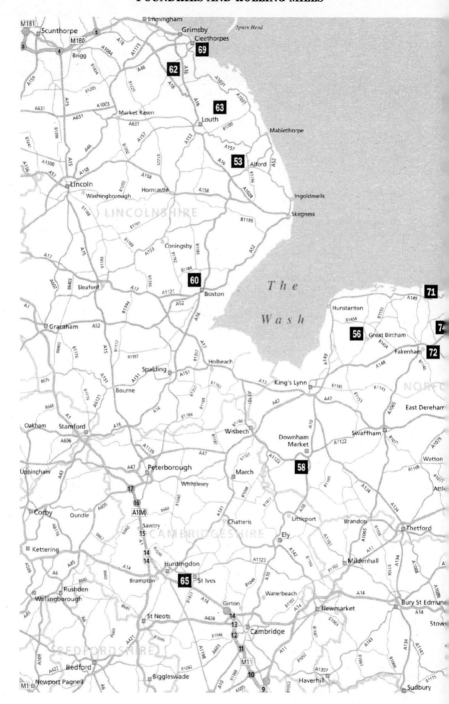

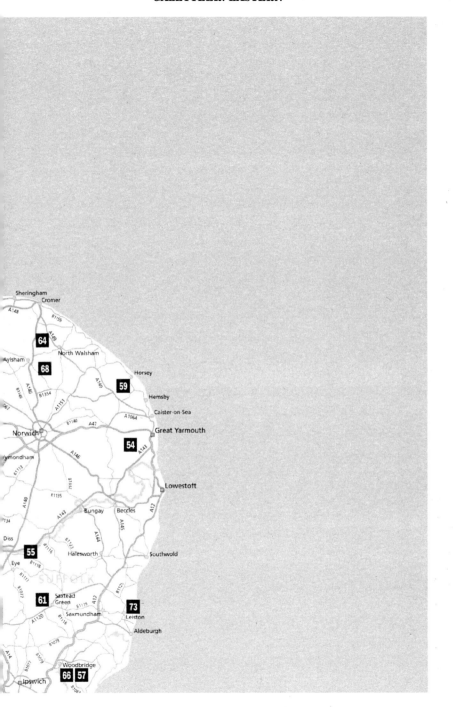

A tower mill built in 1846 on the site of a previous post mill. This five-storey mill, with a sail span of 67 feet (20 m), drives two pairs of French burr millstones.

57 Buttrum's Windmill

Burkitt Road, Woodbridge, Suffolk IP12 4JJ
01473 264755 www.woodbridgesuffolk.info
Off A12 in Woodbridge, signposted from Grunisburgh Road roundabout
Open May–Sept: weekends and Bank Holiday Mon 2–6
Built by John Whitmore in 1836, this is a six-storey tower mill. Four sails drive four pairs of grindstones, and the ground floor includes a display of the restoration and workings of the mill.

58 Denver Windmill

Sluice Road, Denver, Norfolk PE38 0EG
01366 384009 www.denvermill.co.uk
About 2 miles S of Downham Market
Telephone for opening times
Five-storey tower corn mill built in the early nineteenth century, with one set of the original three grindstones remaining. An adjacent three-storey steam mill was added so that grinding could take place without wind, and the original steam engine was replaced by a Blackstone oil engine.

59 Horsey Wind Pump

Horsey, near Great Yarmouth, Norfolk NR29 4EF
01263 740241 www.nationaltrust.org.uk
15 miles N of Great Yarmouth on B1159
Open Apr–early Sept: daily 10–5; Sept and Oct: Wed–Sun 10–5;
Mar: Sat and Sun
A brick tower drainage mill used to pump water from the dykes until 1943. There has been a mill on the Horsey site since the eighteenth century, and the present structure dates from 1912.

60 Maud Foster Windmill

Willoughby Road, Boston, Lincolnshire PE21 9EG
01205 352188 www.maudfoster.co.uk
Follow brown signs to A16/A52 Grimsby–Skegness road; mill is close to Boston town centre
Open all year: Wed, Sat and all Bank Holiday Mons 10–5; during Easter and summer school holidays: Wed–Sat 10–5
Built in the early nineteenth century, this seven-storey tower mill has been

restored to full working order. Five sails drive three pairs of millstones, which produce wholemeal and white flour on a commercial basis.

61 Saxtead Green Post Mill

The Green, Saxstead, Woodbridge, Suffolk IP13 9QQ
01728 685789 www.english-heritage.org.uk
On A1120, about 3 miles NW of Framlingham
Open Apr–Sept: Fri, Sat and Bank Holidays 12–5
Traditional Suffolk post mill, mounted on a painted brick roundhouse. The mill is 46 feet (14 m) high and has a fantail mounted on the tail ladder. The roundhouse has three floors, which contain two pairs of millstones and a display of mill machinery.

62 Waltham Windmill

Brigsley Road, Waltham, Grimsby, Lincolnshire DN37 0JZ
01472 752122 www.walthamwindmill.co.uk
On B1203, 4 miles from Grimsby
Open Easter–Oct: Sat, Sun and Bank Holidays 10–4
Built in 1880, this six-sailed tower mill originally possessed double-sided sails. These were cut down to single-sided sails in the 1920s to improve performance in light winds. There are four pairs of stones, two French burr and two grey stones, one of each being underdriven and overdriven.

WATERMILLS

63 Alvingham Watermill (Closed)

Church Lane, Alvingham, Louth, Lincolnshire LN11 0QD
01507 327544 www.poacherguide.co.uk
3 miles NE of Louth, follow brown signs
No longer open to the public
There has been a mill on the site since the eleventh century. The present building is a three-storey working corn mill with an 11-foot (3.3-m) breast shot wheel that dates from the early nineteenth century. The iron gearing has been preserved; it drives two millstones, one of French burr and the other of Derbyshire grit.

64 Gunton Park Sawmill

Off White Post Lane, Gunton Park Estate, Norfolk NR11 7HL
01603 222705 www.norfolkmills.co.uk
Off A140 between Aylsham and Cromer, turn for Suffield
Open Apr–Sept: fourth Sun in every month 2–5; group bookings available

A water-powered sawmill built in the 1820s and now restored to working order. The mill has two water wheels that date from 1888, one of which drives a circular saw and the other a reciprocating saw. A grist mill is also operational on the site.

65 Houghton Mill

Houghton, Huntingdon, Cambridgeshire PE28 2AZ
01480 301494 www.nationaltrust.org.uk
In Houghton village, signposted off A1123 Huntingdon to St Ives road
Open end Mar–end Oct: Sat and Sun 11–5; plus Sat–Wed during May and Sept 1–5
A five-storey brick and timber watermill with parts of the building dating from the seventeenth century, and alterations added in the eighteenth and nineteenth centuries. The machinery dates from the nineteenth century and is still used to produce flour.

66 Woodbridge Tide Mill

Tide Mill Way, Woodbridge, Suffolk IP12 4SR
01473 626618 www.woodbridgesuffolk.info
Off A12, NE of Ipswich on riverside at Woodbridge, off Quayside
Open Easter and May–Sept: daily 11–5; Apr and Oct: weekends only 11–5; group bookings at other times
The present tide mill dates from 1793, although there have been mills on the site since 1170. It has a mansard roof, and a tide pond drives an 18-foot (5.5-m) water wheel. The mill is a Grade I listed building.

RAILWAYS

67 Bressingham Steam Museum

Bressingham, Diss, Norfolk IP22 2AB
01379 686900 www.bressinghamsteammuseumguide.co.uk
On A1066 Thetford road 2½ miles W of Diss
Open Mar–Oct: daily Mar–May, Sept and Oct 10.30–5; Jun–Aug 10.30–5.30
Steaming programme varies – telephone for details.
The museum houses a collection of steam locomotives ranging from small narrow-gauge engines to mainline locos. An exhibition traces the history of the railways, while narrow-gauge railways run around the site. There are also displays of traction engines, steam wagons and stationary engines.

68 Bure Valley Railway

Norwich Road, Aylsham, Norfolk NR11 6BW

01263 733858 www.bvrw.co.uk

Aylsham is on A140 N of Norwich; look for brown signposts

Open Mar–Oct and selected dates in Dec and Feb

Built on the track bed of the former East Norfolk Railway, which opened in 1880. The railway runs on 15-inch (38-cm) gauge for 9 miles (14.5km) between Aylsham and Wroxham with three stations in between.

69 Cleethorpes Coast Light Railway

Lakeside Station, Kings Road, Cleethorpes, Lincolnshire DN35 0AG

01472 604657 www.cleethorpescoastlightrailway.co.uk

Signposted within town

Open Good Friday–Sept: daily 11–6; weekends throughout the year 11–dusk; also Feb half-term

The railway runs along the coastal defences and gives good views of the Humber estuary. A variety of steam locomotives is used.

70 North Norfolk Railway

Sheringham Station, Sheringham, Norfolk NR26 8RA

01263 820800 www.nnrailway.co.uk

Take A148 King's Lynn to Cromer and follow brown signs

Open Feb and Mar: weekends 9.30–3.30; Easter–Sept: daily 11–3.30;

Oct: Tues, Thurs and weekends 11.30–3.30

Telephone 01263 820808 for timetable

The railway is part of the former Melton Constable to Cromer Beach branch line built in 1887. The line runs from Sheringham through Weybourne to Holt using a number of steam locomotives, including an LNER B1213 restored to working order after thirty years out of use.

71 Wells & Walsingham Light Railway

Wells-next-the-Sea, Norfolk NR23 1QB

01328 711630 www.wellswalsinghamrailway.co.uk

Wells station is on A149 Cromer Road. Walsingham Station is in the village of Little Walsingham, off the B110

Open 2 Apr–end Oct: daily 10–6

This is the longest 10¼-inch (26-cm) narrow-gauge railway in the world and runs a Garratt locomotive, Norfolk Hero, which was specially built for the line.

SHIPS AND ENGINEERING

72 Fakenham Museum of Gas and Local History

Hempton Road, Fakenham, Norfolk NR21 7LA

01328 863150 www.fakenhamgasmuseum.com

Follow A1065 S of the River Wensum in Fakenham

Open June–Sept: Thur, Sat and Bank Holidays 10.30–3.30

The museum gives an insight into the process by which gas was made and the working conditions of the men who made it. The pumps that fill the working gas-holders can be seen in operation on selected days.

73 Long Shop Museum

Main Street, Leiston, Suffolk IP16 4ES

01728 832189 www.longshopmuseum.co.uk

Off A12. Take B119 through Saxmundham into Leiston

Open end Mar–end Oct: Mon–Sat 10–5, Sun 11–5

The collection of exhibits concentrates on the products of the firm of Richard Garrett & Sons. The Long Shop building was conceived by Richard Garrett III as a means of assembling a range of portable steam engines on a production-line basis. The major exhibits include the 4CD agricultural tractor built in 1916 and the 'Suffolk Punch', an agricultural traction engine built in 1919.

74 Thursford Collection

Thursford Green, Thursford, Fakenham, Norfolk NR21 0AS

01328 878477 www.thursford.com

1 mile off A148, from which it's signposted

Open Good Friday–Oct: daily 12–5; Nov–Dec: by appointment

A varied collection of steam-powered machinery built up by George Cushing. The working exhibits include showman's engines, fairground rides, pipe organs, steamrollers and farm machinery. Live musical shows given daily with nine mechanical organs and a Wurlitzer.

CENTRAL
(MAP 4)

WINDMILLS

75 Danzey Green Windmill

Avoncroft Museum of Historic Buildings, Stoke Heath, Bromsgrove,
Worcestershire B60 4JR
01527 831363 or 831886 www.avoncroft.org.uk
Off A38 Bromsgrove bypass, 2 miles S of town
Open Jan and Feb: weekends only; Nov, Dec and Mar: Fri, Sat and Sun
10.30–4; Apr–Jun, Sept and Oct: Tues–Sun; Jul and Aug: daily 10.30–5
*Built in 1820, the windmill was moved to its present site at the museum in
1969. It is a post mill with a 'Midlands-type' roundhouse that grinds regularly
using a single pair of millstones.*

76 Greens Windmill

Windmill Lane, Sneinton, Nottinghamshire NG2 4QB
01159 156878 www.greensmill.org.uk
Off A612 to Southwell, 1¼ miles E of city centre
Open all year: Wed–Sun and Bank Holidays 10–4
*An early nineteenth-century tower mill that was once owned by George Green,
the mathematical physicist. The mill has been restored to working condition
and produces wholemeal flour when there is adequate wind. A hands-on
interactive science centre is also on site.*

77 North Leverton Windmill

Mill Lane, North Leverton, Retford DN22 0BA
01427 880254 www.north-leverton-windmill.co.uk
About 5 miles E of East Retford. Follow unclassified road E towards
North Leverton
Open all year: Sat 2–5 (summer); 10–3 (winter); other times by appointment
*Built in the early nineteenth century by shareholders, this tower mill has
worked ever since and is one of the few mills that is still working commercially.*

78 Tuxford Windmill

Retford Road, Tuxford, Nottinghamshire NG22 0NW
01777 871202 www.tuxford-windmill.co.uk

FOUNDRIES AND ROLLING MILLS

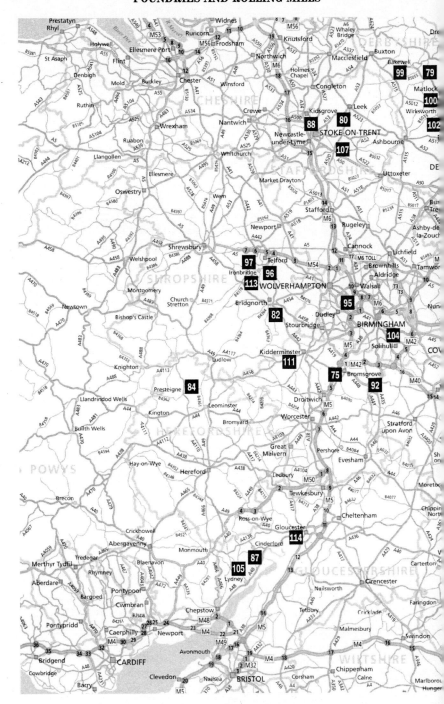

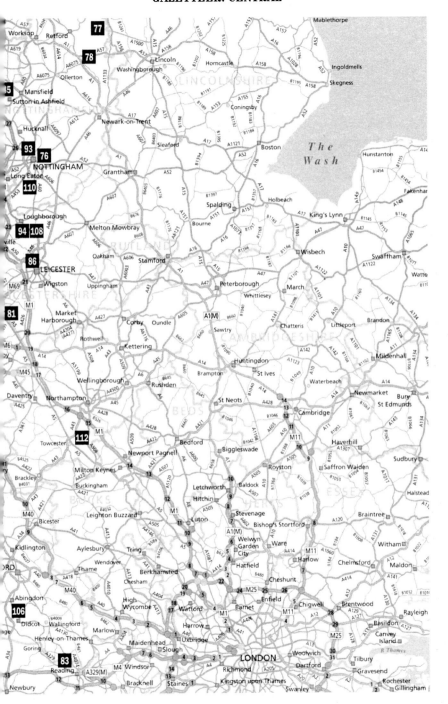

½ mile N of Tuxford, near A1

Open daily except Tues and Wed: 10–4.30. Other times by appointment

A four-storey black tower mill with four sails, which has been restored to full working order.

WATERMILLS

79 Caudwell's Mill and Craft Centre

Bakewell Road, Rowsley, Matlock, Derbyshire DE4 2EB

01629 734374 www.caudwellsmillcraftcentre.co.uk

On A6 in village of Rowsley, 5 miles N of Matlock

Open daily: 10–5.30

A nineteenth-century water turbine-powered flour mill, with flour rollers and four floors of machinery and exhibitions. Still producing flour, which is available for sale.

80 Cheddleton Flint Mill

Cheadle Road, Cheddleton, Staffordshire ST13 7HL

01614 085083 www.cressbrook.co.uk

3 miles S of Leek on A520

Open all year: weekends 2–5 and some weekdays in summer

The site has two mills, with large low breast water wheels running side by side. The older, South Mill, was a corn mill and also a fulling mill. In the late eighteenth century a second mill, North Mill, was built to grind flint for the pottery industry.

81 Claybrooke Watermill

Frolesworth Lane, Claybrooke Magna, Lutterworth, Leicestershire LE17 5DB

01455 202443 www.claybrookewatermill.co.uk

Between Claybrooke Magna and Frolesworth E of A5

Open to the public by appointment only, or contact for open days

A three-storey working watermill, built in 1780 and extended in the mid-nineteenth century. It is powered by an overshot wheel and uses two pairs of French burr stones, as well as a flour dresser and mixer.

82 Daniel's Mill

Eardington, Bridgnorth, Shropshire WV16 5JL

01746 762753 www.danielsmill.co.uk

On B4555 Highley road, ½ mile S of Bridgnorth

Open Easter–end Oct, plus school and Bank Holidays: 11–5

A working watermill driven by a 38-foot (11.5-m) water wheel. The mill sits below a viaduct on the Severn Valley Railway and produces flour.

83 Mapledurham Watermill

Mapledurham, Reading, Oxfordshire RG4 7TR
01189 723350 www.mapledurham.co.uk
3 miles NW of Reading off A4074
Open Easter–Sept: weekends and Bank Holidays 2–5.30
Working watermill with undershot wheel. Produces 100 per cent and 81 per cent wholemeal flour, which is on sale.

84 Mortimers Cross Mill and Battle Centre

Mortimers Cross, Lucton, Leominster, Herefordshire HR6 9PE
01568 708820 www.mortimerscrossmill.com
On B4362, 7 miles NW of Leominster
Open Apr–end Sept: Sundays 10–4 and Bank Holiday Mons
The watermill dating from 1750 is on the banks of the River Lugg near the 1461 battlefield of Mortimers Cross. The undershot cast-iron wheel and machinery were installed in 1871 and are still used to grind animal feed for Mill Farm. It has three sets of grindstones – one French burr and two Derbyshire gritstones. There is also an information centre about the battle of Mortimers Cross.

85 Stainsby Mill

Near Hardwick Hall, Doe Lea, Chesterfield, Derbyshire S44 5QJ
01246 850430 www.nationaltrust.org.uk
From M1 junction 29 take A6175 towards Clay Cross, then first left and first left again back under motorway and follow brown signs
Open mid Feb–Oct: Wed, Sun and Bank Holiday Mons 10–4; Dec: weekends 11–3
The present mill and machinery date from 1850, but there has been a mill on this site since the twelfth century. Powered by a 17-foot (5-m) pitchback cast-iron water wheel and driven from a line shaft, the mill uses three pairs of millstones.

STATIONARY STEAM ENGINES

86 Abbey Pumping Station

Museum of Science & Technology, Corporation Road, Leicester LE4 5PX
01162 995111 www.leicester.gov.uk
3 miles N of Leicester, off A6
Open Feb–Oct: daily 11–4.30; Nov–Jan: special events only
Built as a pumping station in 1891 and based around four large beam engines built by the local firm of Gimsons. The station ceased working in 1964 and now includes an exhibition on public health.

87 Dean Heritage Centre

Camp Mill, Upper Soudley, near Cinderford, Gloucestershire GL14 2UB
01594 822170 www.deanheritagemuseum.com
On B4227 at Upper Soudley
Open March–Oct: 10–5; Nov–Feb: 10–4

*This 'museum of the forest' is made up of five galleries, one of which is named
'Steam Power and Transport'. On show is a working Lightmoor beam engine
built by Samuel Hewlett around 1830 in his iron foundry in the Soudley Valley.
The other galleries focus on the development of the Forest of Dean. The site
also has a millpond with a water wheel.*

88 Etruria Industrial Museum

Lower Bedford Street, Etruria, Stoke-on-Trent ST4 7AF
01782 233144 www.stoke.gov.uk
Off B5054 Shelton road. Exit 15 or 16 from M6, A500 to Stoke-on-Trent,
then follow signs
Open Apr–Dec: Wed–Sun 12–4.30
Steaming on first weekend of the month, Apr–Dec. Craft demonstrations
on first weekend of the month.

*Based around the Etruscan Bone and Flint Mill that was used to grind material
for the china industry. The mill was built in 1857 and contains an 1820s' beam
engine that has been restored to full working order. There are also several other
small engines that are occasionally steamed, as well as a blacksmith's forge and
canal warehouse. An exhibition about the mill and canals is also on site.*

89 Leawood Pumphouse

Mill Lane, Cromford, Derbyshire
01629 823204 www.middleton-leawood.org.uk
Alongside Cromford Canal, off A6 between Derby and Matlock
Open Easter–Oct
Steaming occurs on selected weekends during summer.

*Built in 1849 to pump water from the river to the canal. The beam engine
was manufactured by Graham & Co. of Elsecar, Yorkshire, and is capable of
pumping 4 tonnes of water seven times a minute into the canal.*

90 Middleton Top Engine House

Middleton Top Visitor Centre, Wirksworth, Derbyshire DE4 4LS
01629 823204 www.middleton-leawood.org.uk
12 miles S of B5036, signposted from A6 in Cromford
Telephone for opening times

Sole survivor of eight winding engines built for the Cromford & High Peak Railway. The beam engine was built in 1829 and is housed in its original octagonal engine house.

MILLS AND FACTORIES

91 Cromford Mill

Mill Lane, Cromford, Derbyshire DE4 3RQ
01629 823256 www.arkwrightsociety.org.uk
Turn off A6 Derby to Matlock road at junction with B5012 and follow the brown signs
Open all year: daily 9–5
Site of the world's first water-powered cotton-spinning mill, built in 1771 by Richard Arkwright and partners, which ceased production in 1846. The are no water wheels or machinery, but excavations have uncovered the foundations of the second mill built on the site.

92 Forge Mill Needle Museum

Needle Mill Lane, Riverside, Redditch, Worcestershire B98 8HY
01527 62509 www.forgemill.org.uk
N of Redditch, off A441 Birmingham to Evesham road
Open Apr–Sept: 11–4.30; Feb, March, Oct, Nov: Tues–Fri 11–4, Sat and Sun 1–4
Water-driven needle-scouring and polishing mill. The machinery dates from the eighteenth century and is demonstrated regularly.

93 Museum of Nottingham Lace

3–5 High Pavement, Lace Market, Nottingham NG1 1HN
01159 487365 www.touruk.co.uk
Open daily: 10–5
The museum has an exhibition of lace machinery and traces the development of lace-making from the cottage industry to the Industrial Revolution. Demonstrations of lace-making on site.

IRON-, STEEL- AND METAL-WORKING

94 The Bellfoundry Museum

Freehold Street, Loughborough, Leicestershire LE11 1AR
01509 212241 www.taylorbells.co.uk
In Loughborough, off M1 junction 23
Open currently only for pre-booked tours

The museum is part of the working John Taylor's bellfoundry. The exhibitions chart the changes in the craft of bell making, showing techniques of moulding, casting, turning and fitting. At selected times you can combine a visit with the modern bell-works and see a bell being cast.

95 Black Country Living Museum

Tipton Road, Dudley, West Midlands DY1 4SQ
0121 557 9643 www.bclm.co.uk
On A4037, 10 miles from Birmingham centre, and signposted from M5 junction 2
Open Mar–Oct: daily 10–5; Nov–Feb: Wed–Sun 10–4
A 26-acre (10.5-ha) open-air museum relating to the social and industrial history of the Black Country. Exhibits include the Racecourse Colliery with underground tour and working replica Newcomen engine; Castlefields Ironworks complete with the rolling mill; and a variety of workshops, including a glasscutter's, an engine shed and brass foundry. There is also an early twentieth-century village with a school, chapel, inn and shops.

96 Blists Hill Victorian Town

Ironbridge Gorge Museums, Telford, Shropshire TF7 5DU
01952 884391 www.ironbridge.org.uk
Brown and white signs from M54 via M6 and on all main routes into Telford. The different sites are signposted within the gorge
Open daily: 10–5
A re-creation of town life at the turn of the last century, including shops and cottages. The site contains a small 'jobbing' foundry, which used the greensand casting method and made a range of products from statues to doorstops, a wrought-iron-works and a mine with steam winding engine.

97 Coalbrookdale

Ironbridge Gorge Museums, Telford, Shropshire TF8 7DQ
01952 884391 www.ironbridge.org.uk
Brown and white signs from M54 via M6 and on all main routes into Telford. The different sites are signposted within the gorge
Open daily: 10–5
The site where Abraham Darby first smelted iron with coke. The Museum of Iron, in the Great Warehouse built in 1838, tells the story of iron and steel and exhibits many of the Coalbrookdale decorative iron and bronze castings. The site also contains the Darby Furnace, the Rosehill and Dale House, and the restored homes of the Quaker ironmasters. See also Ironbridge Gorge Museums, page 163.

98 Moira Furnace

Furnace Lane, Moira, Swadlincote, Derbyshire DE12 6AT
07976 673858 www.moirafurnace.org.uk
On B586 and B5003 from Swadlincote to Measham
Open 1 May–30 Sept: Tues–Sun 10–4; 1 Oct–30 Apr: Tues–Sun 11–3 and
Bank Holiday Mons
An early nineteenth-century blast furnace built by the Earl of Moira.

MINING AND QUARRYING

99 Magpie Mine

Sheldon, Bakewell, Derbyshire
01629 583834 www.derbyshire-peakdistrict.co.uk
About 3 miles W of Bakewell, off B5055 Macclesfield road
Telephone for opening times; public footpath through site at any time,
staffed at weekends
*The surface remains of lead-mining from the eighteenth century that were last
worked in 1958. The shells of the winding house and boilerhouse remain,
along with a number of other buildings used by the Peak District Mining
Historical Society as a field centre.*

100 Peak District Mining Museum

The Pavilion, Matlock Bath, Derbyshire DE4 3NR
01629 583834 www.peakmines.co.uk
Off A6 and signposted within town
Open Apr–Oct: daily 10–5; Nov–Mar: daily 11–4
*The museum explains the history of Derbyshire's lead industry from Roman
times to the present, and artefacts on display include lead ingots from the
Roman period which were found on the land. There is also an 1819 Trevithick
water pump on display, which was retrieved from 360 feet (110 m) under
ground in the Winster Mine.*

101 Temple Mine

The Pavilion, Matlock Bath, Derbyshire DE4 3NR
01629 583834 www.peakmines.co.uk
Off A6 in Matlock Bath. Follow signs within town
Open Easter–Oct: daily 12–4; Nov–Easter: weekends only
*A fluoride mine opened in 1922 which supplied the mineral for use in the
iron and steel industry, as well as for the fluoride additive in toothpaste and
drinking water. The underground tour of the mine illustrates the geology,*

mineralization and mining techniques used during the 1920s.

102 Wirksworth Heritage Centre

Crown Yard, Wirksworth, Derbyshire DE4 4ET

01629 825225 www.storyofwirksworth.co.uk

On B5023, signposted within town

Open Good Fri–end Sept: Wed–Sat and Bank Holidays 10.30–4.30, except Sundays 1.30–4.30

Housed in an old silk and velvet mill, the centre explains the history of the town's lead-mining and quarrying industry. Exhibits include an early twentieth-century quarryman's houseplace with a grandfather's recorded reminiscences of life at the quarries when he was a child.

RAILWAYS

103 Battlefield Line Railway

Shackerstone Station, Shackerstone, Leicestershire CV13 0BS

01827 880754 www.battlefield-line-railway.co.uk

3 miles NW of Market Bosworth on B585 at Shackerstone Station

Open: Sat and Sun 11–5 all year round. Trains at weekends and Wed afternoon in summer

The line runs from Shackerstone to Shenton, site of the Battle of Bosworth Field. The museum houses a collection of rolling stock and other interesting artefacts from the age of steam rail travel.

104 Birmingham Railway Museum

670 Warwick Road, Tyseley, Birmingham B11 2HL

0121 708 4960 www.vintagetrains.co.uk

On A41 Warwick road, 5 miles E of city centre

Telephone or check website for opening times

The museum is on the site of a former Great Western Railway steam shed and locomotive works. It houses a dozen steam locomotives, ranging from the 7029 Clun Castle to Henry, a tiny industrial tank engine. Exhibits can be viewed on the fully operational turntable and inside the workshop, where restoration projects are undertaken.

105 Dean Forest Railway

Norchard, Forest Road, Lydney, Gloucestershire GL15 4ET

01594 845840 www.deanforestrailway.co.uk

On B4234 N of Lydney and signposted in the forest

Open daily 11–4. Telephone or check website for train running times
A standard-gauge branch line, mainly steam operated between Norchard and Lydney Junction. Several steam locomotives, coaches and railway equipment are on show at the museum in the Norchard Centre.

106 Didcot Railway Centre

Didcot, Oxfordshire OX11 7NJ
01235 817200 www.didcotrailwaycentre.org.uk
10 miles S of Oxford, signposted from M4 junction 13 and A34
Open Sat and Sun all year; June–Sept and school holidays daily 10.30–5; closes at 4 in winter
The Great Western Railway ran from London to Bristol through Didcot. The centre is based around the old engine shed, which houses a collection of locomotives, passenger coaches and freight wagons. A 1930s' country station has also been created, complete with a ticket office, waiting room, level crossing and signal box.

107 Foxfield Steam Railway

Caverswall Road Station, Blythe Bridge, Stoke-on-Trent ST11 9BG
01782 396210/259667 www.foxfieldrailway.co.uk
Off A50 Stoke-on-Trent to Derby
Open Easter–end Sept: Sun and Bank Holidays 10.30–5.30. Oct: Sun; special events in Dec. Telephone for daily train timetable.
The railway was constructed in 1893 to carry coal from Foxfield Colliery to the North Staffordshire Railway at Blythe Bridge. A museum houses a collection of locomotives and rolling stock.

108 Great Central Railway

Great Central Road, Loughborough Central, Leicestershire LE11 1RW
01509 230726 www.gcrailway.co.uk
In Loughborough town centre, signposted from A6
Telephone or check website for opening times
Telephone for train timetable
This mainline steam railway runs over 8 miles (13 km) from Loughborough Central to Leicester. At Loughborough Central there is a working engine shed and a museum charting the line's history.

109 Midland Railway Centre

Butterley Station, Ripley, Derbyshire DE5 3QZ
01773 747674 www.midlandrailwaycentre.co.uk
On B6179, 1 mile N of Ripley

Open all year: weekends 10–4.15. Trains run on selected days, Mon–Fri.
Visitor information line: 01773 570140
*The railway exhibition hall contains locomotives and rolling stock covering over
100 years of railway history from the 1860s. Trains run between Butterley Station
and Swanwick, while a narrow-gauge railway runs through the country park.*

110 Nottingham Transport and Heritage Centre

Mere Way, Ruddington, Nottinghamshire NG11 6NX
01159 405705 www.nthc.co.uk
3 miles S of the city centre, just off A52 ring road
Open Feb half-term; Apr–Aug: Sat, Sun and Bank Holiday Mons; Sept–
Oct: Sun only and half-term Sat; Nov–Dec: specials only
*Steam trains run on a 2-mile (3-km) round trip within Rushcliffe Country Park
at Ruddington. The centre also has a miniature railway and a classic public
road transport collection.*

111 Severn Valley Railway

The Railway Station, Bewdley, Worcestershire DY12 1BG
01299 403816 www.svr.co.uk
Kidderminster Station (where line begins) is in town centre 50 yards
(45 m) from the BR station
Open all year: weekends; late May–early Oct, daily. Telephone for
timetable information
*A standard-gauge steam railway with services operating on 16 miles (25 km)
of track from Kidderminster to Bridgnorth with four stations in between. The
railway has twenty-eight steam locomotives, as well as over sixty coaches and
seventy goods wagons.*

SHIPS AND ENGINEERING

112 Stoke Bruerne (formerly Canal Museum)

National Waterways Museum, Stoke Bruerne, near Towcester,
Northamptonshire NN12 7SE
01604 862229 www.nwm.org.uk/stoke
From M1 junction 15 take A508 to Stoke Bruerne and follow brown signs
Open summer: daily 10–5; winter: Wed–Fri 10–4 and weekends 11–4
(closed Tues)
*The museum, an old mill situated on the canal side, portrays the history of over
200 years of canal navigation.*

113 Ironbridge Gorge Museums

Ironbridge, Telford, Shropshire TF8 7AW
01952 884391 www.ironbridge.org.uk
Signposted from M54
Open all year: daily 10–5
The site is spread over 6 square miles (15.5 sq km). The Jackfield Tile Museum is based around two decorative tile-works; the Blists Hill Victorian Town re-creates life at the turn of the last century; the Coalport China Museum houses a collection of Coalport china and displays on how it was produced; at Coalbrookdale, the Museum of Iron recounts how iron was first smelted with coke in 1709; and at Ironbridge, the visitors' centre provides an introduction to the history of the valley. Crafts and skills are demonstrated (carpenter, cobbler, foundry, leatherwork, tinsmith, potter, glazier) and all work is on sale.

114 National Waterways Museum

Llanthony Warehouse, The Docks, Gloucester GL1 2EH
01452 318200 www.nwm.org.uk
Follow brown signs for Historic Docks in Gloucester
Open daily throughout the year 11–4
Based within Gloucester Docks, the museum occupies three floors of a Victorian warehouse. The museum recounts the 200-year story of Britain's first transport system with the use of models, archive film and hands-on exhibits. The quay sports a variety of boats, including an 82-foot (25-m long) No. 4 steam dredger and the Northwich, *built in 1898 as a horse-drawn boat.*

115 Snibston Discovery Museum

Ashby Road, Coalville, Leicestershire LE67 3LN
01530 278444 www.leics.gov.uk
At junction of A511 and A447 between Leicester and Ashby-de-la-Zouch
Open Apr–Oct: daily 10–5; Nov–Mar: Mon–Fri 10–3, weekends and school holidays 10–5
Situated in the former Snibston Colliery, the site includes a surface tour of the mineshaft, winding engine, explosives store and control room. The exhibition hall houses a number of interesting galleries, including Engineering, Transport, Extractive Industries, and Textile and Fashion.

WALES
(MAP 5)

WINDMILLS

116 Llynnon Mill

Holyhead, Isle of Anglesey LL65 4AB

01407 730797 www.attractionsnorthwales.co.uk

About 8 miles NE of Holyhead, signposted on A5025 and B5109

Open Mar–end Sept: daily 11–5

A four-storey stone tower mill built in 1776, with a boat-shaped cap and common sails. Three pairs of millstones, one French burr, one Anglesey stone and one bed stone. Three craft shops on site.

WATERMILLS

117 Cenarth Mill

Near Newcastle Emlyn, Carmarthenshire SA38 9JL

01239 710980 www.welshmills.org.uk

On the banks of the River Teifi at Cenarth Falls (A484)

Open Easter–Oct: daily 10.30–5.30; other times by appointment
(telephone 01239 710507)

A water-powered corn mill probably dating from the seventeenth century, with undershot timber and cast-iron water wheel. There are two pairs of stones, one for barley and the other for oats. Production of flour is limited to high-river conditions at present.

118 Y Felin

St Dogmaels, near Cardigan, Ceredigion SA43 3DY

01239 613999 www.yfelin.talktalk.net

About 1 mile W of Cardigan. Second turning on left when entering
St Dogmaels

Open all year: Mon–Sat 10–5.30

The base of the mill is medieval; it was renovated in 1820. An overshot water wheel drives three sets of millstones and also contains a flour bolter and an oatmeal kiln producing wholemeal and speciality flours.

119 Ffestiniog Power Station

Ffestiniog Visitor Centre, Tan-y-Grysiau, Blaenau Ffestiniog,

Gwynedd LL41 3TP
01766 830465 www.fhc.co.uk
Off A496 SW of Blaenau Ffestiniog
Telephone for visiting times
Opened in 1963, it was the first hydroelectric-pumped storage scheme. Water is released from an upper dam through the turbines to generate electricity. The visitor centre has exhibitions and demonstrations explaining the origins of electricity.

MILLS AND FACTORIES

120 Gower Heritage Centre (formerly Abbey Woollen Mill)

Parkmill, Gower, Swansea SA3 2EH
01792 371206 www.gowerheritagecentre.co.uk
On 14118 (S Gower road), 8 miles W of Swansea
Open daily: 10–5
The original factory was based in Neath but was moved to the museum in 1974. Most of the machinery is from the nineteenth century, including the carding set and looms. The traditional methods of production are demonstrated daily. There is a display that illustrates the history of the woollen industry in south-west Wales, using equipment from the former Abbey Woollen Mill at Neath; it shows how fleece is turned into a finished fabric.

121 National Wool Museum (formerly Museum of the Welsh Woollen Industry)

Dre-Fach Felindre, near Newcastle Emlyn, Llandysul, Ceredigion SA44 5UP
01559 370929 www.museumwales.ac.uk
Off A484, in village of Dre-Fach Felindre, between Carmarthen and Newcastle Emlyn
Open Apr–Sept: daily 10–5; Oct–Mar: Tues–Sat 10–5
The museum occupies the site of the former Cambrian Mills, built in 1902 and 1912. An exhibition traces the wool from fleece to fabric, and demonstrations are given of hand-carding, spinning, and hand-loom and power weaving. Cloth made by the staff is washed, dried and pressed using traditional methods and is on sale.

122 Penmachno Woollen Mill

Penmachno, near Betws-y-coed, Gwynedd LL24 0PS
01690 710545 www.penmachno.net
About 2 miles S of Betws-y-coed, take A5 in direction of Llangollen, turn right on to B4406 signposted Woollen Mill

FOUNDRIES AND ROLLING MILLS

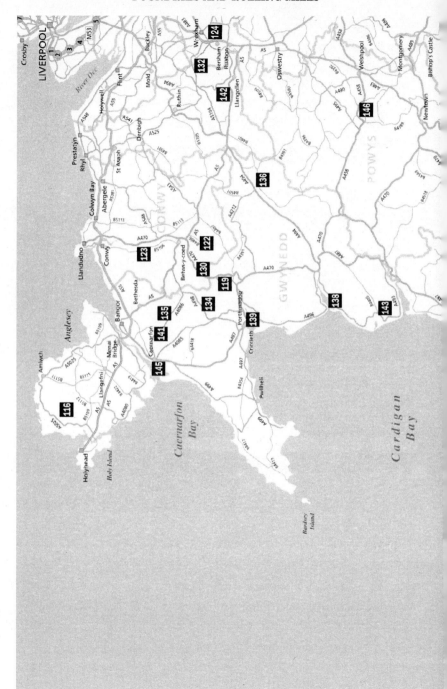

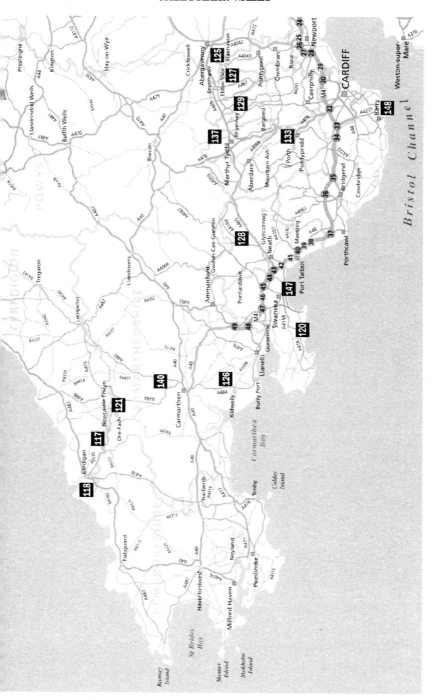

Open daily: 10–5.30

A working woollen mill that uses nineteenth-century power looms to produce lightweight tweed and rug cloth. An exhibition explains the process and the history of the mill.

123 Trefriw Woollen Mills

Trefriw, Conwy, Gwynedd LL27 0NQ

01492 640462 www.t-w-m.co.uk

In Trefriw, on B5106 Betws-y-coed to Conwy road

Open daily: Apr–Oct 9.30–5.30; Nov–Dec 9.30–5; Jan–Mar 10–5

Originally an eighteenth-century fulling mill, the water wheels were dismantled in 1900 and replaced by a hydroelectric scheme. All the processes of the mill are demonstrated – blending, carding, spinning, dyeing, warping and weaving. The produce is on sale.

IRON-, STEEL- AND METAL-WORKING

124 Bersham Ironworks and Heritage Centre

Bersham, Wrexham, Clywd LL14 4HT

01978 318970 www.wrexham.gov.uk

2 miles from Wrexham, follow signs for Bersham and the Clywedog Valley from A483

Open Easter, summer and half-terms: Thurs–Mon 12–5; Apr–July: Sat and Sun only 12–5; Bank Holiday Mons 12–5

Based around the unearthed remains of the eighteenth-century iron-works, the museum recounts the history of the furnace and foundry that produced cannon for the American War of Independence and cylinders for James Watt's steam engines.

125 Blaenavon Iron Works

North Street, Blaenavon, Blaenau, Gwent NP4 9RN

01495 792615 www.cadw.wales.co.uk

From A4042 to Pontypool take A4043 signposted Blaenavon. Follow signs for Big Pit and Blaenavon Iron Works

Open Apr–Oct: daily 10–5; Nov–Mar: Fri and Sat 9.30–4, Sun 11–4

Iron was first produced at Blaenavon in 1787 by three English businessmen. The principal features of the site remain, including cast houses, furnaces and calcining kilns. The site is preserved by CADW Welsh Historic Monuments.

126 Kidwelly Industrial Museum

Broadford, Kidwelly, Carmarthenshire SA17 4LW
01554 891078 www.kidwellyindustrialmuseum.co.uk
Signposted from Kidwelly bypass, 1 mile from Kidwelly
Open June–Sept: weekdays and Bank Holidays 10–5, Sat and Sun 12–5
*The museum exhibits the processes and machinery by which tin plate was
made at the Kidwelly tin-plate works. In addition, the museum has preserved
the machinery from the industries that served the works, including the mining
and steel industry. At the coal complex the story of the mining is recounted
with the use of a winding engine and pithead gear.*

MINING AND QUARRYING

127 Big Pit Mining Museum

Blaenavon, Torfaen NP4 9XP
01495 790311 www.museumwales.ac.uk
Off B4246; follow brown signs from M4 junction 26 eastbound and
junction 25 westbound
Open daily 9.30–4.30; underground tours 10–3.30
*The Big Pit was a working coal-mine until 1980 and is now a museum of the
South Wales mining industry. The underground tour begins with a 300-foot (9-
m) descent in a pit-cage and then charts the evolution in coal-mining techniques.
On the surface there are the colliery buildings, including a winding engine house,
blacksmith's and pit baths, with exhibitions and simulated mining galleries.*

128 Cefn Coed Colliery Museum

Neath Road, Crynant, Neath, Port Talbot, West Glamorgan SA10 8SN
01639 750556 www.neath-porttalbot.gov.uk
5 miles N of Neath on A4109
Open Apr–Sept: daily 10–6; other periods 10.30–4
*The museum is on the site of a former working colliery and tells the story
of mining in the Dulais Valley. A steam winding engine has been preserved
and is operated on electricity for demonstrations. There is also a simulated
underground mining gallery, boilerhouse, compressor house and exhibition area.*

129 Elliot Colliery

The Winding House, Cross Street, New Tredegar, Gwent NP24 6EG
01443 822666 www.caerphilly.gov.uk
From A465 follow A469 to New Tredegar, signposted to Rhymney
Open Tues–Sun: 10–5

The museum traces the history of coal and the effects of industry on the area. The winding engine has been restored to full working order.

130 Llechwedd Slate Caverns

Blaenau Ffestiniog, Gwynedd LL41 3NB
01766 830306 www.llechwedd-slate-caverns.co.uk
Beside A470 between Llandudno and Porthmadog, 11 miles (17.6 km) from Betws-y-Coed
Open Apr–Sept: daily 10–5.15; Oct–Mar: daily 10–4.15
Two underground rides explore this nineteenth-century slate-mine. The miners' tramway carries visitors into areas where early mining conditions have been re-created, while the Deep Mine is reached by an incline railway and includes visual displays. The on-site village has been restored and includes an old bank and miners' pub.

131 Llywernog Silver Lead Mine

Ponterwyd, Aberystwyth, Ceredigion SY23 3AB
01970 890620 www.silverminetours.co.uk
On A44 between Aberystwyth and Ponterwyd
Open Mar–May: 10–5; June–Aug: 10–6; Sept–Oct: 11–5
Telephone for timetable and prebooking: 01545 570823
A traditional water-powered metal-mine that was worked between 1745 and 1910. The heritage trail tells the story of silver- and lead-mining in Wales, while the underground tour explores the eighteenth-century tunnels and chambers. Other exhibits include the 1870 counting house, a rock-crusher house and an engine shaft and head frame.

132 Minera Lead Mines

Bersham Heritage Centre, Bersham, Wrexham, Clywd LL14 4HT
01978 261529 www.wrexham.gov.uk
Follow signs on A525 Ruthin road, passing through Coedpoeth, then follow B5426 for 2 miles
Open Easter and summer: Thurs–Mon 12-5; April–July: Sat and Sun only 12–5
Archaeological remains of the nineteenth-century lead-mine, including the restored engine house. The visitor centre has displays relating to the mine's history and the people who worked there.

133 Rhondda Heritage Park

Lewis Merthyr Colliery, Coed Cae Road, Trehafod, Nr Pontypridd CF37 2NP

01443 682036 www.rhonddaheritagepark.com
Off A470 between Pontypridd and Porth
Open all year: daily 9–4.30; closed Mons during Oct–Easter
The park is situated on the former colliery of Lewis Merthyr. In the restored pithead buildings an audio-visual presentation tells the story of the people who lived and worked in the Rhondda. The underground tour includes a cage ride to the 'Pit Bottom' and a guided tour through the underground roadways of the colliery pre-mechanization and the working coalface.

134 Sygun Copper Mine
Beddgelert, Snowdonia, Gwynedd LL55 4NE
01766 510100 www.sygun-coppermine.co.uk
1 mile from Beddgelert on A498 to Capel Curig
Open March–Oct: 9.30–5
The underground tour explores the workings of this nineteenth-century copper-mine, and each stage of the mining process is explained by audio-visual presentations. There are wind tunnels and large chambers, large stalactite and stalagmite formations, and copper ore veins that contain traces of gold and silver.

135 Welsh Slate Museum
Gilfach Ddu, Padarn Country Park, Llanberis, Gwynedd LL55 4TY
01286 870630 www.wales-underground.org.uk
Follow signs for Llanberis from A55 Expressway and A5
Open Easter–Oct: daily 10–5; Nov–Easter: Sun–Fri 10–4
Most of the machinery on this site was originally driven by the 50-foot (15-m) water wheel, which is still in working order. The quarry workshop continues to be operational, while the forge produces specialized tools and gifts. There is also a narrow-gauge steam locomotive and loco shed on site.

RAILWAYS
136 Bala Lake (Llyn Tegid) Railway
The Station, Llanuwchllyn, Gwynedd LL23 7DD
01678 540666 www.bala-lake-railway.co.uk
The A494 trunk road runs along the opposite side of the lake and a side road at the south-west end leads to Llanuwchllyn
Trains run in July and Aug daily; Apr–June and Sept: not on Mon and Fri
The steam locomotives that once worked in the slate quarries of North Wales now haul passenger coaches for 4½ miles (7.2 km) from Llanuwchllyn station along the lake.

137 Brecon Mountain Railway

Pant Station, Merthyr Tydfil CF48 2UP

01685 722988 www.breconmountainrailway.co.uk

Off A465, about 3 miles N of Merthyr Tydfil

Open Easter–late Oct: Tues–Thurs and weekends; Aug: daily; Sept and Oct: closed some days. Times vary, so telephone first

A narrow-gauge railway using vintage steam locomotives to cover the 7-mile (11-km) round trip into the Brecon Beacons National Park along the length of the Taf Fechan Reservoir to Dol-y-Gaer

138 Fairbourne Steam Railway

Beach Road, Fairbourne, Gwynedd LL38 2EX

01341 250362 www.fairbournerailway.com

On A493 into Fairbourne, signposted from Dolgellau

Open Feb half-term, Apr–Oct: most days 10–5; Santa Specials in Dec

Built-in 1890 as a horse-drawn railway to carry building materials for the construction of Fairbourne village, it was later converted to steam and now runs 2½ miles (4 km) to Penrhyn Point, where it connects with the ferry to take passengers across to Barmouth. Four steam engines operate the service along the 12¼-inch (31-cm) gauge.

139 Ffestiniog Railway

Harbour Station, Porthmadog, Gwynedd LL49 9NF

01766 516000 www.ffestiniograilway.co.uk

Harbour Station is at the end of the High Street in Porthmadog

Open Apr–Oct and selected days during rest of year

The steam-hauled narrow-gauge railway runs along a 13½-mile (22-km) track from Porthmadog through Snowdonia National Park to Blaenau Ffestiniog. The route allowed the original slate-filled wagons to run down to the coast by gravity, while horses were used to pull the empty wagons up the line. Steam locomotives replaced horsepower in 1863.

140 Gwili Railway

Bronwydd Arms Station, Carmarthen, Carmarthenshire SA33 6HT

01267 238213 www.gwili-railway.co.uk

Bronwydd Arms is signposted off A484 Carmarthen to Cardigan road, 3 miles N of Carmarthen

No regular opening hours. Telephone 01267 230666 for timetable

The railway runs over 1½ miles (2.4 km) from its southern terminus at Bronwydd Arms Station to a riverside station at Llwyfan. The station building

was built in 1911 and was moved to the railway from Felin Fach,
near Aberaeron.

141 Llanberis Lake Railway
Gilfach Ddu, Llanberis, Gywnedd LA55 4TY
01286 870549 www.lake-railway.co.uk
Off A4086 Caernarvon to Capel Curig road
Open Feb half-term, late Mar–Oct: weekdays 11–4.30; weekends 1–5
Telephone ahead to confirm, as occasionally closed Sat
The railway was formerly used to carry slate from the nearby quarry. Steam
locomotives from 1889 to 1948 cover the 4-mile (6.4-km) return trip along the
shore of Padarn Lake.

142 Llangollen Railway
The Station, Abbey Road, Llangollen LL20 8SN
01978 860979 www.llangollen-railway.co.uk
Llangollen station is between the A5 and A542, adjacent to the bridge over
the River Dee
Open May–early Oct: daily – first train 11; Nov–Apr: weekends; also
weekends and school holidays throughout the year
This standard-gauge steam railway runs on an 8-mile (13-km) track from
Llangollen to Carrog Station and offers a Pullman-style dining-train as well as
scheduled steam services.

143 Talyllyn Railway
Wharf Station, Tywyn, Gwynedd LL36 9EY
01654 710472 www.talyllyn.co.uk
On A493 in Tywyn
Open late Mar–Oct: daily 9.30–5; mid-July–end Aug: daily 9–6.30;
telephone to check winter dates
Built in 1865, this 27-inch (68.5 cm) gauge railway runs from Tywyn on
Cardigan Bay to Nant Gwernol. The round trip includes a stop at Dolgoch
Falls. There is a narrow-gauge railway museum at Tywyn, with a display of
locomotives from Welsh slate quarries and other memorabilia.

144 Vale of Rheidol Railway
Park Avenue, Aberystwyth, Ceredigion SY23 1PG
01970 625819 www.rheidolrailway.co.uk
Adjacent to the BR station in the town
Open Apr–Oct: daily; closed Mon and Fri during Apr and Sept–Oct;

closed Fri during May and Sept

The railway opened in 1902 to serve the lead-mines and the timber and passenger traffic of the Rheidol Valley. The journey between Aberystwyth and Devil's Bridge takes an hour in each direction and the train overcomes a height difference of 600 feet (183 m).

145 Welsh Highland Railway

St Helen's Road, Caernarvon, Gwynedd LL55 2YD
01766 516000 www.welshhighlandrailway.net
Follow A487 through town. Follow filter for Porthmadog
Open Easter–early Nov: daily; closed some Mons in Apr, May and Oct
Telephone for timetable information

The Welsh Highland Railway Project has now opened the line from Caernarfon through Bedgellert to Hafod y Llyn and hopes to extend to Porthmadog in 2010.

146 Welshpool & Llanfair Railway

The Station, Llanfair Caereinion, Powys SY21 0SF
01938 810441 www.wllr.org.uk
Welshpool and Llanfair are alongside A458 Shrewsbury to Dolgellau road
Open Apr–May: weekends and selected dates; Jun–mid-July: Tues–Thurs and weekends; late-July–mid-Sept: daily; late Sept: Tues–Thurs and weekends; other opening times by appointment; trains 10.30–4.15 throughout the year

The railway was opened in 1903 to connect the farming communities with Welshpool, the local market town. The two original locomotives, built by Beyer Peacock in 1902, survive: the Countess is running, while the Earl is undergoing restoration. There are also samples of original rolling stock, as well as Continental locos and coaches.

SHIPS AND ENGINEERING

147 National Waterfront Museum (formerly Swansea Maritime and Industrial Museum)

Oystermouth Road, Maritime Quarter, Swansea SA1 3RD
01792 638950 www.museumwales.ac.uk
M4 junction 42, then follow signposts into city
Open daily 10–5

This museum tells the story of industry and innovation in Wales, over the last 300 years. It shows communities and lives and the contribution of transport materials and networks.

148 Waverley Paddle Steamer

Gwalia Buildings, Barry Docks, South Glamorgan CF62 5QR

08451 304647 www.waverleyexcursions.co.uk

A4055 to Barry, then follow signs for the docks

Telephone for details of departure points

This sea-going paddle steamer was built in 1947 in the Clyde shipyards. The Waverley is powered by triple-expansion engines and is capable of 18 knots.

NORTH-WEST
(MAP 6)

WINDMILLS

149 Marsh Windmill

Marsh Mill in Wyre, Marsh Mill Village, Thornton, Lancashire FY5 4AE

01253 860765 www.cleveleys.co.uk

M55 junction 3 then A585 to Fleetwood. Signposted to Marsh Mill Village at third roundabout

Open Apr–Oct: daily 10.30–5; Nov–Mar: daily 11–4

Built in 1794, the mill stands 70 feet (21 m) high and since being restored has been powered by an electric motor. Guided tours are given, and a tourist village has been built up around the mill.

WATERMILLS

150 Eskdale Mill

Boot, Cumbria CA19 1TG

01946 723335 www.eskdalemill.co.uk

About 8 miles E of Gosforth, at end of the Ravenglass & Eskdale Railway

Open Apr–Sept: 11.30–5.30 (closed some Mons); Bank Holiday Mons 11–5

A working mill dating back to the sixteenth century, with two external overshot water wheels. It contains its original wooden machinery and an oatmeal kiln. Now mills animal feed.

151 Heron Corn Mill and Museum of Paper Making

Mill Lane, Beetham, Milnthorpe, Cumbria LA7 7PQ

01539 564271 www.heronmill.org

1 mile S of Milnthorpe on A6. Follow brown signs at Beetham

Open Wed–Sun 11–4

Dating from around 1740, the mill is of the Lowder type of arrangement, having its four pairs of stones mounted on a frame above the floor level. The giant spur wheel, stone nuts and bridge trees are all within the frame, and the power is provided by a 14-foot (4.2-m) high breast-shot wheel with metal buckets from a launder or trough.

152 Little Salkeld Water Mill,

Penrith, Cumbria CA10 1NN

01768 881523 www.organicmill.co.uk
1 mile off A686 Penrith to Alston road
Open daily 10.30–5
*Built in 1750 with two overshot water wheels, and enlarged in 1870. In full
operation and producing organic flours. Milling and bread-making courses
are available.*

153 Muncaster Watermill (Closed)

Ravenglass, Cumbria CA18 1ST
01229 717232
Off A595, 1 mile N of Ravenglass
Presently not open to the public
*A seventeenth-century mill with nineteenth-century machinery that is used
regularly to produce organic flours. A layshaft drive from the 13-foot (4-m)
overshot water wheel powers three pairs of millstones. Also includes ancillary
machinery and a kiln.*

154 Nether Alderley Mill

Congleton Road, Nether Alderley, Cheshire SK10 4TW
01625 445853 www.nationaltrust.org.uk
On A34, 1½ miles S of Alderley Edge
Open only to booked groups
*A sixteenth-century mill with mainly Victorian machinery that is driven by
tandem overshot water wheels enclosed within the building. The wheels are
12 feet (3.6 m) in diameter and the mill has two sets of French burr millstones
that grind flour occasionally for demonstrations.*

STATIONARY STEAM ENGINES

155 Ellenroad Engine House

Elizabethan Way, Newhey, Rochdale, Lancashire OL16 4LG
07789 802632 www.ellenroad.org.uk
Beside M62 junction 21. Take A640 S, drive under the bridge, then turn
first right
Open Easter–Oct: Sun 12–4; Nov, Dec and Feb–Easter: first Sun of each
month 12–4. In steam first Sun of each month (except Jan)
*The Ellenroad Cotton Mill was demolished in 1985, but the engine house and
220-foot (67-m) chimney remain. The twin, tandem compound steam engine
produces 3000 horsepower and is powered by one of the original boilers. An
1842 Whitelees Beam Engine has also been erected in the former boilerhouse.*

FOUNDRIES AND ROLLING MILLS

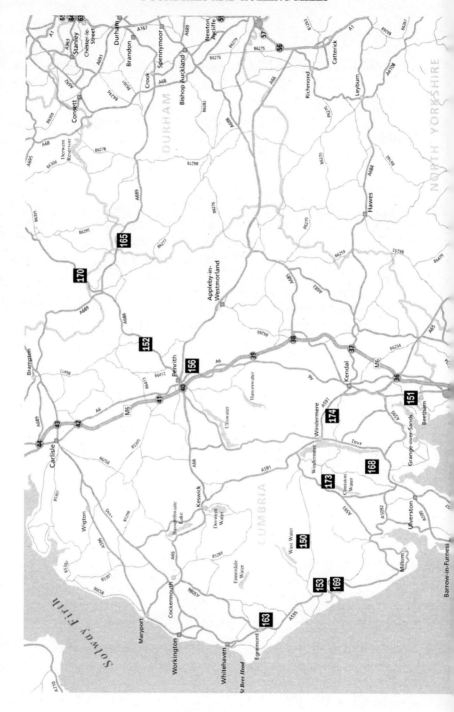

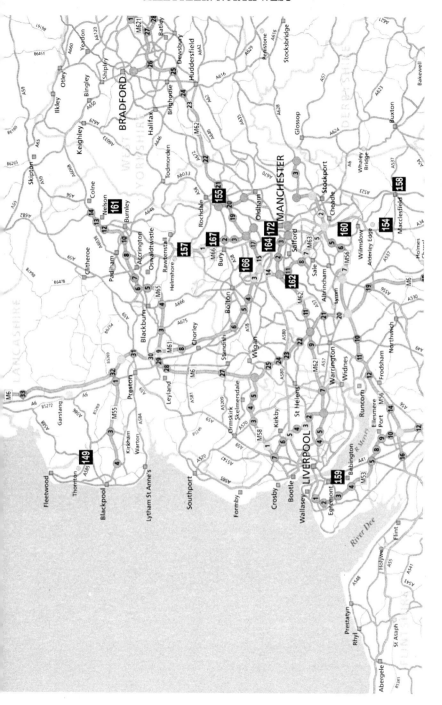

156 Wetheriggs Pottery (Closed)

Clifton Dykes, Penrith, Cumbria CA10 2DH
01768 892733
2 miles S of Penrith off A6
Pottery now closed. Ring for details.
Originally built as a brickyard and tilery in 1855, Wetheriggs became a pottery ten years later. The original steam engine and the boiler of this steam-powered pottery have been fully restored.

MILLS AND FACTORIES

157 Helmshore Mills Textile Museum

Holcolme Road, Helmshore, Rossendale, Lancashire BB34 4NP
01706 226459 www.lancashire.gov.uk
Helmshore is 1 mile S of Haslingden on the B6235
Open Apr–Oct: Mon–Fri 12–4, Sat and Sun 12–5
Two stone-built mills that depict the history of the Lancashire textile industry. Higher Mill, built in 1789, is a water-powered woollen fulling mill, while the adjacent Whitakers Mill is a cotton-spinning mill with its original machinery.

158 Silk Museum, Paradise Mill

Park Lane, Macclesfield, Cheshire SK11 6TJ
01625 618228 www.macclesfield.silk.museum
Signposted in town centre
Open year round: Mon–Sat 11–5, guided tours 11.45–2.15
A working silk-mill until 1981, it now houses exhibitions that illustrate life in the mill during the 1930s. The Jacquard hand-looms have been restored, and former mill workers demonstrate the production processes.

159 Port Sunlight Museum and Garden Village

23 King George's Drive, Port Sunlight, Wirral CH62 5DX
0151 644 6466 www.portsunlightvillage.com
On B5137 to Bebington, from M53 junction 4 or 5, or follow signs on the A41 (new Chester road)
Open daily 10–5
Built in 1888 by William Hesketh Lever for the workers of his soap factory. The centre tells the story of the workers, their village and the factory. In the village is the Lady Lever Art Gallery, which holds a collection of Pre-Raphaelite paintings.

160 Quarry Bank Mill

Quarry Bank Road, Styal, Wilmslow, Cheshire SK9 4LA

01625 445896 www.nationaltrust.org.uk

About 20 minutes from Manchester city centre and 1½ miles N of
Wilmslow, off B5166 and signposted on all major routes

Open Jan–Feb: Wed–Sun 11–4; Mar–Oct, Bank Holiday Mons and
selected dates in Dec: 11–5

*Georgian cotton mill now restored as a working museum. Exhibits of all
aspects of the textile process, including spinning, reeding, weaving, dyeing and
printing. The weaving shed is powered directly from the 24-foot (7.3-m) iron
water wheel. The mill also used steam power, and the site houses a working
1836 beam engine similar to the one that was used in the mill.*

161 Queen Street Mill Textile Museum

Queen Street, Harle Syke, Burnley, Lancashire BB10 2HX

01282 412555 www.lancashire.gov.uk

M65 junction 10. The mill is about 2 miles from Burnley centre

Open May–Sept: Tues–Sat and Bank Holiday Mons 12–5; April and Oct:
Tues–Fri 12–5; Mar and Nov: Tues–Thur 12–4

*A working textile mill that is still powered by the original 500-horsepower
steam engine* Peace. *The large weaving shed contains over 300 looms, a
number of which are still used to produce cloth. Other working machinery
on view includes cylinder-sizing and warp-tying machines.*

MINING AND QUARRYING

162 Astley Green Colliery Museum

Higher Green Lane, Astley, Manchester M29 7JB

01772 431937 www.agcm.org.uk

Off East Lancashire Road (A580) signposted Higher Green

Open all year: Tues, Thurs and Sun 1–5

*The colliery ceased production in 1970, and the steam winding engine, the
largest in Europe, is now run and maintained by a charity. The 100-foot
(30-m) headgear still remains, and the site also contains a narrow-gauge
railway, stationary steam engines and an informative mining exhibition.*

163 Florence Mine Heritage Centre (Closed)

Egremont, Cumbria CA22 2NR

01946 820683 www.showcaves.com

SE of Egremont on A595 at Wilton turning

164 Lancashire Mining Museum (Closed)

Buile Hill Park, Eccles Old Road, Salford, Manchester M6 8GL

0161 736 1832

On A576 (Eccles Old Road), off A6 between Manchester centre and Pendleton

165 Nenthead Mines Heritage Centre

Nenthead, Alston, Cumbria CA9 3PD

01434 382037 www.npht.com

On A689 Alston to Stanhope road

Open 4 Apr–31 Oct: daily 11–5

Once the centre of the North Pennines lead industry, the heritage centre tells the story of the area's mining history. Archaeological excavation is uncovering the 200 years of mining history, and tours of the dig are given on certain days.

166 Wet Earth Colliery

Clifton Country Park, Clifton, Salford, Manchester M27 6NG

0161 736 1832 www.salford.gov.uk

Off A666 between Salford and Kearsley, signposted Clifton Country Park

Wet Earth Colliery Exploration group, meets at 9 a.m. every Sat morning at the park's visitor centre. Telephone for details

The excavated remains of the eighteenth-century Wet Earth Colliery are of primary importance due to James Brindley's unique solutions to the flooding problems on the site. Many of the surface features of the colliery have been excavated, including the wheel chamber, boilerhouse, fanhouse and loco shed. The volunteer group explores the underground tunnels on Saturday mornings.

RAILWAYS

167 East Lancashire Railway

Bolton Street Station, Bury, Lancashire BL9 0EY

0161 764 7790 www.east-lancs-rly.co.uk

In Bury town centre adjacent to the leisure centre

Open every weekend throughout the year; mid-week services in Easter holidays and May–mid-Sept. Telephone for timetable

Opened in 1846 to link the Manchester to Bolton line with Radcliffe, this steam railway runs from Bury to Rawtenstall, through Summerseat, Ramsbottom and Irwell Vale.

168 Lakeside & Haverthwaite Railway

Haverthwaite Station, near Ulverston, Cumbria LA12 8AL

01539 531594 www.lakesiderailway.co.uk

On B5278, off A590 from Lakeside

Open Easter–Oct: daily 10.30–4.30 (Jun–Aug until 6). Telephone for train timetable information.

Originally, this Furness railway branch line carried passengers and freight from Ulverston to Lakeside, but now the only part remaining is the 3½-mile (5.5-km) section from Haverthwaite to Lakeside.

169 Ravenglass & Eskdale Railway

Ravenglass, Cumbria CA18 1SW

01229 717171 www.ravenglass-railway.co.uk

On A595 coast road between Barrow-in-Furness and Whitehaven

Open late Mar–Nov and Boxing Day–New Year's Day: daily 10–5; also Feb half-term and weekends in late Mar, Nov and Dec

A narrow-gauge miniature steam railway that was laid in the nineteenth century to carry iron ore from the mines at Boot. The railway has seven steam locomotives, the oldest being the River Irt, *built in 1894.*

170 South Tynedale Railway

The Railway Station, Alston, Cumbria CA9 3JB

01434 381696 www.strps.org.uk

Off A686 Hexham road, N of Alston

Open Apr–Oct: weekends including Bank Holiday Mons; July and Aug: daily 11–4; certain other days in June

Telephone 01434 382828 for times

This narrow-gauge railway follows the route of the former Alston to Haltwhistle branch line. The route runs to Kirkhaugh in Northumberland, with Gilderdale station in between.

SHIPS AND ENGINEERING

171 The Dock Museum

North Road, Barrow-in-Furness, Cumbria LA14 2PW

01229 876400 www.dockmuseum.org.uk

Signposted within the town

Open Easter–Oct: Tues–Fri 10–5, weekends and summer Bank Holidays 11–5, last admission 4.15; Nov–Easter: Wed–Fri 10.30–4, weekends 11–4.30, last admission 3.15

The museum explores with the aid of a film show the history of the iron, steel and shipbuilding industries in the town, while the gallery, situated in the Victorian Graving Dock, hosts a changing programme of exhibitions.

172 Museum of Science and Industry

Liverpool Road, Castlefield, Manchester M3 4FP
0161 8322244 www.mosi.org.uk
Signposted on all main routes in the city
Open all year: daily 10–5
Situated in the old Liverpool Road Station, the museum houses collections that reflect the importance to the city of technology and science. The Power Hall contains a collection of working steam mill engines, the Air and Space Gallery charts the history of flying, while the Electricity Gallery examines how electricity has changed people's lives.

173 Steam Yacht Gondola

Pier Cottage, Coniston, Cumbria LA21 8AJ
01539 441288 www.nationaltrust.org.uk
Off A593, on NW shore of lake
Open late Apr–Oct: daily
Sailings are subject to the weather
Launched in 1859, the Gondola *worked on Coniston Water until 1937. The vessel has now been fully restored and carries eighty-six passengers.*

174 Windermere Steamboat Museum (Closed)

Rayrigg Road, Windermere, Cumbria LA23 1BN
01539 445565 www.steamboats.org.uk
Off A592 on E shore of lake
Currently closed. Check website for details
A collection of Victorian and Edwardian steamboats and vintage motorboats that all have connections with Windermere. Exhibits include the Esperance, *which was built by T.B. Seath for Henry Schneider, the founder of iron ore production in the Barrow-in-Furness area, and* Dolly, *built in about 1850 and still using its original engine.*

NORTH-EAST
(MAP 7)

WINDMILLS

175 Skidby Mill and Museum of East Riding Rural Life

Beverley Road, Skidby, Humberside HU16 5TE
01482 848405 www.eastriding.gov.uk
4 miles S of Beverley off A164 in village of Skidby
Open all year: weekends and Bank Holidays 10–5

A six-storey brick-built tower mill, with four 36-foot (11-m) self-righting patent sails. Built in 1821 and worked almost continuously since, the mill is fitted with three pairs of millstones: Derbyshire grit, French burr and carbon composite. The museum has exhibits on rural life in Yorkshire during the nineteenth century.

WATERMILLS

176 Crakehall Water Mill

Little Crakehall, Bedale, North Yorkshire DL8 1HU
01677 423240 www.crakehallwatermill.co.uk
About 3 miles W of Leeming Bar, in Crakehall village on A684
Open only by pre-arrangement

A mill was recorded on this site in the Domesday Book. This mill was built in the seventeenth century, although machinery dates from the eighteenth and nineteenth centuries and includes a breast-shot water wheel powered from Crakehall Beck, and two pairs of French burr millstones.

177 Darley Mill Centre

Darley, Harrogate, North Yorkshire HG3 2QQ
01423 780857 www.darleymill.com
11 miles W of Harrogate on A59, 2 miles on B6451 towards Pateley Bridge
Open all year: daily 9.30–5.30; Sun 11–5

A seventeenth-century corn mill with a working water wheel.

178 Heatherslaw Corn Mill

Near Ford, Cornhill-on-Tweed, Northumberland TD12 4TJ
01890 820488 www.ford-and-etal.co.uk
6 miles S of Coldstream on B3654
Open mid-Mar–Oct: daily 10–5

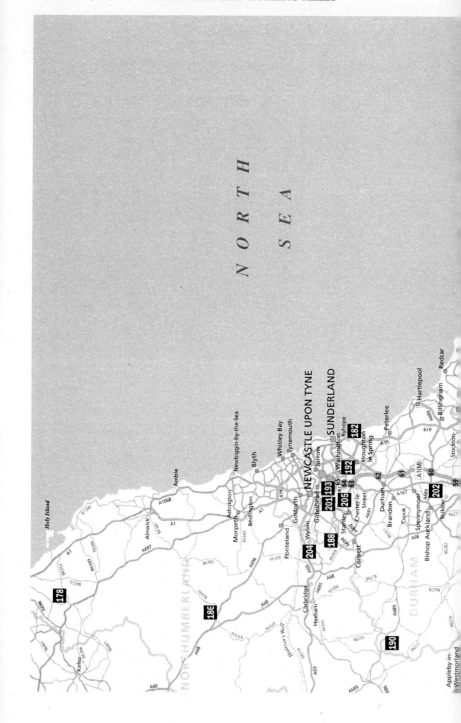

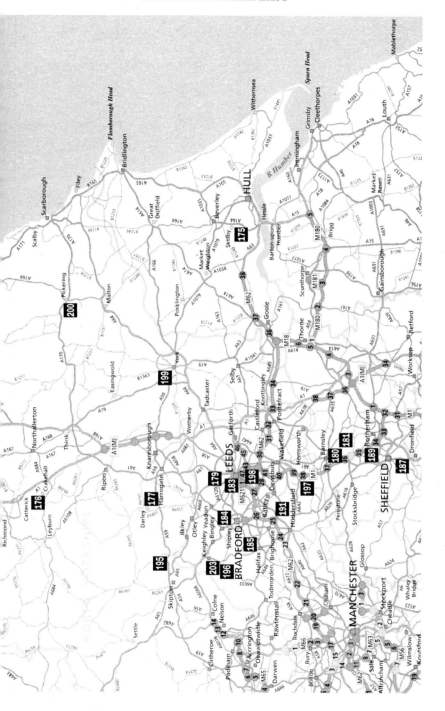

This early nineteenth-century building houses two independent mills which stand side by side, each complete with its own millrace and own water wheel. Each has three pairs of horizontal grinding stones, and a vertical stone for polishing pearl barley. The Upper Mill is now fully restored and produces flour, while the Lower Mill is used to explain the milling process and is not worked.

179 Thwaite Mills

Thwaite Lane, Stourton, Leeds, West Yorkshire LS10 1RP

0113 276 2887 www.leeds.gov.uk/thwaitemills

2 miles S of Leeds centre, off A61

Open Sat, Sun and Bank Holidays: 1–5; school holidays: Tues–Fri 10–5

Built in the 1820s on the site of a fulling mill, Thwaite was used originally as a wood, oil and corn-grinding mill. From 1872 it was used to crush stone for the pottery industry. Two 18-foot (5.5-m) low breast shot water wheels provide power for the mill. The manager's house has been restored and displays the history of the mill.

180 Worsbrough Mill Museum

Worsbrough, Barnsley, South Yorkshire S70 5LJ

01226 774527 www.barnsleylive.co.uk

2 miles N of M1, junction 36. Follow brown signs

Open April–Oct: Sat–Wed 11–4; Thurs and Fri prebooked groups only; Nov, Dec and March: Sun 11–4

Constructed in the early seventeenth century, this stone-built corn mill produces flour for sale. The mill is water powered with an adjacent steam-powered mill that houses a Hornsby hot bulb engine.

STATIONARY STEAM ENGINES

181 Elsecar Heritage Centre

Wath Road, Elsecar, Barnsley, South Yorkshire S74 8HJ

01226 740203 www.elsecar-heritage-centre.co.uk

M1 junction 36. Follow brown signs for 2 miles along A6135

Open all year: daily 10–5; closed Christmas Eve–New Year's Day

A heritage centre that includes a working museum, science centre and steam railway, as well as a Newcomen beam engine. Built in 1795 and still in its original location, the engine was used to pump water from local mines. The steam railway runs alongside the Dearne and Dove Canal and operates a 0-6-0 Avonside Saddletank locomotive built in 1926.

182 Ryhope Engines Museum (formerly Ryhope Pumping Station)

Waterworks Road, Ryhope, Sunderland, Tyne & Wear SR2 0ND

0191 521 0235 www.ryhopeengines.org.uk

3 miles S of Sunderland, just off B1522 (formerly part of the A1018)
signposted in Ryhope village

Open Easter–end Oct. Telephone for steam days

*Preserved machinery connected with the supply and the use of water. The
station includes two nearly identical double-acting, compound, rotative beam
engines arranged parallel to one another.*

MILLS AND FACTORIES

183 Armley Mills Leeds Industrial Museum

Canal Road, Leeds LS12 2QF

01132 637861 www.leeds.gov.uk/armleymills

2 miles W of city centre off A65

Open all year: Tues–Sat 10–5, Sun 1–5, Bank Holiday Mons 10–5

*A woollen mill built in 1806 that demonstrates the production of clothing woven
from wool. Exhibits also include water wheels, turbines, beam engines and steam
locomotives. A 1930s' working cinema is also on site.*

184 Bradford Industrial Museum

Moorside Mills, Moorside Road, Eccleshill, Bradford,
West Yorkshire BD2 3HP

01274 435900 www.bradfordmuseums.org

Signposted from Bradford ring road and Harrogate road (A658)

Open all year: Tues–Sat and Bank Holidays 10–5, Sun 12–5

*Moorside Mills was originally a spinning mill that is now part of a museum
charting the history of the Bradford woollen industry. Demonstrations of the
textile machinery and of the original steam engine that powered the mill are
given daily.*

185 Calderdale Industrial Museum

Central Works, Square Road, Halifax, West Yorkshire HX1 0QG

01422 358087 www.calderdale.gov.uk

Signposted in Halifax town centre

Open Tue–Sat: 10–5; Sun: 2–5

*Houses a collection of working machinery that represents 100 years of industry
in Halifax, from textiles to toffee-wrapping. The textile machinery includes a
spinning jenny, and there is also a number of working steam engines.*

186 Otterburn Mill

Otterburn, Northumberland NE19 1JT
01830 520225 www.otterburnmill.co.uk
Near junction of A68 Corbridge to Jedburgh road and A696 Newcastle to Jedburgh road
Open daily all year: summer 9–5.30; winter 10–4
A textile mill built in 1812 and extended in 1895. The mill still has much of its original water-driven machinery, including a fully restored nineteenth-century water turbine.

IRON-, STEEL- AND METAL-WORKING

187 Abbeydale Industrial Hamlet

Abbeydale Road South, Sheffield, South Yorkshire S7 2QW
01142 367731 www.simt.co.uk
4 miles SW of city centre on A621 Sheffield to Bakewell road
Open Apr–early Oct: Mon–Thur 10–4, Sun 11–4.45; all year for prebooked groups
A restored water-powered scythe-works dating from the eighteenth century. The hamlet includes water-powered tilt hammers and operating grinding hull and hand forges as well as a working Huntsman crucible steel furnace.

188 Derwentcote Steel Furnace

Forge Lane, Hamsterley Colliery, County Durham, Tyne & Wear NE39 1BA
0191 269 1200 www.english-heritage.org.uk
10 miles SW of Newcastle on the A694 between Hamsterley and Rowland's Gill
Open 1 April–30 Sept: every Sunday 1–5
An eighteenth-century steel furnace that was once at the centre of the British steel-making industry.

189 Kelham Island Museum

Alma Street, off Corporation Street, Sheffield, South Yorkshire S3 8RY
01142 722106 www.simt.co.uk
½ mile NW of city centre; take A61 to West Bar
Open all year: Mon–Thurs 10–4, Sun 11–4.45
Housed in a former generating station, the museum charts the history of the city's steel industry. The site includes a working 12,000-horsepower steam engine that originally powered a high rolling mill making armour plate for dreadnoughts.

Visitors can also see self-employed craftsmen, or 'Little Mesters', using traditional skills, including a cutler, grinder, hand-grinder and surgical-instrument maker.

MINING AND QUARRYING

190 Killhope, the North of England Lead Mining Centre

Near Cowshill, Upper Weardale, County Durham DL13 1AR

01388 537505 www.killhope.org.uk

On A689 between Cowshill and Alston

Open Apr–end Oct: daily 10.30–5

An open-air museum of the Victorian lead-mining industry based around a water-powered lead-mine and crushing mill. An underground tour of Park Level Mine explores the working conditions of the lead-miners and includes an 18-foot (5.5-m) water wheel that turns in a giant cavern. On the surface is a working 34-foot (10.4-m) diameter water wheel that was built in the 1850s and used to power the ore-crushing and separation machinery.

191 National Coal Mining Museum for England

Caphouse Colliery, New Road, Overton, Wakefield,
West Yorkshire WF4 4RH

01924 848806 www.ncm.org.uk

On A642 half-way between Wakefield and Huddersfield

Open all year: daily 10–5

A tour 450 feet (137 m) under ground by ex-miners uses a large collection of machinery and models to depict the methods and conditions of mining from the early nineteenth century. A steam winder used in the colliery between 1876 and 1980 is still operated for demonstration purposes.

192 Washington 'F' Pit Mining Museum

Albany Way, Washington, Tyne & Wear NE37 1BJ

0191 553 2323 www.twmuseums.org.uk

N of town centre, off Albany Way

Telephone for opening times

The Victorian steam engine, engine house and headgear are preserved to mark the town's 250 years of coal-mining heritage. The horizontal steam winding engine was built in 1888 and is driven by an electric motor for demonstration purposes. A working model shows how a mine shaft is operated, and it is accompanied by miners' recorded reminiscences of working down the pit.

RAILWAYS

193 Bowes Railway

Springwell Road, Springwell Village, Gateshead, Tyne & Wear NE9 7QJ

0191 416 1847 www.bowesrailway.co.uk

On B1288 Springwell Lane at N edge of Springwell village

Open Mon–Sat 9–4. Trains run on selected Suns and special days.
Telephone for details

Developed to carry coal to the River Tyne from pits in the north-west of Durham. A passenger service now operates using steam locomotives and brake vans formerly used on the colliery railway. At Blackham's Hill, two working rope-haulage systems can be viewed. These were designed by Stephenson and opened in 1826 to haul the wagons up two inclines.

194 Head of Steam, Darlington Railway Museum (formerly Darlington Railway Centre and Museum)

North Road Station, Darlington, County Durham DL3 6ST

01325 460532 www.darlington.gov.uk

On A167, 1 mile N of town centre

Open Apr–Sept: Tues–Sun 10–4; Oct–Mar: Fri–Sun 11–3.30

Located on the original 1825 route of the Stockton & Darlington Railway, the restored North Road Station, dating from 1842, is now a museum devoted to the railway heritage of the north-east. Exhibits include Stephenson's Locomotion, *as well as a large collection of engines and wagons.*

195 Embsay & Bolton Abbey Steam Railway

Bolton Abbey Station, Bolton Abbey, Skipton, N Yorkshire BD23 6AF

01756 710614 www.embsayboltonabbeyrailway.org.uk

Embsay Station signposted off A59 Skipton bypass

Open all year: most Suns; July and Aug: Tues–Thurs and weekends.
Telephone 01756 795189 for timetable

The railway runs from Embsay Station, built in 1888, to Bolton Abbey Station, ½ mile (0.8 km) from the abbey ruins. The Embsay ticket office was transported in derelict condition to Embsay from Barmouth in North Wales and has been fully restored.

196 Keighley & Worth Valley Railway

The Haworth Railway Station, Haworth, Keighley, West Yorkshire BD22 8NJ

01535 645214 www.kwvr.co.uk

Haworth Station is in village centre on Station Road.

Open daily all year. Telephone 01535 647777 for timetable
The steam railway runs for 5 miles (8 km) from the mills of Keighley to the Pennine village of Oxenhope, with six stations in total.

197 Kirklees Light Railway
Park Mill Way, Clayton West, near Huddersfield, West Yorkshire HD8 9XJ
01484 865727 www.kirkleeslightrailway.com
On A636 Wakefield to Denby Dale road
Open all year: weekends May–Sept 10–5, Oct–Apr 10–4; Bank Holidays and school holidays: May–Sept 11–5, Oct–Apr 11–4; 5 Jun–23 July: daily
A 15-inch (38-cm) narrow-gauge railway run on an old country branch line. Steam locomotives are operated on the railway along with enclosed and open carriages.

198 Middleton Railway
The Station, Moor Road, Hunslet, Leeds, West Yorkshire LS10 2JQ
01132 710320 www.middletonrailway.org.uk
Next to M621 motorway at junction 5, 2 miles from Leeds city centre
Open Easter–Christmas: weekends and Bank Holidays 10–5
Established in 1758, while commercial steam locomotives commenced operation on the track in 1812. The railway currently operates over 1 ½ miles (2.4 km) of track from Moor Road to Park Halt.

199 National Railway Museum
Leeman Road, York, North Yorkshire YO26 4XJ
08448 153139 www.nrm.org.uk
Signposted on major routes into the city
Open all year: daily 10–6; closed Christmas Eve–Boxing Day
The museum is home to a comprehensive collection of locomotives and rolling stock that tells the history of the railway from the Rocket *to the* Eurostar*. One of the permanent displays is Palaces on Wheels: royal saloons dating back to the Victorian era. Other exhibits include a replica of the* Rocket *and the* Mallard, *the world's fastest steam locomotive.*

200 North Yorkshire Moors Railway
12 Park Street, Pickering, North Yorkshire YO18 7AJ
01751 472508 www.nymr.co.uk
In Pickering off A170
Open Easter–Nov: daily 10.20–4.20; Santa Specials.
Telephone for details: 01751 473535
The railway operates a route of 18 miles (29 km) between Grosmont and Pickering.

201 Tanfield Railway

Marley Hill, Sunniside, Tyne & Wear NE16 5ET
0845 463 4938 www.tanfield-railway.co.uk
Marley Hill is on the A6076 Stanley to Sunniside road, exit A1 (M) at
Chester le Street
Site open daily: summer 10–5; winter 10–4.
Trains all year: Sun and Bank Holiday Mon, plus Wed–Thurs during
summer school holidays
The line originally opened in 1725 with horses pulling wagons on wooden
rails. The site includes steam-hauled passenger trains, steam locomotives,
vintage carriages and stationary steam engines. The original engine shed from
1854 remains and is still in full use.

202 Timothy Hackworth Victorian and Railway Museum

Soho Cottages, Shildon, County Durham DL4 1PQ
01388 777999 www.railcentre.co.uk
From A1(M) junction 8, head towards Bishop Auckland on A68, then take
the A6072. The museum is signposted in Shildon
Open daily throughout year: summer 10–5; winter 10–4, with limited
openings on Mons and Tues. Telephone to check
The home and workplace of Timothy Hackworth, superintendent engineer to
the Stockton & Darlington Railway. Exhibits include Hackworth's restored
cottage, engine and goods sheds complete with his Braddyll locomotive. The
museum is now incorporated into the National Railway Museum at Shildon
and includes its reserve collection of railway vehicles. Passenger rides are
available on certain days on the original 1825 track.

203 Museum of Rail Travel/Vintage Railway Carriage Museum

Ingrow Railway Station, Ingrow, Keighley, West Yorkshire BD21 5AX
01535 680425 www.vintagecarriagestrust.org
1 mile from centre of Keighley on A629 Halifax road
Open all year: daily 11–4.30
The museum houses a collection of historical railway coaches and early steam
locomotives. The exhibits include an 1876 Great Central Railway coach and a
1874 Bellerophon steam locomotive.

204 Wylam Railway Museum

Falcon Centre, Falcon Terrace, Wylam, Northumberland NE41 8EE
01661 852174 www.culture24.org.uk
About 10 miles W of Newcastle centre, off A69

Open all year: Tues and Thurs 2–7.30, Sat 9–12. Book visits in advance
*Displays show the importance of Wylam in railway history – George
Stephenson was born in Wylam, William Hedley (designer of* Puffing Billy)
was its colliery manager, and Timothy Hackworth was colliery blacksmith.

SHIPS AND ENGINEERING

205 Beamish Museum

Beamish, County Durham DH9 0RG
0191 370 4000 www.beamish.org.uk
Follow signs from Al (M) junction 63, 4 miles along A693 towards Stanley
and follow signs
Open Apr–Oct: daily 10–5; Nov–Mar: Tues–Thurs and weekends 10–4;
reduced operation in winter
*The open-air museum illustrates life in the north of England from the early
nineteenth to the early twentieth century. The re-created street includes
houses, a dentist's surgery, sweet shop and public house, while the colliery
village is complete with winding house, pithead and pitmen's cottages. An
existing drift mine has been re-opened, and tours are given to show how coal
was worked early this century. There is also a railway station and medieval
fortified manor house.*

206 Tees Cottage Pumping Station

Coniscliffe Road, Darlington, County Durham DL3 8TF
01325 483261 www.communigate.co.uk
E of Darlington town centre on A677 towards Barnard Castle. Look for
Broken Scar picnic site
Open Apr–Oct: 11–5 certain weekends.
Telephone the site owner, Northumbrian Water, during working hours
*Former Darlington water-works established in 1849 and now a water-
works museum. The changes in the machinery used for pumping water
is shown in the range of exhibits, which include a 25-tonne, 1904 beam
engine with a 15-tonne flywheel, a 1914 gas-powered engine and a 1926
electric pumping house.*

SCOTLAND
(MAP 8)

WATERMILLS

207 Aberfeldy Watermill

Mill Street, Aberfeldy, Perthshire & Kinross PH15 2BG

01887 822896 www.aberfeldywatermill.com

On A827, about 20 miles NW of Perth off A9 to Inverness

Open: daily 10–5 (5.30 in summer); Sun 11–5

A working watermill, over 450 years old, that is still used to produce oatmeal.

208 Barony Mill

Mill Cottage, Birsay, Orkney KW17 2LY

01856 721439 www.birsay.org.uk

On A968 from Dounby to the Earl's Palace

Open May–Sept: daily 10–1, 2–5; telephone ahead rest of year

The mill produces oatmeal (beremeal) using most of the original machinery from 1873. It is a three-storey building driven by a wood and iron water wheel.

209 Barry Mill

Barry, Carnoustie, Angus DD7 7RJ

0844 4932140 www.nts.org.uk

About 9 miles E of Dundee. The mill is N of Barry village and signposted between A92 and A930

Open Apr–end Oct: Thurs–Mon, 12–5, Sun 1–5

A three-storey water-powered mill that was used commercially to produce oatmeal until 1882. Now it grinds animal feed for demonstration.

210 Blair Atholl Watermill

Ford Road, Blair Atholl, Perthshire & Kinross PH18 5SH

01796 481321 www.blairathollwatermill.co.uk

Turn off A9 in Blair Atholl, 6 miles N of Pitlochry. Mill is signposted in Blair Atholl

Open Apr–Oct: Mon–Sat 10–5.30, Sun 11–5.30

Built around 1613, this three-storey mill with kiln has been restored to working order. The two pairs of millstones produce flour and oatmeal on a commercial basis. It is a 'working' museum.

211 Click Watermill

Hillside Road, Dounby, Orkney
01856 841815 www.historic-scotland.co.uk
Off B905 Dounby to Evie village
Open all year round
A small Norse mill built in the early nineteenth century with a horizontal water wheel that drives a single pair of millstones without gearing.

212 Crofthouse Museum

South Voe, Dunrossness, Shetland
01595 695057 www.shetland-museum.org.uk
Off A970, about 20 miles S of Lerwick
Open Apr–Sept: daily 10–1 and 2–5
Horizontal water wheel with thatched roof and a thatched house from the 1870s.

213 Dalgarven Watermill

Dalgarven, Kilwinning, North Ayrshire KA13 6PL
01294 552448 www.dalgarvenmill.org.uk
Half-way between Kilwinning and Dalry on A737
Open Easter–Oct: Tues–Sat 10–5, Sun 11–5; Oct–Easter: same times but closes at 4 on weekdays
The mill is driven by a breast-shot wheel 20 feet (6 m) in diameter that powers French burr millstones through cast-iron gearing. Originally erected in 1640, it was rebuilt in 1880 after being damaged by fire.

214 Huxter Mills

Huxton, Melby, Sandness, Shetland
01595 694688 www.scotlandsplaces.gov.uk
Signposted on Sandness road. Follow markers across field – mills are in valley
Open all year at any time
Three watermills, one of which has been restored to working order, the other two have been rethatched.

215 Keathbank Mill

Balmoral Road, near Blairgowrie, Perthshire & Kinross PH10 7HU
N of Blairgowrie off A93 Braemar road
Visitor centre now closed
A large former flax and jute mill powered by an 18-foot (5.5-m) breast-shot water wheel. Also contains an 1865 single-cylinder steam engine.

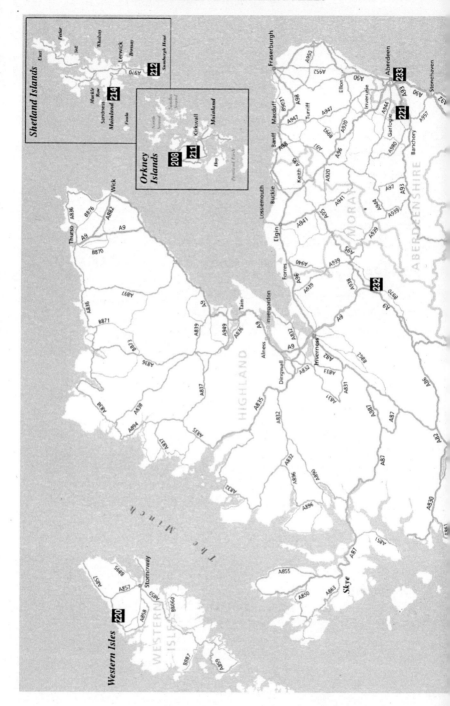

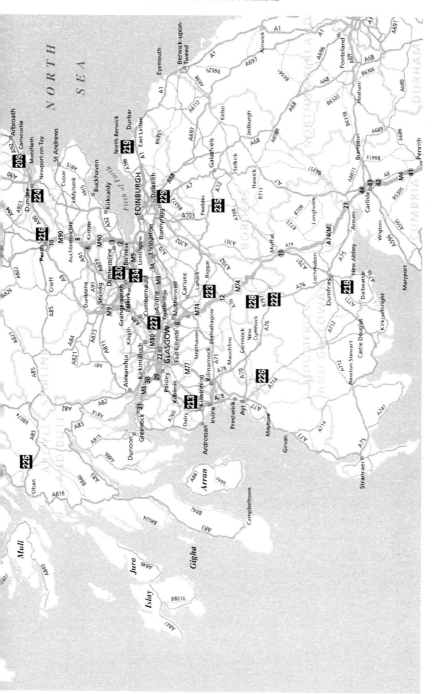

216 Lower City Mills

West Mill Street, Perth, Perthshire PH1 5QP
01738 627958 www.perthshire.co.uk
In Perth city centre
Open Apr–Oct: Mon–Sat 10–5, and Sun July–Sept 12–5; shop open all year
Originally the building housed a barley and malt mill and an oatmeal mill.
The barley mill ceased production in the 1930s, but the oatmeal mill continued
until the 1950s and has been restored to working order, producing three grades
of oatmeal. The large internal water wheel drives the mainly nineteenth-century
oatmeal machinery.

217 Mill of Benholm

Johnshaven, near Montrose, Aberdeenshire DD10 0HT
01561 362466 www.scotlandsplaces.gov.uk
1 mile N of Johnshaven, off A92 between Montrose and Inverbervie
Check website for opening times
A two-storey oatmeal mill that was worked commercially until 1982.

218 New Abbey Corn Mill

New Abbey, Dumfries, Dumfries & Galloway DG2 8BU
01387 850260 www.historic-scotland.gov.uk
About 6 miles S of Dumfries on A710. Follow brown signs in New Abbey
Open Easter–Sept: daily 9.30–5.30; Oct: 9.30–4.30; Nov–Mar: 9.30–4.30
(not Thurs or Fri)
The oatmeal mill dates from the late eighteenth century and continued in
production until the 1930s. It has been restored to full working order.

219 Preston Mill

Preston Road, East Linton, East Lothian EH40 3DS
01620 860426 www.aboutbritain.com
Follow brown signs in East Linton, which is 5 miles W of Dunbar
Open June–Sept: Thurs–Mon 1–5
Powered by a wood and iron breast-shot water wheel, this mill dates back to
the sixteenth century and has an adjacent drying kiln with a pointed tiled roof.

220 Shawbost Norse Mill and Kiln

Shawbost, Isle of Lewis, Western Isles HS2 9BD
01851 710208 www.undiscoveredscotland.co.uk
In the village of Shawbost, off A858, on NW coast of Isle of Lewis
Open access all year around

A horizontal watermill that has a kiln alongside it. The thatched mill ceased work in the 1930s but has been restored to working order.

STATIONARY STEAM ENGINES

221 Garlogie Mill Power House Museum (Closed)
Garlogie, Skene, Aberdeenshire AB32 6RX
01771 622807 www.aberdeenshire.gov.uk
From Aberdeen take A944 to Alford; museum on B9119 W of Aberdeen
Closed at present. Telephone for opening times
Houses power-generating machinery for now-demolished mill. Includes a beam engine in its original location.

222 Wanlockhead Beam Engine
Wanlockhead, by Biggar, South Lanarkshire ML12 6UT
www.historic-scotland.gov.uk
In Wanlockhead village, off B797 between Mennock and Abington
Open at all times, including Bank Holidays and Christmas
An early nineteenth-century wooden water-balance pump for lead-mining, with the track of a horse-powered engine beside it.

MILLS AND FACTORIES

223 New Lanark World Heritage Village
New Lanark Mills, Lanark, Strathclyde ML11 8BY
01555 661345 www.newlanark.org
1 mile S of Lanark, signposted from all major routes
Open daily all year: Oct–Mar 11–5; Apr–Sept 10–5
Built in the late eighteenth century, this cotton-mill village became renowned as a model village under the management of the social pioneer Robert Owen. The visitor centre includes a ride that recreates the experiences of a nineteenth-century mill worker, and also has working textile machinery. Other exhibitions include restored mill workers' homes, a period village store and Robert Owen's house.

224 Verdant Works
West Henderson's Wynd, Dundee, Angus DD1 5BT
01382 309060 www.rrsdiscovery.com
In the Blackness area of Dundee, signposted from city centre
Open Apr–Oct: 10–6, Sun 11–6; Nov–Mar: Wed–Sat 10.30–4.30, Sun 11–4.30
Housed in an early nineteenth-century flax and jute mill, the works explore the history of the city's textile industries. The story is told from the jute fields of

201

India, and the original working machinery is used to demonstrate how the raw jute is turned into cloth.

IRON-, STEEL- AND METAL-WORKING

225 Bonawe Iron Furnace

Taynuilt, Argyll PA35 1JQ

01866 822432 www.historic-scotland.gov.uk

By village of Taynuilt off A85

Open daily Apr–Sept: 9.30–5.30

Founded in 1753 by Cumbrian ironmasters, the furnace is a restored charcoal blast furnace for smelting iron and making cast iron. The works exploited the Forest of Lorne to provide charcoal for fuel.

226 Dunaskin Open Air Museum

Dalmellington Road, Waterside, Patna, Ayrshire KA7 6JF

01292 531144 www.showcaves.com

Adjacent to A713 Ayr to Castle Douglas and Dumfries road

Open daily Apr–Oct: 10–5; by appointment during winter

The museum is the preserved site of a Victorian iron-works. The open-air site includes a period cottage, industrial machinery and an excavated engine blowing house. A visitors' centre has audio-visual displays.

227 Summerlee Heritage Centre

Heritage Way, Coatbridge, North Lanarkshire ML5 1QD

01236 638460 www.monklands.co.uk/summerlee

From M8 junction 8 follow signs for Coatbridge and Summerlee

Open daily Apr–Oct: 10–5; Nov–Mar: 10–4

A museum of social and industrial history designed around the remains of the Summerlee Ironworks of the 1830s. The exhibition hall displays working machinery and reconstructed workshops such as a brass foundry and tinsmith's. There is also a reconstructed coal-mine and engine house with the 1810 beam engine from Farme Colliery.

MINING AND QUARRYING

228 Museum of Lead Mining

Wanlockhead, by Biggar, South Lanarkshire ML12 6UT

01659 74387 www.leadminingmuseum.co.uk

Signposted from the Abington junction of the A74 Dumfries to Kilmarnock road. Follow signs to Leadhills and then to Wanlockhead on the B797

Open daily Easter–Oct: 11–4.30; July and Aug: 10–5; also open in winter for school groups

The visitor centre houses a collection of rare minerals and mining artefacts, including working models of machinery. The underground guided tours of Lochnell Mine show the working conditions of the eighteenth-century miners, while the Straisteps cottages re-create their living environment. There is also a multimedia library.

229 Scottish Mining Museum
Lady Victoria Colliery, Newtongrange, Midlothian EH22 4QN
0131 663 7519 www.scottishminingmuseum.com
10 miles S of Edinburgh on A7
Open daily: 10-4

Ex-miners give guided tours around the site, which includes the pithead, a steam winding engine and a full-scale replica of an underground coalface. The museum also re-creates the home and working environment of a nineteenth-century miner.

RAILWAYS

230 Bo'ness & Kinneil Railway
Bo'ness Station, Union Street, Bo'ness, West Lothian EH51 9AQ
01506 822298 www.srps.org.uk
On S shore of Firth of Forth, 8 miles W of Forth Bridge, exit 3, 5 or 6 from M9
Open Easter–mid-Oct: weekends 10.30–4; July and Aug: Tues–Sun 11–4; special events, including Santa Specials, on certain days: telephone for details

The railway runs for a distance of 3½ miles (5.6 km) along the shore of the Firth of Forth. The Scottish Railway Exhibition houses a collection of over twenty steam engines, as well as historic carriages and wagons.

231 Caledonian Railway
The Station, Park Road, Brechin, Angus DD9 7AF
01356 622992 www.caledonianrailway.com
Brechin is off A90, 25 miles from Dundee. Follow signs in Brechin for Caledonian Steam Railway
Open late May–early Sept: Suns 11.20–5 (inc. Easter Sun) 11.20–5; Santa specials. Telephone for details

The trains operate between the Victorian station at Brechin and Bridge of Dun. The railway has a fleet of seven steam engines and eight diesel locomotives, some working and some undergoing restoration. A static display of rolling stock is on view every day at Bridge of Dun.

232 Strathspey Steam Railway

Aviemore Station, Dalfaber Road, Aviemore PH22 1PY

01479 810725 www.strathspeyrailway.com

Off B970 in Aviemore

Open daily July and Aug; June and Sept: Wed–Sun; April, May and Oct:
Wed, Thurs, Sat and Sun. Telephone for details

The railway covers the 5½ miles (8.8 km) from Aviemore to Boat of Garten.

SHIPS AND ENGINEERING

233 Aberdeen Maritime Museum

Shiprow, Aberdeen, Aberdeenshire AD11 5BY

01224 337700 www.aagm.co.uk

Off Union Street in city centre

Open all year: Tues–Sat 10–5, Sun 12–3

*The museum houses an oil-production platform to re-create the living and working
environment on board. Other exhibits include a nineteenth-century lighthouse lens
and a reconstruction of a 1925 shipyard drawing office and steam trawler deck.*

234 Kinneil Estate and James Watt's Cottage

Kinneil Estate, West Lothian EH51 0PR

01506 778530 www.kinneil.wordpress.com

On S side of Firth of Forth, on the western edge of Bo'ness, off the A904/A993

Open all year: Mon–Sat 12–4; closed Bank Holidays

*Kinneil House can be viewed from the outside but is open only on certain days.
Kinneil Museum is in the seventeenth-century stableblocks and recounts the
history of the estate from its origins as a Roman fortlet. James Watt's cottage
was erected in 1769 as a workshop for the inventor, who tested his prototype
engines on the estate to avoid being copied.*

235 Robert Smail's Printing Works

7–9 High Street, Innerleithen, Borders EH44 6HA

0844 4932259 www.nts.org.uk

Innerleithen is on A72, 6 miles from Peebles

Open April–Oct: Thurs–Mon 12–5; Sun 1–5

*This is a working museum still producing on a commercial basis. The premises
consist of a shop, office and printworks, and the presses can be seen in action
in the machine-room. The presses were driven originally by water power, and
the undershot water wheel has been reconstructed.*

INDEX

INDEX

PICTURE CREDITS

Pg 1 – David Hall; Pg 2 – David Hall (*top*), East Anglian Daily Times Company Ltd (*btm*); Pg 3 – David Hall, Shell Film Video Unit/Kew Bridge Steam Museum (*btm rt*); Pg 4 – David Hall, Mark Hamilton (*btm left*), Coldharbour Mill Trust (*btm right*); Pg 5 – Mark Hamilton (*top*), David Hall (*btm*); Pg 6 – David Hall (*top*), Mark Hamilton (*btm*); Pg 7 – Trustees of the Long Shop Museum (*top*), Mark Hamilton (*middle*), David Hall (*btm*); Page 8 – Lancashire Mining Museum (*top*), David Hall – (*btm*); Pg 9 – MOSI, Manchester (*top*), Lancashire Mining Museum (*btm*); Pg 10 – David Hall (*top*), National Coal Mining Museum for England (*btm*); Pg 11 – David Hall (*top*), Lancashire Mining Museum (*btm*); Pg 12 – David Hall; Pg 13 – Ffestiniog Railway Company Archives (*top*), David Hall (*middle*), Mark Hamilton (*btm*); Pg 14 – Mark Hamilton, David Hall (*btm*); Pg 15 – David Hall; Pg 16 – Trustees of the Long Shop Museum.